THE
WILDLIFE PHOTOGRAPHER
A COMPLETE GUIDE

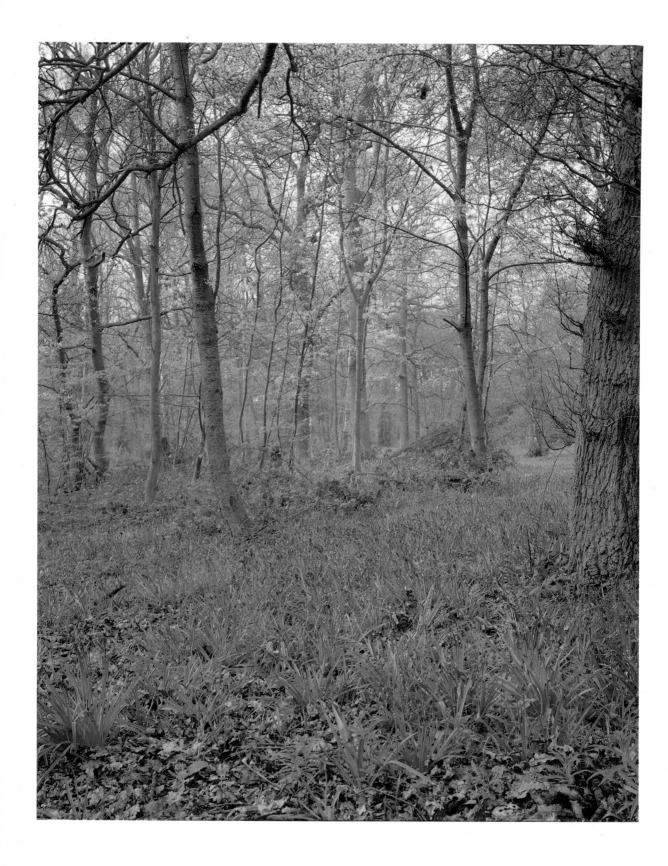

THE
WILDLIFE PHOTOGRAPHER
A COMPLETE GUIDE

Bob Gibbons & Peter Wilson

BLANDFORD PRESS
POOLE · NEW YORK · SYDNEY

First published in the UK 1986 by Blandford Press,
Link House, West Street, Poole, Dorset, BH15 1LL

Distributed in the United States by
Sterling Publishing Co., Inc.,
2 Park Avenue, New York, N.Y. 10016

Distributed in Australia by
Capricorn Link (Australia) Pty Ltd.,
P.O. Box 665, Lane Cove, NSW 2066

British Library Cataloguing in Publication Data

Gibbons, Bob
 The Wildlife photographer
 1. Nature photography.
 I. Title II. Wilson, Peter
 778.9 3 TR721

ISBN 0 7137 1524 3

Typeset by Graphicraft Typesetters Ltd., Hong Kong

Printed in Italy by New Interlitho SpA., Milan

Contents

Acknowledgements

Line drawings

Karen Saxby

Black and white photographs

Robin Fletcher: p. 129 (top); Bob Gibbons: pp. 11 (x2), 16, 18 (x2), 19, 32 (x2), 37 (x2), 40 (x2), 42 (x2), 56, 57, 61 (left), 64, 65, 92, 100 (x2), 105 (x2), 106, 107, 115 (top left), 128, 141, 144; Liz Gibbons: p. 125; Peter Wilson: pp. 41 (x2), 61 (right), 73, 77, 78 (x2), 80 (x2), 82, 89, 93, 94, 113, 114, 115 (top right), 116, 117, 119, 122, 124, 129 (bottom), 138, 140, 150, 152.

Colour photographs

Robin Fletcher: pp. 107, 130 (top); Bob Gibbons: pp. 35, 38, 39, 43 (x2), 46, 47 (x2), 50, 51 (x2), 54, 54–55, 55, 58, 63 (x2), 66, 66–67, 98 (x3), 99, 102 (top right and bottom), 103, 110 (x2), 126 (bottom), 130, 142 (bottom), 143 (x2), 146 (bottom), 147 (bottom), 155 (bottom); Tom Leach: p. 134; Mike Read: p. 127; Peter Wilson: pp. 2, 31 (x2), 59, 62, 71, 74, 79, 82, 83, 86 (x2), 87 (x4), 90, 91 (x2), 102 (top left), 111, 114, 115, 118 (x2), 126 (top), 131, 135 (top), 142 (top), 146 (top), 147 (top), 154, 155 (top); Michael Woods: p. 135 (bottom).

Author's Preface

The last few years have seen a remarkable boom in natural history photography. The greatly improved range of lightweight equipment now available, and the wide interest in the natural world, fostered by the many excellent television wildlife films, has led to a tremendous surge in the numbers of people interested in wildlife photography. Photographic competitions run by the major photographic magazines find an overwhelming response to the 'natural history' sections, often exceeding the traditional favourites of children, pets and holidays.

The wealth of films and the great range of published natural history photographs provide a tremendous stimulus and inspiration to the keen naturalist or general photographer to go out and do likewise, yet good solid practical advice on what to do is remarkably difficult to come by. Many existing books are fine showcases of the photographers' work, but they are too remote and unexplained to really help; it may be fascinating to read that a fine photograph was taken on a Hasselblad using three electronic flashes held by an assistant on a mountain top in Ruwenzori, but it is a difficult feat for the amateur to emulate! Nevertheless, it is also true that the range of photographic equipment is better than ever, and also cheaper in real terms than at any time in the past, so many photographers can contemplate buying a reasonable range of equipment. We provide a review of the equipment available, picking out those items we have found to be most useful (as well as mentioning a few that have proved to be useless!), and looking at the main instances where it is better to make the equipment yourself. We think we have learnt, from many years of teaching, practising and demonstrating natural history photography, the sort of questions to which people really need to know the answers, and this book is designed to fill that need. The emphasis throughout is on practicality and there are many pictures throughout the book of the set-ups used to take the pictures shown. Most of the pictures are of common subjects in readily-accessible areas and they are intended to be more than simply an inspiration in the sense that we actually explain how to take similar pictures in your own circumstances.

We have noticed how, increasingly, naturalists and photographers no longer confine their interests to one branch of natural history photography, especially as they delve into the subject further. The bird photographer may turn his attention to insects, while the general photographer may begin to take a closer interest in the inhabitants of the habitats which he photographs. Between the two of us, our interests have led us to attempt photographs of all forms of natural history, from lichens to oak trees and from aquatic invertebrates to birds at the nest. Not only that, but we try to take the subjects in a variety of ways — from pure portraits or close-ups of detail through to action shots of flight, mating, dispersal and so on. The contents of the book emphasise this comprehensive approach and it is the combination of two author photographers, with divergent but overlapping interests, that allows this comprehensive coverage.

However you enter the fascinating world of natural history photography — as a photographer becoming interested in natural history, or a naturalist becoming interested in photography — you will soon realise that a knowledge of the subject and a sympathy for it is paramount. 'The welfare of the subject must come first' is an oft-quoted statement, but it is essential to recognise the truth of it. We deal with ways in which photographers can avoid causing damage to other forms of wildlife — so easily done thoughtlessly — and the increasing legal controls on photographers of wildlife are mentioned where relevant.

We have derived enormous pleasure from natural history photography over the years, and the enjoyment and excitement shows no signs of diminishing! We hope that this book will provide enough information and stimulation for anyone who reads it to derive similar pleasure from this fascinating activity.

Bob Gibbons and Peter Wilson

1
Photographic Equipment

The range of equipment available to the natural history photographer, or any other photographer, is wider today than ever before and, in most cases, the products are considerably cheaper relatively than they have ever been. Equipment is not a substitute for skill, care or experience, but it can certainly help! Some types of equipment are better suited than others to natural history photography, while some items are a positive hindrance. We cannot cover every make and type of equipment here, so this chapter can only be taken as a guide which, if followed, will narrow down the choice considerably and help to reduce wasted time and money.

CAMERAS

The range of cameras available is enormous and daunting but, if you are buying mainly for natural history photography, it can be narrowed down considerably.

General considerations when choosing a camera

Firstly, the size of film that the camera takes (i.e. the format) must be considered. Generally speaking, the larger the film size, the more impressive the result and the more detail one can expect, but against that the equipment is much larger, heavier and more expensive, as well as being generally less versatile. The largest formats, i.e. larger than 6 × 6cm (2¼ inches square) are too heavy and bulky for most natural history photography, while the smallest formats, such as 110 or disk do not give adequate definition, nor is a satisfactory range of film speeds and accessories available. This limits the choice to 35mm, 6 × 6cm or something in between, such as 6 × 4.5cm, which is either a compro-

mise or the best of both worlds, depending on how you look at it.

For most people, financial limitations will still push them towards 35mm, and it is here that the range of equipment available reaches its zenith, though many nature photographers do use the larger sizes, accepting the drawbacks in order to gain the extra definition and impact that they bring. At one time, the larger images may have helped to sell photographs to publishers, but the advantage is now less than it used to be. One final advantage of the more expensive larger format camera is the ability to change the film mid-way through a roll by the use of interchangeable backs, though additional camera bodies for the 35mm user are barely more expensive and not much heavier.

Having decided on the film size for your requirements, there are a further range of options. Firstly, the viewing system, i.e. whether the camera is a single lens reflex (SLR), a rangefinder camera, a compact, or whatever. The SLR allows you to view the subject through the same lens as the picture will be taken through, whatever lens or accessories are used, and this has become the *sine qua non* of the nature photographer, as anything else presents you with immediate disadvantages. Examples of current good SLRs include: Olympus OM2 Program and OM4, Nikon F series, Canon A1, Pentax ME Super and numerous others in 35mm, while such examples as the Mamiya M645, and Hasselblad series are representative of the larger formats. Virtually all serious nature photographers, unless they concentrate on nature in the widest sense – in the form of landscapes and habitats only – use an SLR camera in one or other format (or quite often use more than one size).

Virtually all SLR cameras have interchangeable lenses – that is, the standard 50mm lens can be removed from the body and replaced with an alternative, such as a

The effect of changing lenses can be dramatic. The picture above was taken with a 50mm standard lens while that on the right was taken with a 500mm mirror lens from the same point.

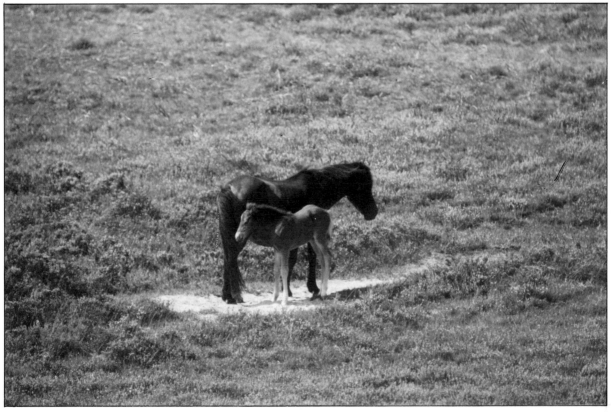

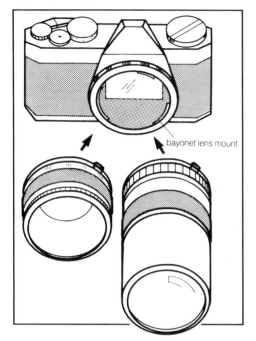
bayonet lens mount

Figure 1.1. Most single lens reflex cameras allow the lens to be changed, giving the greater flexibility needed for nature photography.

to work through the lens (TTL metering) so that it sees and meters what the camera is going to photograph.

Nature photography in all its forms is greatly facilitated by having TTL metering and it is wise to ensure that this is the case for any camera you acquire. Most TTL metering systems work in a broadly similar way, taking most notice of what is in the centre but reacting to a lesser extent to the rest of the frame; this works for most general situations, but is less than ideal for many natural history photographs – for example when taking a flower spotlit by a shaft of sunshine against a dark woodland background, or a black bird against a bright sky. There are ways around these problems, derived from experience, and these are described in the appropriate chapters. A different type of metering, known as spot metering, involves taking a reading *only* from a clearly defined central area, which allows very accurate metering of the subject, but it has disadvantages for many forms of photography and is rarely found on cameras nowadays, though a few cameras are produced with the 'ideal' of a choice between 'spot' and 'average' metering. A new extension of this idea, at present only available on the Olympus OM4 and related cameras, involves a choice of both sorts of metering and also gives the option of up to eight separate spot readings from the subject which can be integrated and averaged (if desired) by a built-in computer. This appears to be the ideal system, giving perfect results every time (though some experience in what to take readings from is still required), but it is expensive.

One other development of TTL metering also has advantages for the natural history photographer. This is known as 'off-the-film' (OTF) metering and involves measurement of the light reflected from the film during the actual exposure time. This has two particular advantages for us. First, and more obviously, it allows the camera shutter to react to any changes of light during the exposure – for example, if the sun comes out during a long exposure for a flower on a dull day – and all the cameras offering this facility have electronic shutters linked to the metering system to allow this sort of flexibility. It also allows the user to fire off flashguns, move reflectors and so on during a long

wide-angle or telephoto lens, to give a different perspective on the subject (see p. 17). Finally, mention should be made of what is, strictly speaking, a film type, though it has become synonymous with the trade name Polaroid. Cameras made by Polaroid – of which there are now a very wide range – are instant cameras, i.e. they produce a print within a minute or less of taking the picture. Similar film systems and cameras are now manufactured by Kodak and others. The enormous advantage of 'instant' pictures is the opportunity they provide to check whether you have everything set up right – whether the complicated flash system will give the light you require, whether a backlit subject is correctly exposed, and so on. At present, no instant picture camera provides the flexibility required by a nature photographer, so this sort of camera can only be a useful adjunct, but 35mm instant film has just been introduced, bringing these advantages to a wider range of subjects.

Camera metering systems

Most cameras manufactured nowadays have built-in light meters, coupled to the shutter speed and aperture of the camera. In SLR cameras, the meter is almost always designed

exposure, in the knowledge that the camera can take it all into account!

The second advantage conferred by OTF metering is the fact that it allows genuine TTL metering of flash exposures. The system works like this: during the incredibly short exposure time of the flash, the sensors in the camera read the amount of light reaching the film and switch off (i.e. shorten the duration of) the flash (or flashes) when enough light has reached the film for correct exposure. This can happen within as little as 1/50,000 second and can be be used with up to nine flashguns. The advantages are obvious, especially in difficult or complex situations, such as aquarium photography where exposure calibration would normally be needed, or in bird photography from the hide where opportunities are unrepeatable.

The system still demands some experience, as we discuss later (p. 112), but it is an undoubted advance on other flash systems such as 'computerised', 'auto' or 'dedicated' flash. It was pioneered by Olympus on the OM2 and is now available on the OM4 and in top-range models from Contax, Pentax, Nikon and others.

Automatic or manual metering?

The camera user or prospective purchaser will almost certainly have noticed that, in recent years, many cameras, including SLRs, have been labelled as 'automatic metering', or just 'auto', or with finer details such as 'aperture priority automatic' or 'shutter priority automatic'. What do these terms mean and are they of any significance to the natural history photographer?

There was, and still is, considerable resistance amongst photographers, including many natural history photographers, to methods of automatic metering on the grounds that it takes away creativity or flexibility. We believe this is erroneous and a waste of a good opportunity. What a good automatic camera does is to allow you to set, for example, the shutter speed that you require, and then it will automatically give you the correct aperture (subject to the limitations of the meter, as always) for the photograph you are taking. Some cameras work by setting the aperture automatically after you have chosen the shutter speed you

require (known as 'shutter priority automatics' e.g. the Canon AE1), while others work by setting the shutter speed automatically according to the aperture you have chosen (known as 'aperture priority automatics'; most automatic SLRs work on this principle, including the Olympus OM2, Pentax ME Super etc.). Finally an increasing number can do either, according to the position of a switch, and they are usually known as 'multi-mode automatics', e.g. Canon A1, Pentax Super A, Nikon FA and Canon T70.

All except the cheapest have some means of over-riding the automatic exposure mechanism, allowing manual control of both shutter speed and aperture, as well as some means of compensating for unusual situations by up to 2 stops either way while still on automatic. As long as you avoid the 'Auto only' types, which are usually the cheapest, then these automatic cameras give you everything that a manual metering camera provides, plus the benefits of automatic. If set on 'auto', you have the speed of use and instant reaction to changing circumstances that only an automatic can give you, yet you can compensate for difficult subjects, such as a dark bird against a bright sky (by giving, perhaps + 1 stop compensation) and still retain automatic metering. If you prefer, or if you need more than 2 stops of compensation, you can switch to wholly manual metering and do as you please. Most users of manually metered cameras will line up the needle to the correct position in the viewfinder and expose at the indicated aperture – an automatic camera simply does this operation for you but more quickly. Beware, however, of 'programmed automatic' cameras which set both aperture and shutter speed for you and allow you no control – these should be avoided.

There are two more, less obvious, advantages of an automatic metering system. Firstly, in either type, the setting that the camera makes is completely stepless and so the exposure can be exactly right for the circumstances; for example, in an aperture priority camera, you may have set the aperture to f.5.6 and the meter will determine that 1/104 second will give the exactly correct exposure; on a manual camera you would have to use 1/125 second. Secondly, and especially welcome to plant photographers, though only found in the better aperture priority systems,

is the ability to give exposures of up to 2 minutes automatically. In, for example, a dark woodland, such exposures are not unusual but are extremely difficult to gauge with a manual meter – if, indeed, you can see the needle at all.

We both use automatic cameras regularly and leave them set on 'automatic' for almost everything, compensating if judged necessary, and we get consistently accurate exposures. The only point to beware of, especially if you travel abroad to exotic locations, is the fact that most automatics are totally dependent on battery power for all functions, including the shutter mechanism. Some automatic SLRs provide a single mechanical shutter speed of about 1/100 second to allow some photography if the battery fails. The obvious answer is to carry spare batteries, but one can easily forget, and it is surprising how often the spare fails to operate, especially in difficult circumstances, just when you need it most. Most (but not all) manually metered cameras have mechanical shutters, so only the meter fails if the battery fails.

Finally, before leaving the subject of automatic metering systems, we should endeavour to answer the question (which many camera magazines imply is of paramount importance!) of whether aperture priority or shutter priority automatics are most suitable for the natural history photographer. There will always be many other considerations involved in choosing a camera, and we feel that this should properly be well down the list, but, as a guideline, the shutter priority camera will probably suit the person who concentrates on available-light action pictures, while all other natural history photographers will be better advised to go for an aperture priority, with its long-exposure capability, better control of depth of field and so on.

Other factors in choosing a camera

There are a few other important factors to consider when buying a camera, in addition to the obvious personal factors such as cost. The main ones are as follows:

a) Quality and extent of back-up system. It is almost certain that you will wish to extend your system beyond that of simply camera body and standard lens and it is wise to ensure that the camera you select has a good back-up system. Some otherwise good cameras do not have such a system. Important items to look for include: autowinder/motordrive capacity; a range of good macro lenses, including bellows-macro lenses for extreme close-ups; availability of automatic extension tubes and bellows; interchangeable viewing screens; availability of a right-angle viewfinder (mainly for plant photographers); a range of good quality lenses; and a good quality dedicated flash system.

Nowadays, more and more items of interchangeable equipment are being made by independent manufacturers, and many of these are very good quality, so the problem is less acute, but we believe that the nature photographer is most likely to find what they need if they stick to one of the main system camera makers – Olympus, Nikon, Minolta, Canon, Pentax – with all the access to both professional and amateur equipment that this implies.

b) Quality and reliability of the camera. These are not easy to quantify and, indeed, the standard of most cameras and lenses is now so high that quality of the basic equipment is rarely a problem. However, we would strongly advise against buying the cheapest cameras because they tend to be less reliable and the quality is suspect when pushed to the limits. Generally speaking, Nikon, Canon and Leica are amongst the most reliable, with Olympus, Pentax and Minolta close behind.

c) Top shutter speed of at least 1/1000 second. If you are contemplating bird flight photography and action pictures of mammals, or regularly use high speed film, then a top shutter speed of 1/1000 second is essential. A few cameras now offer 1/2000 second, or even more, and these have occasional uses but are not essential.

d) Depth of field preview lever. This is a small lever on the camera body, or on the lens, which allows the lens to be stopped down to the aperture you are going to use (or any other aperture) to allow an impression of the depth of field in the final picture. This is *essential* for the plant photographer (see p. 43). The best types have a locking knob,

but a non-locking one will do. Some otherwise good cameras, such as the Pentax K1000, are ruled out because of their lack of such a mechanism.

e) The ability to lock the mirror up during exposure. This can be very useful during long exposures to reduce vibration, especially with close-up work, though it is certainly not an essential feature.

f) A flash synchronisation speed of 1/125 second or faster. This can be very useful, especially where 'fill-in flash' is being used (see p. 84). Many cameras only allow the use of flash at 1/60 second or below, but Nikon and a few other manufacturers now provide a faster synchronisation speed.

Recommendations

It is impossible to recommend a specific camera, since individual circumstances vary so much, but a few generalisations are possible:

a) Go for a good quality camera with an extensive back-up system. Olympus, Canon, Nikon and Pentax are most suitable.

b) A camera with automatic metering, *provided* it has adequate exposure compensation (+ or − 2 stops) and a manual metering setting, is better than a purely manual metering camera.

c) Cameras offering genuine TTL flash metering have many advantages, especially if you are interested in photographing insects, birds at the nest, reptiles and amphibians, or any studio photography. The cheapest way to achieve this, at the time of writing, is by buying an Olympus OM2, and this camera fulfils all the other main requirements. Other cameras offering TTL flash include the Nikon F3 and FE2, Contax 139 and the Pentax LX – all are fine cameras, though expensive.

d) Avoid cameras that are automatic only or, worse, have programmed shutters, cameras with built-in motordrives, cameras without a depth of field preview lever.

This narrows the field considerably and should allow a reasonable range of choice in each price range. Cameras not offering all these features will, of course, be satisfactory for a proportion of photographic opportunities, but is is probably still wisest to stick to the cheapest, good cameras from the main system manufacturers, e.g. the Olympus OM2O and the Nikon EM, and then gradually progress from these into the system, as and when possible.

LENSES

The lenses on the camera play a greater part in natural history photography than the camera itself and, as stressed in the section on cameras, it is really essential to have a camera which will accept a range of good lenses. The types of lenses best suited to each aspect of natural history will be looked at in more detail in the relevant chapters; the following provides a general review of what is available and particular points to look for. For convenience, we have classified the range of lenses into: wide-angle, standard, telephoto, macro and tele-converters (including macro-converters).

Zoom lenses are not categorised since they may fall into one or other of these categories, or even into three or four of them. We begin, though, with a general consideration of the advantages and disadvantages of zoom lenses. A prime lens is a lens of fixed focal length, e.g. 28mm, 135mm, 300mm and so on. A zoom lens is a lens of variable focal length, e.g. from 70 to 210mm, giving a range of 'magnifications', and they are becoming increasingly known as variable-angle lenses in reference to their ability to cover different fields of view as they are 'zoomed'. Nowadays, zooms are available in an enormous range of focal length combinations and much effort has been put into their development. Common variations include 28–48mm (wide-angle zoom), 35–70mm (standard zoom or wide-angle to telephoto zoom) and 70–210mm (telephoto zoom). Many are described as 'macro-zooms' because of their close-focusing ability. Their great advantages are that they replace two or more prime lenses by a single lens *and* they offer all focal lengths in between, *and* they avoid the delay of changing lenses. The disadvantages include their additional weight and size over any single lens that they replace, which means that this additional

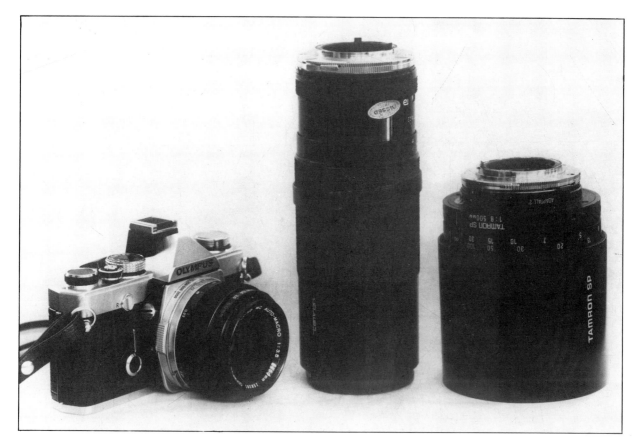

weight is there all the time, whether using 70mm or 210mm; their quality is usually lower, though the better zooms now available are virtually indistinguishable in quality from prime lenses; they cost more than any individual prime lens that they replace, though not, of course, more than all the lenses they replace; and, finally, they tend to have smaller maximum apertures than equivalent prime lenses, e.g. f.4 rather than f.2.8, though the difference is less than it used to be and is not usually very significant anyway.

General considerations when buying lenses

There are a few general points to look out for when purchasing any lens for natural history photography:

a) Minimum aperture. It is extremely useful to have lenses that stop down to f.22 or even f.32 on occasion; f.16 as a minimum is inadequate since it gives significantly less depth of field compared to f.22 or f.32 and this may be critical in close-ups, portraits of flowers, and even some habitat pictures. The often-mentioned drop in quality at f.22 and beyond is rarely noticeable in a good lens, and is usually irrelevant since the subject is most often in the centre of the frame where the effect is least noticeable;

b) Close-focusing ability. We discuss genuine 'macro' lenses, designed particularly for close-up work, below. It is helpful, however, if other lenses in your collection focus reasonably close – there are many occasions when it is impractical to put on extension tubes for fear of frightening your subject and a close-focusing lens will allow chance shots of birds, reptiles, small mammals etc. Many zoom lenses focus closer than the average lens, though the quality is not always especially good. Some manufacturers seem to have the natural history photographer in mind when designing lenses and Tamron are no-

Modern equipment is both small and light. This picture shows an Olympus OM1 with macro lens attached (focusing to ½x life size). On the right of it is a lightweight, 300mm, f.5.6. conventional telephoto lens and on the far right is a 500mm mirror lens (see p. 18).

ticeable in this respect, with their excellent close-focusing range of SP lenses.

c) Independent manufacturer's lenses or camera maker's own lenses? As most people will be aware, there is an enormous range of lenses made by non-camera makers to fit most popular camera types. For some people, the choice is not a matter of logic – they simply feel that a Tokina lens would not look right with a Nikon! Common sense, however, dictates that this enormous range of glassware should be carefully considered since individual lenses may offer considerable advantages in terms of price, size, close-focusing ability, maximum and mimimum aperture and even, occasionally, quality. The advantage of a camera manufacturer's own lens will usually include: consistent quality, colour rendition and control layout through the range. Against this must be set the individual advantages of a given independent lens and the much wider range of choice – for example, several 'independents' offer excellent 90mm or 100mm 'macro' lenses which may be missing from the maker's own range. Don't dismiss 'independents' on principle – we use a number of them and have not been disappointed.

Types of lenses for natural history photography

1. *Wide-angle lenses* These are lenses of a focal length shorter than 50mm (on 35mm film) or equivalent standard lens. Typical examples include 35mm, 28mm and 24mm. They offer a much wider field of view than a standard lens and, at first glance, may appear to offer little to the natural history photographer. In fact, they can be very useful, even exciting, in three main situations:

a) For the plant photographer, and anyone else who wishes to show their subject in relation to its habitat, they are ideal. They can produce a picture in which the main subject still fills the centre of the frame, but much more background is shown – and it will be in sharper focus. The means of achieving this is discussed on p. 42, but suffice it to say that such pictures can have greater impact and provide a good deal of information to the viewer.

b) for the habitat photographer, they allow pictures to be taken in confined spaces, such as woodland, that would otherwise be impossible.

c) they can provide much higher magnifications, when mounted on bellows or extension tubes, than a standard lens or telephoto lens, at an equivalent extension length. It is essential that a good quality lens is used for such purposes, however.

A range of wide-angle zooms are now available and we have found that a 24–48mm or 28–50mm zoom is ideal as an all-purpose lens for plant, habitat and general photography. In the absence of a zoom, a 28mm or 35mm lens is probably the most useful. Lenses offering an altered perspective, such as 'fish-eye' lenses are best avoided in representative natural history photography, though they can be fun to use!

2. *Standard lenses* These are lenses of about 50mm (on 35mm film) or equivalent, usually supplied with the camera. Many general photographers dispense with a 50mm lens altogether, but for natural history photography we would advise the retention of this focal length for those times when one wishes to portray a situation just as it is, without perspective distortion. If you can afford it though, it is a great advantage to replace the normal 50mm lens with a macro lens of the same focal length, e.g. a 50mm f.3.5 macro (or micro), which does everything that the standard lens does plus a bit more. If buying a new system, there is no need to buy a standard lens at all – you can simply buy a body with a 50mm macro lens. The advantages of macro lenses are discussed below.

3. *Telephoto lenses* There are lenses that cover a narrower field of view than a standard lens and therefore 'pull-in' distant objects to make them appear closer. Focal lengths range from 85mm or so to 500mm, 1000mm or even more. A 500mm lens, for example, will give an image 10x larger than a 50mm lens from the same point (see p. 11). Thus, the value to the natural history photographer is immediately obvious and such lenses find many uses here. Short telephotos, such as 90mm and 135mm, are useful for

A shift lens can help to correct perspective distortion: the picture on the far left was taken with a normal 35mm lens, while, for that on the left a perspective-correcting (shift) lens was used, giving less converging verticals and an impression of the picture having been taken halfway up the trees. Such lenses are expensive and awkward to use but may be worthwhile if you take a lot of tree pictures.

giving a pleasing perspective on static subjects and for helping to differentiate subjects from their background (p. 42). If used with extension tubes or close-up lenses, they are ideal for photographing larger insects, reptiles, amphibians or garden birds, and for some bird-at-the-nest work (p. 71).

Larger focal lengths, of 300–500mm, are the optimum for stalking less approachable subjects. Anything larger is difficult to use on the move. When working from a hide away from the nest, such as on a lagoon, the larger focal lengths may be used mounted on a tripod for optimum results. It is into this focal length range that the majority of mirror lenses fall. Mirror lenses use mirrors in place of some lenses and, in effect, they 'fold' the light path. The result is a very short lens, usually lighter than its conventional counterparts and often able to focus to very close distances. They have become popular in recent years and are very attractive, though they do have some disadvantages. These are:

a) They are not as easy to hand-hold as they may look.
b) They usually have a fixed aperture, of, say, f.8, which cannot be stopped down (though this facility is just appearing on a few new mirror lenses). This means that the depth of field is very limited, and you may experience overexposure in bright light with faster films.
c) They cannot be used on automatic exposure with shutter priority systems, though they can with most aperture priority cameras.
d) Out-of-focus highlights of light appear as circular 'doughnuts', and out-of-focus lines appear double. Collectively, this can look very unattractive.

Telephoto lenses of larger than 500mm are very expensive and rather specialised. Their use is almost confined to tripod photography, but of course they may represent the only way that a very shy subject can be photographed at all.

Beware of rushing into buying a very long focal length lens unless you are sure you will use it and are aware of the difficulties. One of us once spent a month walking in the Himalayas with an Australian photographer who carried a 500mm lens all the way, but only used it once – to photograph the moon!

4. *Macro lenses* The term 'macro' is a loosely applied term indicating lenses that focus more closely than normal. We use it here to denote lenses that focus to at least half life size and in many cases closer.

A whole range of such lenses are available, and they fall readily into two types:

a) On-camera lenses, that mount directly on to the camera like most other lenses.
b) Bellows-macro lenses that operate only on bellows or variable extension tubes and have very limited focusing capability built in.

Generally the latter are designed for extreme close-up work, with a few exceptions. On-camera macro lenses are available for 35mm cameras in focal lengths of about 50mm (i.e. 'standard'), 100mm and 200mm. The range for larger format cameras is more limited, though the main system manufacturers usually offer a macro lens alternative to the standard lens in 6 × 6cm or 6 × 4.5cm systems.

The enormous advantage of these lenses is that they focus from infinity right down to half life size or even life size without interruption and without extension tubes. They are also specifically designed to work at close distances, where they give optimum results, though good ones are perfectly adequate for general use. This close-focusing ability greatly speeds the process of photographing close-ups, and also aids your ability to quickly assess a close-up picture through the viewfinder to see if it is worth taking. We have used 50mm macro lenses in place of standards for many years without any problems. The disadvantages of replacing a standard 50mm lens with a standard macro lens include the increased cost of the macro, the smaller maximum aperture and the slightly increased weight and size, though we feel it is well worthwhile. A larger focal length macro lens, of about 90 to 105mm is invaluable for insect or reptile photography, giving about twice the working distance compared to a standard lens for the same result. In other words, a butterfly that would fill the frame at 20cm away with a standard lens would fill it at 40cm away with a 100mm lens. This

Mirror lenses frequently produce distracting backgrounds with ring-shaped out-of-focus highlights, though at times they can be used as part of the photograph. Indian cuckoo, 500mm lens, f.8.

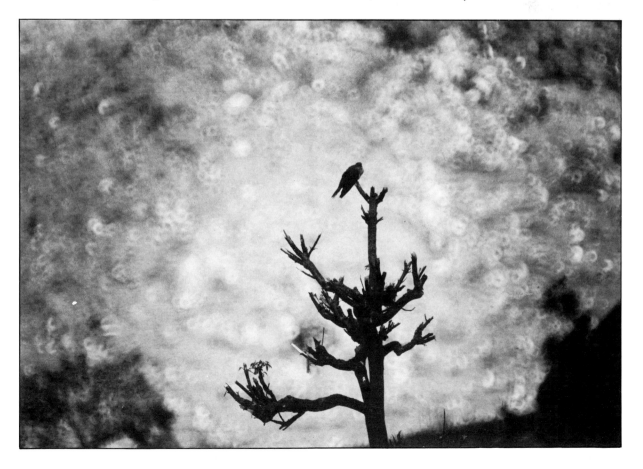

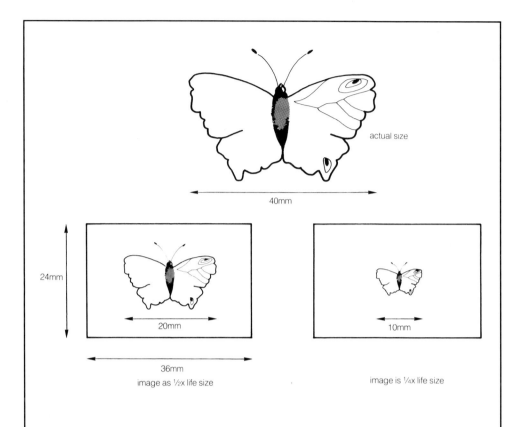

actual size

40mm

24mm

20mm

36mm

image as ½x life size

10mm

image is ¼x life size

Image sizes and magnifications

In close-up photography, you will often hear mention of such terms as 'life size', 'half life size' and so on, or see ratios such as 1:2 quoted. These are a way of indicating how large your subject will appear in the final picture and they are much more practical and relevant than thinking in terms of how far away the subject is from the camera. Image sizes work like this: If an object, say, a small beetle, that is 1cm long in life appears on the final negative or slide as 1cm long, then we say that the picture has been taken at life size, or a magnification ratio of 1:1. In other words, image size = object size. If, however, the object was twice as far away then, as long as you use the same lens, it will appear at half its size in life, so we say that it has been taken at half life size, or a magnification ratio of 1:2, and so on. For the photographer, the important thing in this respect is not whether he can get within 1m or 2m of the subject, but how large the subject appears in the final picture. A 50mm lens will produce a half life size image at 23cm from an object, while a 90mm macro lens will produce the same-sized image from about 39cm, so it makes much more sense to talk in terms of image sizes rather than minimum focusing distances. Most macro lenses will produce half life size images at their closest focusing distance, though a few will produce life size images.

obviously makes a shy subject less likely to take fright, but it also makes it less likely that your shadow will fall on the subject if using daylight to work by. The 200mm macro lenses appear only in a few systems and are much more expensive than those of shorter focal lengths. They are helpful for very difficult small subjects, e.g. large dragonflies which refuse to come to the shore of a lake, but are heavy and difficult to hand hold adequately.

We are often asked 'Which macro lens should I buy?'. Regrettably, the answer is not simple. The choice for a first macro would exclude the 200mm types and we would advise a 100mm type for someone mainly photographing insects, spiders, small reptiles and similar subjects, and a 50mm macro for someone who concentrates more on flowers, though other factors will determine your final choice. We have both avoided deciding by opting for both types! Bellows-macro lenses are available in a wide and increasing range of types. Once, they were only available as short focal length 'heads' for extreme close-up work, but the advent of automatic bellows and variable extension tubes has opened up new possibilities. Novoflex (a German independent manufacturer) offer a 105mm lens head which couples with their excellent automatic bellows to focus continually from infinity to almost life size without interruption. These are available to fit most cameras, but they are very expensive. Olympus offer a 135mm f.4 head that couples with their excellent variable extension tubes to focus from infinity to almost half life size, or to over life size when mounted on bellows. Clearly, these are direct competitors for 'on-camera' macros, though the complete set-up is usually heavier and may be slower to operate. Most other bellows-macro lenses are of focal lengths between 20 and 40mm and they only focus at close distances, typically to give magnifications of 2x to 6x, or 5x to 10x life. Generally, the shorter the focal length, the greater the possible magnification. Most such lenses for extreme close-up work do not have automatic diaphragms, though a few now do.

5. *Tele-converters* Tele-converters are optical devices that can be inserted between the camera body and the lens you are using to increase the focal length of that lens. They are generally available in magnifications of about 1.4x, 2x and 3x and the effect of these on a 100mm lens would be to convert it to 140mm, 200mm or 300mm respectively, so, in effect, they cheaply double the size of your lens armoury. They also have the great advantage to us that they allow the original lens still to focus as close as it would on its own and the net result of this is to allow an image size twice as large (with 2x conver-

ter); for example, a 50mm macro lens focusing to half life size will become a 100mm macro lens focusing to life size, yet still going back to infinity.

So, where is the catch? Firstly, they significantly reduce the amount of light reaching the film by, for example, 2 stops with a 2x converter. This means that a 300mm f.5.6 lens would become a 600mm f.11 lens, with a much darker viewfinder and less chance of being able to use a fast shutter speed. Conversely, though, they do convert the minimum aperture of, say, f.16 to f.45 which is occasionally useful.

Secondly, there is always some reduction in image quality, though today's top quality multi-element, multi-coated versions are excellent, especially those that are matched to specific lenses or ranges of lenses. Inevitably, they will magnify any faults in the main lens, but this should not be a major problem.

Overall, they are well worth considering, especially with a limited budget. It is certainly worthwhile spending a few pounds more to get a really good one though, and we advise that 3x converters are best avoided!

A recent development of the converter is the macro-converter. These devices increase the focal length of your lens, but they also allow closer focusing than with the lens on its own — at the penalty of losing focus at longer distances. In other words, they are rather like a tele-converter with an extension tube attached, except that they are optically more corrected for close-up work. A standard 50mm f.1.8 lens focusing to, say, 45cm, would be converted to a 100mm f.3.5 lens focusing from perhaps 1:20 to 1:1 — a very useful range. The better quality examples can be recommended as a cheaper alternative to a macro lens, though a genuine macro lens will always be preferable.

SUPPORTING THE CAMERA

The reasons for requiring a camera support are discussed in greater detail under each subject, according to their requirements; suffice to say here that we found that starting to use a tripod afforded the greatest advances in our own photography of all the accessories that we use, and it is also true to say that almost all photographs taken unsupported

could have been improved by the use of a support.

Range of supports

There are many forms of camera support, from huge rigid tripods to bags of beans, and most have their value at some time or other, though a few are useless. We attempt here to give some guidance on what is available and what will give the best results.

1. *Tripods* These are, literally, the mainstay of the plant, bird and habitat photographer and no-one specialising in these fields should do without one. There seem to be hundreds of models to choose from, but this is rapidly narrowed down by the following requirements:

a) A good rigid tripod is necessary under all normal conditions – try it out with a telephoto lens on the camera, if you can, and see if it vibrates. A shaky tripod is worse than useless!
b) For the plant photographer, the ability to splay the legs of the tripod widely and get close to ground level is essential; a minimum height of 46cm is totally inadequate for plant photography. Reversing centre columns are some compensation, but they are very difficult and slow to cope with, and there is always a leg in the way of the lens or viewfinder!
c) The tripod must have a good 'head' which is adjustable in three directions. A small ball-and-socket head is useless as it will not hold a camera with any weight of lens on, though many people favour a large ball-and-socket (such as the professional Gitzo ball-and-socket head) to the more conventional 'pan-and-tilt' head usually fitted. The pan-and-tilt is better if you need to move the camera in one plane only, but a ball-and-socket is more manoeuvrable.

There is one tripod that fills almost all the requirements of the natural history photographer and that is the Kennett Benbo tripod. It is made to a highly unusual design, but the net result is a tripod that can be adjusted to almost any position, including

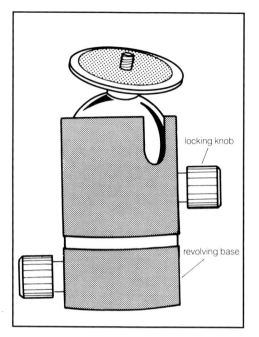

Figure 1.2. A ball-and-socket head provides a quick means of adjustment of the angle and direction of a camera or flashgun mounted on a support.

locking knob

revolving base

below ground level, or overhanging to a point well away from the centre of the legs. It is also extremely stable and durable. The only drawbacks are a certain difficulty in use, since all three legs and the column are released by one bolt, and a rather high price – but it's worth it! Cheaper alternatives include braced-leg models from the Velbon or Cullmann ranges, both of which are good, and the versatility of these more conventional tripods can be extended by purchasing a Velbon (or equivalent) 'super-arm', which allows the camera to reach right to ground level or away from the centre of the tripod (see Figure 1.3). Useful accessories for tripods include a spirit level, especially for landscapes and seascapes, arms on which to fit flashguns, and a cable-release that threads through the handle of the pan-and-tilt head.

Tripods to avoid include 'table-top' tripods, which are fine for table-tops, but useless on uneven ground since they are not adjustable and they fall over. We have, however, found the small adjustable-leg tripods, such as the Velbon HE-3 mini, useful at times, and they may be just right for pressing against a tree to photograph, say, a lichen (see p. 64) or to steady a long lens. They can also be very useful for supporting flashguns or other accessories, both in the field and in the studio.

lichen

Figure 1.3. The Kennett Benbo range of tripods are ideal for nature photography, giving great stability with complete flexibility in difficult situations.

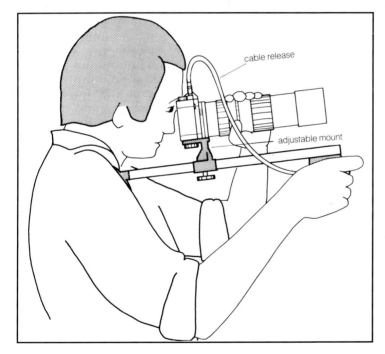

cable release

adjustable mount

Figure 1.4. An adjustable rifle-grip with cable-release is an invabluable aid for steadying the camera when you need to be mobile.

2. *Monopods* These are single telescopic tubes with some form of camera support at the top, e.g. a ball-and-socket head. They are much less rigid than a tripod and do not allow long exposures, but they can reduce camera movement and are very useful for semi-action photography, such as when stalking a deer or a large dragonfly, where a tripod can be cumbersome. It is best to look for one that has strongly locking legs (some types give way if you lean hard on them) and a head that can be moved in different ways. They are generally much lighter and more portable than a tripod, though they certainly cannot replace it.

3. *Rifle-grips* These are useful devices which comprise an adjustable 'stock' with a shoulder-butt at the near end and a hand-grip at the far end. The camera fits on a adjustable plate to allow it to be used close to the eye and the shutter is fired, *via* a long cable-release, from a trigger on the hand-grip. The combination of steadying the set up against the shoulder and releasing the shutter with a cable-release makes for a very smooth operation, and they can add to your ability to avoid camera shake by about 2 steps of the shutter speed (e.g. from 1/250 to 1/60 second) in some circumstances. They are highly mobile supports and we have found them most useful when stalking birds or mammals, with relatively long focal length lenses fitted. They can also be used with a flash set-up to photograph insects or reptiles and, in these situations, their advantage is to enhance your

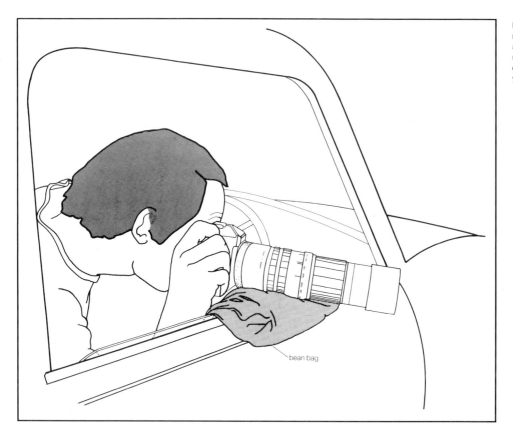

Figure 1.5. The bean bag makes a stable support for, amongst other things, using a telephoto from the car window, as long as you switch off the engine.

bean bag

ability to keep the subject in focus, rather than stopping camera shake, since the flash solves the latter problem. When choosing one, avoid the very cheapest makes, which tend to be flimsy; you may find it worth looking for one which gives the option of an electronic release as well as cable-release, especially if you plan to use motordrive (some motordrive/autowinders are not triggered by an ordinary cable-release). You can also make your own fairly readily from wood or metal, with the aid of a long cable-release.

4. *Other supports* Although a good solid tripod is the basis of many good photographs, there is no doubt that there are times and situations when it is impractical to use one: such as on a day-long walk in the mountains (though it is usually worth the effort), when photographing from the car, or when taking photographs very close to ground level. In these instances, some of the many alternative camera supports will be useful.

The *bean bag* is a fascinatingly useful and versatile support, readily made at home or available commercially. It consists of a strong bag filled with dried beans, polystyrene or similar material and closed up. The best shape for the bag is rectangular rather than square, so that it can be stood on end for a higher viewpoint. If working close to ground level, the bag is placed on the ground and the camera then manipulated so that it is steady in the position that you want it to be; in most cases it will remain there without further support, allowing exposures as long as you like, if a cable-release is used; in other cases, some extra support is needed, but you can still get away with, say, 1/8 second exposure. If working from the car, a good solid bean bag can readily support a camera with telephoto lens placed on the roof (but turn off the engine!) or – rather less well – on a wound-down window. Many other situations present themselves – rocks, treestumps and so on – and it makes an invaluable addition to a gadget bag. You can even eat the beans if you get stuck on a mountainside!

Most other supports comprise a ball-and-socket head attached to some form of support. A *G-clamp* with a head on can be clamped to fence posts, car windows and so on to give some support, though it is rarely solid enough to use a long lens and the support is hardly ever where you want it! A *magnapod* attaches to any metal surface by a powerful magnet, so it too can be used on a car. The *ground-spike* consists of a sharp spike with a cross-piece at the top and a head above this. The spike is pushed into the ground to give a firm ground-level support, though personally we have found the bean bag to be better for most situations and more versatile.

If nothing else is available, it is surprising how useful a folded-up coat, a gadget bag or rucksack, or even a fence-post can be. Something is nearly always better than nothing!

Before leaving the subject of supports, one further item should be mentioned. To get the best out of any support, a *cable-release* is invaluable to prevent any vibration arising from you touching the camera. A reasonably long one is best, preferably with a collar lock. You will find that you keep it longer if you colour it brightly with tape or paint. The number of times that we have put one down in the grass . . . and left it there!

FLASHGUNS AND FLASH ACCESSORIES

Range of flashguns

The 'flash' has become an invaluable part of the nature photographer's armoury with the advent of cheap electronic flashguns, but the range is now so enormous, and so many are unsuitable, that some guidance is necessary. It may help, perhaps, to first define a few terms:

1. *Electronic flash* Nowadays, any flash unit that you buy will be electronic, unless you specifically seek out something else, and the days of flash bulbs are almost gone. Most electronic flashes are powered by batteries, which usually last for about 50–100 'flashes', and the light comes from a gas-filled tube through which a high voltage current is passed. The great advantage of electronic

flash over bulb flash, other than the fact that you can get so many 'flashes' without having to change anything, is the fact that the duration of the 'flash' itself is extremely short – usually 1/1000 second or less – and so it provides a sure way of 'freezing' movement.

An automatic electronic flashgun has a light sensor and additional circuitry which allows it to 'read' the light coming back from the subject and switch itself off when enough light has been emitted to correctly expose the subject at a pre-determined aperture. This is very clever, but not entirely satisfactory for the natural history photographer since it is generally not accurate out-of-doors or in close-up work, although macro-sensors are available for some models, and these overcome some of the problems.

2. *Through-the-lens flash systems* In this type, the amount of light actually *reaching the film* from the flashgun is metered and the camera will switch off the flash when enough light has reached the film. This has tremendous advantages, particularly on account of its accuracy and its versatility since it can be used with any lens, extension or filter combination, or bounced, diffused or used with multiple flash, and can be used at any aperture. With some makes it can even be used to give accurate fill-in flash metering. With the excellent Olympus system, we have also found that one can 'paint' the subject with light from a series of 'open' flashes (see below) during a long exposure, and simply carry on until enough light has been provided. The versatility of these systems is endless and, with the best, up to nine flashguns can be used at once in any combination of positions as long as they are all connected to the camera.

3. *'Open' flash* Better flashguns have an 'open flash' or 'test' button which allows you to fire the flash gun separately from the camera. This means, amongst other things, that you can flash at any time during a long exposure and as many times as the flash will allow during a very long exposure to build up a complex lighting pattern.

Which flashgun?
As usual, there is no straightforward answer. For close-up photography of insects using

flashes mounted on brackets, a pair of small, cheap manual flashguns are ideal. Ring-flashes do a similar job, though with flatter, more penetrating lighting. These small manual guns are also ideal for fill-in light for flower and other close-ups. For studio photography, a larger unit is useful and this will almost invariably be automatic, but make sure that it has a manual setting, $\frac{1}{2}$ power and $\frac{1}{4}$ power settings are also useful options. For bird photography, a reasonably powerful unit (or two) is necessary; automatic flashguns can be used with advantage in some circumstances, though a manual setting is essential. Dedicated flashguns are useful, depending on what they offer, but do make sure that they can be used 'off' the camera and not just confined to the 'hot-shoe' flash shoe on top of the camera. If you have a camera which will take a TTL flash metering system, we urge you to buy one if you can (or look for an independent interchangeable dedicated unit, making sure that it will couple to all the camera's functions including the metering).

In general, one does not often need a very powerful flashgun and it is wisest to buy a reasonably small and compact one if you intend to use it mounted on or close to the camera. For flashguns that will be used mainly in the studio, a mains connection is useful. 'System' flashes with filters, reflectors and so on are inevitably likely to be better, though may not always offer the other features you require.

Flash accessories

1. *Flash brackets* To give better 'modelling' of the light, and to allow two or more flashes to be used, some form of bracket to mount the flash close to the camera is desirable, or essential for insect photography, and the possibilities are discussed in Chapter 4.

2. *Slave units* These are small triggering sensors that fit onto a flash lead to trigger that flashgun when light from another flash falls on it. They are much more convenient than leads in multiple flash set-ups, especially over long distances.

3. *Zoom heads* Some flashguns have built-in

– while others offer as accessories – a variable optical magnifier which allows the light beam to be narrowed, and therefore strengthened, for use on more distant subjects. Since many flashguns emit light in a wide enough arc to cover the field of view of a 28mm lens, then narrowing down a beam to cover the field of view of, say, a 100mm lens, greatly increases its power. At the same time, they usually have the effect of producing a larger reflector which helps to soften the light and avoid hard-edged shadows; overall we have found them to be a useful accessory.

In the same way, some flashguns offer a range of filters to colour the light from the flash, or reduce its strength, though their value to the natural history photographer is rather limited.

4. *Power sources* Normally flashguns are powered simply by pen-light batteries. A mains connector is useful for studio use, while a separate rechargeable pack of batteries, sometimes available as an optional extra, is useful if you need to change batteries in a hurry. For bird photography from the hide, using flash, we have found it well worthwhile making a large power pack of the correct voltage, controllable from inside the hide, to allow for hours of waiting with flashguns charged all the time (p. 85). If you use flashguns a good deal, we would recommend the use of rechargeable batteries in place of normal ones to cut costs considerably.

CLOSE-UP PHOTOGRAPHY

For many people, one of the greatest thrills of natural history photography is to take close-up pictures. Since a normal camera with standard lens is unable to go closer than about 0.5m unaided, some accessories are necessary for closer work, and these need not be expensive or complex.

Accessories

1. *Close-up lenses* These are clear optical lenses which fit, like a filter, on the front of the lens to allow it to focus more closely.

Figure 1.6. Bellows units provide a tremendous range of magnifications by allowing the lens to be extended up to 200mm from the camera, though they are cumbersome and a double cable-release is often necessary to retain the automatic diaphragm.

They are available in a range of strengths to allow progressively closer work and they can be used in combination to enhance the effect. Their advantages are: they are cheap, individually; no light is lost by using them; they are small and light to carry; they can be used on cameras without interchangeable lenses (though there are great difficulties in focusing without through-the-lens viewing).

Their disadvantages are: they have to be kept scrupulously clean; they should be used with a lens hood; each only covers a narrow band of focus so they have to be constantly exchanged; their quality at higher magnification is suspect, though this is rarely a problem.

They are the obvious answer to photography at slightly closer range than the normal lens will allow. There are also *variable close-up lenses* (*zoom proxars*) which are light but bulky items, working in the same way but variable so as to give a range of magnifications, usually up to about life size. Their viewing image is rather poor, but results, if stopped down below full aperture, are quite reasonable, and they are very convenient to use.

2. *Extension tubes or extension rings* These are simply a set of three different-sized tubes which fit between the camera lens and camera body in any combination of one, two or three tubes (or more if you have two sets) to allow progressively closer focusing. A set of three, used together, will give magnifications of greater than life size with a standard lens. They are easy to use, robust pieces of equipment, though perhaps a little slow in action since three operations are required: removal of lens, fitting of tube(s) and replacement of lens, with some uncertainty over which tube to use for a given situation. They have the advantage over close-up lenses that they will fit on any lens for the camera system, regardless of filter size, and they are the solution that most people go for in the absence of a macro lens, or in addition to a macro lens.

Many standard lenses produce a much larger image if reversed and mounted on the camera back to front. This is made possible by a *reversing ring* which screws into the filter mount and has the appropriate lens mount to fit the other end onto the camera. They do produce a good image of considerable magnification (usually about 1:2 or 1:1) but there are many disadvantages, notably the loss of any automatic diaphragm control and the loss of any focusing mechanism, though a few more expensive reversing rings have a built-in focusing mechanism. They can also be used to mount your lens in reverse on bellows units (see p. 28) which solves the focusing problem. In either of these

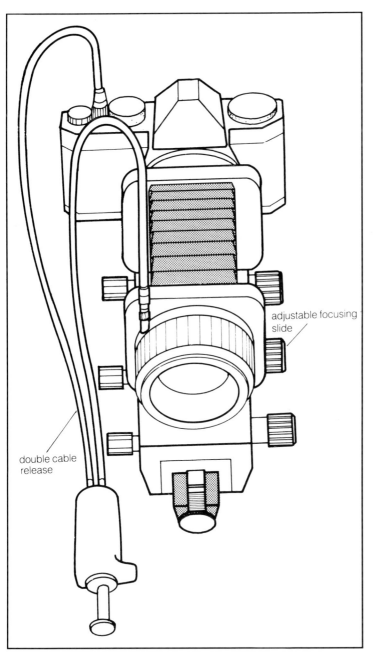

adjustable focusing slide

double cable release

examples, an extension tube can be usefully employed as a lens hood to reduce flare and increase contrast.

3. *Bellows units* These are sets of blackened bellows mounted on a focusing rail, with a mount on each end to take camera and lens respectively. They allow an infinitely variable range of extension of the lens away from the camera body from, usually, about 45mm to 160mm, occasionally more. This gives magnifications, with a standard 50mm lens, from over $\frac{1}{2}$x to about 3x life size, giving really dramatic close-ups. A few bellows units are genuinely 'automatic', retaining all the automatic diaphragm functions of the lens and any automatic metering on the camera, though many others that claim to be automatic employ a double cable-release system with one cable-release firing the shutter and the other one closing the lens diaphragm simultaneously, using only one plunger to simplify the operation.

Not surprisingly, bellows are more suited to use in the studio than in the field, though their capacity for infinite variation over their extension range can be very useful. A purpose-built bellows-head lens can give magnifications from about 2x to 1/30x life size without the need for changing anything – a very useful range for the all-purpose nature photographer, especially on genuine automatic bellows.

If using any type of bellows mounted on a tripod, you will find it much easier to insert a focusing slide between the bellows and the tripod. This allows the whole unit to be moved back and forth without altering the magnification, making focusing at a desired magnification much easier. Some bellows have them built-in, making them better value than they might at first appear. Either way, they are well worth having, as you will rapidly find out if you try using bellows for long without one.

4. *Variable extension tubes* An interesting new alternative way of extending the lens away from the body to allow closer focusing is the variable extension tube. In some respects, they combine the best of bellows and extension tubes, but we suspect that they have not yet reached their fullest development potential. The Olympus variable tube comprises a rigid tube with all automatic facilities transmitted through it, yet it is variable in length and can be be used at any extension from 65mm to 120mm by a simple flick of the wrist to lock or unlock it. It combines the automatic functions and rigidity of tubes with the infinite variability of bellows, and a quicker speed of use than either. At present, though, the range is not quite wide enough – a tube that gave a range from 40mm to 120mm or more would be perfect, and no doubt it will come in due course.

The basic idea of a variable automatic tube has also allowed Olympus to develop a range of excellent *automatic* bellows-head lenses (i.e. designed specifically for use on these tubes or on bellows) and these make close-up work beyond life size a great deal easier!

Finally, before buying any moderate close-up devices, we would urge you to consider buying a macro lens, either to replace your standard lens or as an additional short telephoto lens (see p. 18). For all but extreme close-up work, where additional accessories are needed, these are the best option of all as far as both quality of results and ease of use go.

OTHER PHOTOGRAPHIC ACCESSORIES

Some very specialised accessories are dealt with under their appropriate subject use (e.g. windbreaks for flower photography, hides for bird photography etc.) and only a selection of more generally applicable items are considered here.

General items

1. *Motordrives and autowinders* These are devices for winding on the film automatically, either continuously or singly. Autowinders usually work at a maximum of 2 frames per second, while motordrives generally operate up to about 5 frames per second and have the capability to take bulk-loaded film of about 250 frames. Their advantages include: the ability to wind on rapidly, without taking the camera from the eye, in action situations such

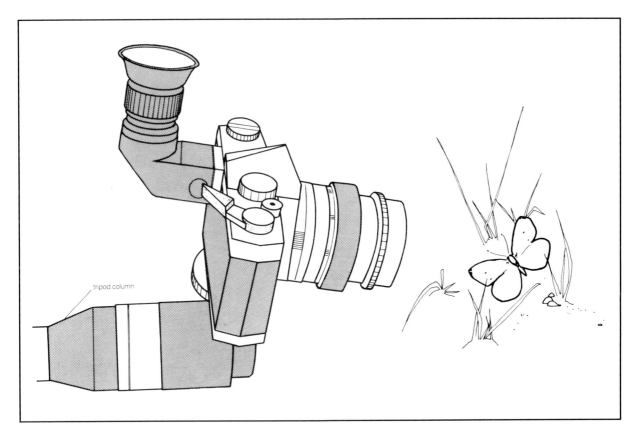

Figure 1.7. For ground-level subjects, a right-angle viewfinder makes composing and viewing easier.

as flight photography; greater speed in sequence photography; the ability to wind on the camera from a distance after each frame is exposed; freeing of one hand from winding on, in case you need a spare hand to hold a flashgun, steady yourself or whatever. Their disadvantages are: they are noisier than winding on by hand; they make the camera heavier and bulkier (though better ones provide an excellent hand-grip which may actually aid stability); they take away the choice of when to wind on, if, for example, you do not wish to frighten a subject by winding on immediately (though the Olympus auto-winder allows you to by-pass the winder at will, even if it is attached and switched on); and finally, they encourage you to use more film without necessarily improving the percentage of good pictures! Overall, they are a useful part of the armoury, but not something to get hooked on!

2. Interchangeable focusing screens A number of better-quality cameras offer a range of interchangeable viewing screens. These items are the translucent screens onto which the image coming through the lens is focused so that you can view it as if it were on the film. There are many different screen types, each suited to different situations; the 'standard' screen, fitted to most cameras, offers a range of focusing aids – ground-glass screen, microprism, split-image rangefinder – but these can become a liability when working with telephotos, macro lenses, extension tubes and other accessories by blacking out or failing to operate adequately. For many natural history purposes, an alternative, such as a plain ground-glass screen, will be preferable in most situations (and perfectly good for general photography) but it is best to consult your camera maker's handbook to find out what is available. We have changed all the original screens in our cameras without any regrets.

3. Reflectors The use of reflectors is not confined to flash photography. Reflectors can be equally useful in other forms of photography which use natural light, for

bouncing light into shaded areas, and no plant photographer should be without one. It is possible to buy excellent silver, gold or white folding reflectors in the Lastolite range, which cleverly pack down to fit in a small circular pouch. The white gives a soft, less strong light than the silver, while the gold is usually too 'warm' for accurate colour rendering. Alternatively, it is very simple to make a reflector, for example by sticking kitchen foil onto one side of a square white card, giving both types of light; this may be made more useful by folding it down the middle, allowing it to be free-standing if required and making storage easier. Alternatives, if you are stuck, include notebooks, opened-out film boxes and even a hand – all can provide just enough extra light to improve the picture.

4. *Filters* A few filters are useful in natural history photography, though for colour film work the range is very limited. Perhaps the most useful is the polarising filter, usable with colour or monochrome but most effective with colour. The mechanism need not be discussed here, but the net effect as far as we are concerned is that careful use of a polarising filter can cut out reflections from water and glass, allowing a clearer image of whatever is below the surface, reduce glare from shiny leaves, giving greatly improved colour rendition, and cut out reflected light in the sky (especially when photographing at right-angles to the sun), giving dramatically improved rendition of cloud structure and making skies a much bluer blue. The filters are provided with a rotating mount and are used at the point where they have most effect, though they cause a loss of 1–2 'stops' of light, which may limit their use. Ultraviolet (UV) and Skylight filters make little difference in most forms of natural history photography, though they are useful as lens protectors, especially in wet, salty or gritty conditions. Remember that the use of a lens hood becomes more important when filters are used since it means that the front reflecting surface of your lens is exposed to light from all directions, making flare and loss of definition more likely. In black-and-white work, the most useful filters are generally green, yellow and yellow-green, though something more dramatic, such as red, has its

(Right) When used with colour material, a polarising filter not only improves sky and cloud rendition, but also improves the distinction between foliage colours by reducing reflections.

Figure 1.8 A photographer's waistcoat is a convenient way of carrying a range of small to medium-sized items of equipment in an accessible way.

Figure 1.9. Most modern system flashguns allow a white reflector to be fitted to produce a bounced flash effect, giving softer, more even, lighting.

white reflector

flash tube

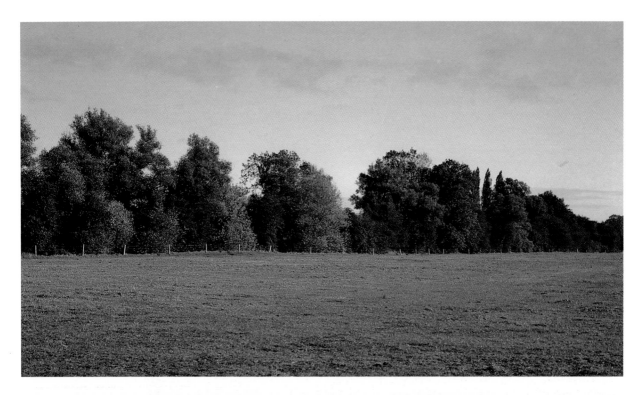

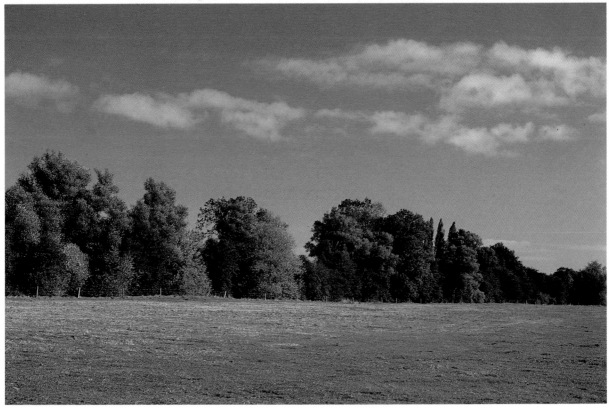

A pair of pictures of a canal surface taken under identical conditions except that the lower picture was taken with a correctly-aligned polarising filter added. The difference in the amount of detail visible below the water surface and in the surface plants is dramatic. 90mm lens, f.16.

uses. Graduated filters, so popular in general photography now, have their uses, especially where a sky can be improved without significantly altering the colour balance of the main subject.

5. *Miscellaneous* Other accessories that are useful to have in your gadget bag for a variety of uses or emergencies include the following: a set of jeweller's screwdrivers for emergency repairs, string, pocket scissors, a penknife, notebook and pencil, a hand lens (e.g. 10x folding lens).

2
Plant Life

Flowers are almost as widely photographed as children and pets, yet how often do you see a really good picture of a flower? Despite their popularity, the serious business of taking good quality photographs of flowers under a wide range of circumstances has been surprisingly little covered. It is a relatively easy matter to take a pleasant picture of a mass of brightly coloured flowers in the sunshine, but it is much more difficult to produce consistently high quality images of all types of flowers, growing in all circumstances in a wide range of weather conditions; to achieve this is a real test of the photographer's skill, knowledge and persistence, involving many techniques and a continuously flexible approach. No two situations are ever quite the same in the world of plant photography and one of the greatest challenges to the photographer is to use this variety to greatest effect and not fall into the rut of taking all flower pictures in the same way. We hope to show, through this chapter, that the best results are produced by working *with* the natural conditions, not against them, taking advantage of the endless variety of form, background and lighting presented to you. On a course that one of us once ran, on general natural history, one of the members took photographs of each plant that we found (except the rarities!) by picking it, holding it 20cm from his camera and photographing it with a single flashgun mounted on a bar. No doubt the plants were all sharp and well exposed, but what a terrible waste of opportunities – and flowers!

APPROACHING THE SUBJECT

In our experience, most people begin flower photography by taking pictures of particularly striking and attractive flowers, often rare ones. Some stay at this level, while others may get more deeply involved and begin to photograph all the plants on a particular nature reserve, or in their area, or all the orchids that they can find. It is an excellent idea, from the point of view of learning to photograph plants, to try to photograph all the species in an area; the problems and opportunities presented by a wide range of plants, from trees to tiny annuals, are enormous and the discipline and experience of doing it greatly improves your technical skill; in contrast, photographing all orchids is more a botanical than a photographic problem since the technical requirements for each species are very similar.

People may take pictures of flowers for purely scientific reasons, concentrating on features of botanical interest, for purely aesthetic reasons, or for some alternative or combination of reasons, and each demands a rather different approach. We have taken the view throughout this chapter that technically sound pictures can be made to have considerable aesthetic appeal as well, given good composition, wise choice of subject and a little thought. We have therefore stressed the technical side, which is the basis of most good pictures, in the knowledge that it is possible to combine artistic, scientific and photographic appeal through sound technique. From this basis, it is then easier to branch out into more artistic pictures with a clear idea of how they will turn out, rather than leaving them to chance.

It is often stated that, to have photographed a species adequately, you need three types of picture: a close-up, a portrait of the whole plant and a view of the plant, or plants, in the habitat. This will certainly provide a good deal of information about the plant if taken well, but it is a pity to follow it slavishly since it depends so much on the type of plant and on your particular needs as a photographer, not to mention the cost of

film! All these options, as well as ones in between, should be considered when you approach a subject, but they will not necessarily all fit the needs of the moment. If you have not tried it, close-up pictures of plants can be highly attractive and rewarding (see pp. 56, 57 & 59), while pictures of a species in its habitat, if taken well, particularly if using a wide-angle lens, can turn out to be dramatic and unusual photographs, full of life and information.

In general, the best and most interesting photographs of flowers are taken where they are growing, using to advantage whatever the situation offers. There are, however, times when a much better picture can be taken indoors, in the 'studio' – often the kitchen table! Here, you can control the light, there is no wind and you can watch the subject closely as a flower opens, pollen is released, or a fruit splits its sides. Grasses and trees are particularly rewarding indoors since in the absence of any wind, the pollen from their long dangling stamens remains in the flowers for longer, making a very attractive sight, rarely noticed outside. Remember, though, that it is illegal to dig plants up from the wild in most countries and they should only be picked if the plant is common enough to stand it. Branches from the commoner trees, picked just before the flowers or leaves open, make fascinating subjects over a period of weeks, often at a time when not much else is about. In late summer and autumn, fruits and seeds make marvellous indoor subjects, continuing on into the winter, and the seeds can always be put back where you found them or can be spread in your garden afterwards.

There are so many possibilities for photographing flowers once you start really looking that there is no possibility of ever running out of subjects! Never be misled into thinking plant photographs are easy though – they are not!

PHOTOGRAPHY IN THE FIELD

Special equipment

For successful photography of a wide range of botanical subjects, it is essential to have: some means of going reasonably close (to $\frac{1}{2}$x or 1x life size), preferably by means of a good macro lens, though extension tubes, bellows or close-up lenses will do; a reflector of some sort (p. 29), for reflecting light back into shaded areas; and, finally, some means of camera support. People have often asked us, on courses or field trips, 'why bother with a tripod? If it is windy, it's the flower that is moving so a tripod will not help; and if it's not windy, then I don't need a tripod'. Inescapable logic, but wrong! Buying a first tripod made the largest single improvement in our own photography of plants and it will improve your pictures in almost every situation. The reasons are:

a) You can set the camera up where you want it and then view the resulting frame at leisure, noting the effects of different apertures and taking time to consider the balance and composition of the picture. It is surprising what you notice after a while.

b) It allows you to use a much wider range of apertures and shutter speeds. In many cases, especially with close-ups or 'plant-in-habitat' pictures, you will need a small aperture for maximum depth of field and this will give you too slow a shutter speed to hand-hold (e.g. 1/8 second) without camera shake. Use of a tripod frees you from this restriction.

c) In windy weather, you can set up the camera in the position you want and it is then much easier to wait for a lull in the wind to allow you to press the shutter at the right moment – this can be very difficult when hand-holding the camera – and it also frees you from the need to look through the viewfinder at the time of exposure, so you can check whether or not the flower moves during the exposure. This is normally impossible with an SLR camera since the viewfinder blacks out at the moment of exposure as the mirror is raised.

d) It is much easier to hold reflectors, fill-in flashguns, or whatever is necessary, once the camera is firmly fixed onto a tripod.

e) A good support is essential for close-ups where the likelihood of camera shake is simply too great.

The range of tripod types and other

The diffuse sunshine and out-of-focus background combine to give colour and impact to this shot of common spotted orchid (Dactylorhiza fuchsii).

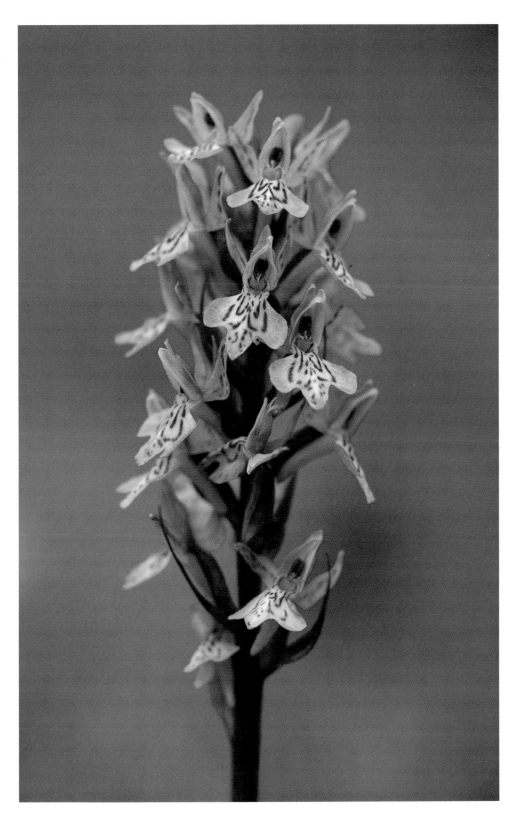

camera supports has been discussed on p. 22. In general, you need something that will support the camera well from near ground level up to at least 1.25m and preferably to eye-level. Avoid tripods that do not open out fully to allow low-level shots – a minimum height of 45cm or so is useless!

Other invaluable minor items of equipment include a polarising filter, which has a surprising range of uses in plant photography (see pp. 42, 52 & 55), a cable-release with a lock, a lens hood, a flashgun (possibly with an additional separate support for it), a knife or pair of scissors, some string or twine, and a notebook and pencil. A right-angle viewfinder, preferably with a built-in magnifier, is very useful if you do much ground-level photography, especially if it is in wet conditions.

With respect to cameras and lenses, most types of SLR camera are satisfactory, though TTL metering is invaluable; good quality aperture priority automatic exposure will also prove to be helpful, allowing accurate metering of very long exposures and precise matching of shutter speed to any aperture chosen. The most useful lens will be one of standard focal length, preferably with macro design, while a wide-angle lens of between 24mm and 35mm (or, better still, a good 24–48mm zoom) is excellent for plant-in-habitat shots (see pp. 42, 44 & 53). A moderate telephoto of 100mm (preferably macro-focusing) or 135mm is useful for shots of slightly inaccessible subjects, for trees, and for giving a different perspective or background with some subjects.

The uses for all these items are discussed in more detail under the appropriate section on techniques below.

Techniques

For convenience, we have separated the business of plant photography into a number of considerations and tried to formulate some general rules. All these factors overlap and interact though, and it quickly becomes second nature to consider them as you approach each subject. The 'rules' are only guide-lines, to be broken where necessary once mastered and understood!

Selecting subjects to photograph

The most important single element in a picture is the subject, whether flowers or anything else. Yet, we have so often seen photographers flop down in front of the first example of the species that they were seeking and photograph from the angle at which they approached it. It cannot be too highly stressed that it is much easier for the photographer, whatever the standard of his/her work, to take a good photograph if the subject is rightly rather than wrongly chosen. It is unusual to find only one plant of a species in one place (though it does happen), so your first general rule should be to find the best specimen for the type of photographs that you want, bearing in mind the following guidelines:

a) Your camera format. With 35mm cameras, this is a rectangle $1\frac{1}{2}$x longer on one side than the other. Examples of a species vary considerably in size and proportion and you should remember that it is often not the largest that will make the best picture – e.g. a tall orchid spike as a portrait will look much more 'leggy', with the flowers smaller in the picture, than a compact short example which fits the format better. *A propos* of this, remember that you can use the camera both vertically and horizontally – it is surprising how many people do forget!
b) The state of flowering of the individual plant; choosing the most attractive or appropriate example.
c) The background and surroundings of the example (see pp. 39, 46 & 47).
d) For some types of work, you will need a 'typical' specimen in a typical situation, so it is best to observe the range of variation before deciding on which example to photograph.

Overall, choosing the right example to photograph is probably the biggest single factor in obtaining a good photograph, yet it is the one that is most often ignored.

Viewpoints and angles

Closely related to the idea of carefully choosing a subject is the angle and direction from which you approach it. Equally, this is inevitably tied to the background of the subject and the light that is falling on it.

The effect of aperture on the background. The picture on the immediate right was taken at f.22, giving a clearer but more distracting background while that on the far right was taken at f.3.5. Red rattle. 90mm lens.

Plants can look very different from different angles. Of paramount importance are the effects of lighting direction (p. 40) and the background produced by different angles of approach (p. 42). In addition, though, the plant itself will appear differently from different angles and viewpoints. A good general rule is to get down as low as possible; with short upright plants, it is usually best to be at a point at right-angles to the main stem, which will usually be about 15cm from the ground; similarly, small ground-growing plants are best photographed from as low as possible, unless the flowers only face directly upwards.

The most important consideration is simply to have thought about all the options and not to have a standard stereotyped approach. In addition, it is important to think about the depth of field (the amount in focus) of the final result and to try to align the film plane (the camera back) parallel with the main points of interest to make the most of what little depth of field you have (p. 43).

Backgrounds

Until they really start looking at photographs of plants, people fail to realise what an important part of a flower picture the background is (with the exception of extreme close-ups). A bad background can distract your attention and clash with, or even overwhelm, the main subject, while a good background can be an attractive complement to the main subject, hinting at the habitat in which the plant was growing, showing the range of plants that it was growing with, or even showing the whole habitat. Different subjects and different situations need different treatment and there are various ways of controlling the background to get the effect that you want.

1. *Differential focus* This sounds complicated, but is not really. By definition, the subject is closer to the camera than its background and this allows you the opportunity to have the subject in sharp focus with the background less well defined. It is the technique of doing this satisfactorily that is known as differential focus. The amount of the picture that is in focus at any one time depends, amongst other things, on the size of the aperture you use; the smaller the aperture, (e.g. f.22), the more depth of field compared with a large aperture, e.g. f.5.6, (see also pp. 43–5). At very large apertures, such as f.4, when photographing any subject closer than about a metre, the background will be out of focus and this will provide a clear distinction between the main subject and its background, which is especially use-

A cluttered background would have spoilt this subdued study of hoary plantain *(Plantago media)* flowers, so a large aperture (f.4.5) was used to throw the background out of focus. This is the technique known as 'differential focusing'.

Water makes a perfect background for many flower pictures, making the subject stand out and giving an impression of the habitat. Yellow flag iris *(Iris pseudacorus)* by River Test.

A change in *direction* can also make a sharp difference to the final result in terms of lighting, background and, sometimes, composition. Ling *(Calluna vulgaris)* taken with the light behind the photographer (far left) and from the opposite direction, with the light behind the flowers (left).

ful when they are of a similar colour. The technique is not quite this simple, however, since at closer working distances a smaller aperture is likely to be needed to keep all the main parts of the subject in focus and, consequently, differential focus involves a fine balance between an adequately sharp subject and an adequately diffuse background. There will be many occasions when it cannot be used successfully and trial and error, trying different apertures and observing the effect using the depth of field lever, is the best guide to the likely success of the result. When done well, it can produce extremely useful and highly attractive effects (see pp. 35 & 38.)

2. *By light and shade* Sometimes, in woodland, one is lucky enough to come across a striking flower 'spotlit' by a shaft of sunlight against the darkness of the wood. Such chances should be taken immediately, since they do not last long and the isolation of the flower from its background is total and dramatic.

To some extent, however, it is possible to create this situation by throwing the background of your subject into shadow, using a strategically placed rucksack or companion, or even your own shadow if the camera is mounted on a tripod. Needless to say, the background in view in the picture should be wholly shaded or the effect will look unreal and unattractive. This technique works well for smallish plants that otherwise tend to merge into their background because of their colour. Incidentally, metering of the correct exposure is best carried out before the shadow is cast since the shadow will influence the meter and lead to an overexposed subject unless due compensation is given.

A similar technique can be employed using flash. The light from a small flashgun falls off very rapidly away from the source and therefore the background will be much less well lit than the main subject. If you use a small aperture — much smaller than you would need in that amount of daylight at 1/60 second — then the background will appear black, unless all that is visible in the picture lies close behind your subject. In general, we do not feel that the results from this are especially attractive, except with close-ups or a very carefully balanced multiple-flash set-up, and it is really a last resort where the background would otherwise be highly intrusive.

3. *By choice of viewpoint and subject* It is very important to remember the effect of the background on the final picture, and the choice of background must be one of the

A small change of *angle* can markedly affect the final results, as in these pictures of *Scolymus hispanicus* taken in Portugal.

The effect of focal length on composition and background. The picture on the far left was taken using a 28mm lens; the picture left was taken from further away, keeping the size of the plant exactly the same, using a 300mm lens. The difference in the subject is minimal, but look at the difference in the backgrounds!

factors that will determine both which example of your subject you choose to photograph and the direction from which you photograph it. In some examples, a change of direction will give you water instead of grass, a dark background instead of a light one, or one that is distant from (and will therefore appear softer) rather than close to your subject. Water in all its forms can make an excellent background, though watch out for reflected highlights and meter carefully to allow for the fact that the water maybe brighter than the subject. A reflector may be helpful in such circumstances.

Change of angle of view can also have a dramatic effect on your background. A high viewpoint will probably give a background wholly composed of vegetation, close to the subject; a lower viewpoint may be chosen to give a more distant background (preferably one that avoids a horizon across the middle, though occasionally this can be made to look right). A *very* low viewpoint, however, can be used to isolate the flowers against the sky, if they are tall enough; take care to give enough exposure for the flowers (probably about 1 stop more than your meter indicates) and try a polarising filter to reduce the contrast between flower and sky which will give you a correctly exposed flower against a beautiful blue sky in many cases. A reflector

is especially useful for shots against the sky, unless you want a silhouette effect.

4. *Artificial backgrounds* Rather like the use of flash, we would consider artificial backgrounds to be a last resort in the field, where all else has failed.

5. *By choice of lens* Different focal lengths of lenses can produce very different backgrounds for a flower shot taken from the same angle, and they can be surprisingly useful tools in the plant photographer's armoury (see p. 44).

A wide-angle lens will show a large expanse of background in apparently sharp detail whilst progressively longer focal lengths will give smaller and smaller expanses of background with apparently decreasing depths of field. Thus if you especially want to show an attractive or interesting background, use a wide-angle lens, but do not use it where the background is 'fussy' and distracting. By contrast, if you want to differentiate your subject more strongly from its background, use a longer focal length lens, such as a 135mm. The size of the subject itself is kept constant simply by adjusting the camera position, closer for a wide-angle lens and further away for a telephoto lens.

The different focal lengths have another effect. If you do not have a tripod with the ability to go very close to ground level, you can produce the same effect by moving further back and using a longer focal length of lens, which narrows the angle in the same way.

Depth of field

Consideration of the backgrounds to your subject leads inescapably to considerations of depth of field, both within the main subject and within the whole picture.

The depth of field under any given circumstances is the range of distances from the camera over which an object will appear to be in focus. Strictly speaking, there is a plane of sharp focus with zones of declining sharpness falling away on either side of this: For example, if you set the focus on your lens to 3m an object will be at its sharpest in the final picture at 3m away from the film, but may be in reasonably sharp focus between 2m and 5m, with some detail visible at distances further from the plane of sharp focus on either side.

The distance over which an object is sharp (i.e. the depth of field) varies, and this variation depends mainly on two factors: the size of the aperture being used (f.22, f.8 etc.) and the magnification of your subject as an image on the film (see p. 20). The smaller the aperture used, then the greater the depth of field that you will have in the final picture; similarly, the smaller the magnification, the greater the depth of field – for instance, a flower might be wholly in focus at f.8 when 2m from the camera, but would not be when taken at 25cm with the same lens and aperture combination. Different focal lengths of lenses all behave according to these principles and a change in focal length does not in itself produce a change in depth of focus.

The ability to manipulate the depth of field and use it to your advantage is one of the most important skills for the plant photographer. In addition to knowing how to manipulate the depth of field *via* aperture and image size as above, it is very important to know how it operates. For most subjects, except close-ups, the depth of field will be divided to give about one-third in front of the subject and two-thirds behind it. As the magnification increases, the depth on either side becomes more nearly equal. A fair idea of the depth of field in any given situation may be obtained by using the depth of field

Although wide apertures can add impact to some flower pictures, by separating the subject from its background, other types of pictures are enhanced by a small aperture. The picture on the right was taken at f.3.5 giving hardly any depth-of-field; that on the far right was taken at f.32 to give great depth and sharpness. Fleabane *(Pulicaria dysenterica)*. 35mm lens.

preview button on the camera or lens, and it is always sensible to do this in any critical work. However, it will not always tell you precisely the depth of field, because the image may go too dark for you to analyse it adequately and because there may not be any reference points to work from. Hence, it is important to know the general principles.

The important thing, however, is putting the knowledge into practice and taking better pictures as a result. Obviously, different subjects demand different depths of field – for example, a large aperture and corresponding small depth of field may be needed

to separate a subject from its background, while a small aperture will be required where the background has to be in focus or the subject has a lot of depth. These are straightforward considerations which, with experience, automatically become part of the process of deciding which aperture, lens, shutter speed, magnification and so on to choose. More subtle, however, is the process of using your knowledge of depth of field to apparently increase the depth of field and this is best illustrated by two examples.

Suppose that you wish to show a group of alpine anemones sharply at about 1m from

Focal length and background
Different focal lengths of lens have different angles of view. It is possible, by moving the camera, to keep the size of the flower constant in the frame, to make the background quite different whilst keeping the subject the same (except for a gradual change of perspective in the subject itself). A wide-angle lens, such as a 28mm,

will give a much wider expanse of background, whilst one of a long focal length will give narrow angle of background. The longer focal lengths appear to produce a smaller depth of field, and the background is likely to be less 'muddled' as a result.

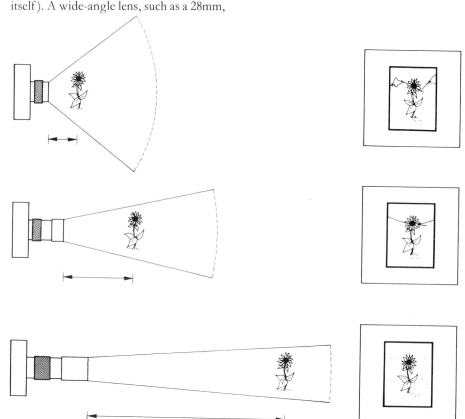

Diagrammatic representation of focal length on depth of field. A wide-angle lens (top) has a much wider angle of background than a short telephoto (middle), while a long telephoto gives a very narrow angle of background. The camera to subject distance is altered in each to keep the size of the flower in the frame constant.

the camera whilst rendering the background mountains as sharp as possible. The natural tendency is to focus on the flowers and stop down as far as you are able in order to get the mountains as sharp as possible. However, when the camera is focused at 1m, with an aperture of, say, f.22, your depth of field extends from about 0.8m to 1.5m, so you are wasting 20cm in front of the subject and not getting the background really sharp. If, however, you focus on a point *behind* your subject, so that your depth of field extends away from 1m towards infinity, you will get much more of what you actually require in focus. The distance to focus on can be worked out either from tables or from the figures on your lens barrel, or by using the depth of field preview lever. The net result is that the background will be sharper than it would otherwise have been.

A second example concerns a close-up of a flower. In this case, the important elements of the picture might be the front edge of the nearest petal and the stamens and styles in the centre of the flower. The depth of field is so small at these large magnifications that it will almost certainly be impossible to get both features in sharp focus by focusing either on one or the other. If, however you focus *between* them, bearing in mind the general rule that the zone of sharpness extends about equally on either side of the plane of focus with close-ups, then you greatly increase your chances of getting both main features in focus and a better picture should result.

Lighting

Photography, by definition, is dependent on light, but it is the marvellous variety of natural light, aided and abetted by the photographer, that can make plant photography so exciting. A change of light, whether natural or not, can transform a dull picture or ruin a good one, and it is essential to be able to harness the qualities of the light to the best advantage.

Light quality

The intensity, direction, colour balance and general quality of the light varies throughout the day and according to the weather and latitude. On many occasions, you simply have to make the best of what you have, but on other occasions – especially with subjects close to your home or other semi-permanent base – you can wait for the particular light quality that is best for the particular subject you are after.

In the early morning, conditions are often ideal for plant photography. When it is sunny, the light is not too bright yet it is strongly directional and usually has a pleasant colour balance. It is not always ideal purely for recording the structure of plants, but it is ideal for creative shots with backlighting and strong modelling, and there are the added advantages of dewy subjects, less breeze (often) and fewer people about. Later in the morning, the colour balance is closest to that for which colour films are designed; colour rendering is therefore usually more accurate, but the light comes more markedly from overhead, giving duller pictures with deep shadows in the wrong places. Late afternoon, like the morning, is a marvellous time for plant photography, with excellent opportunities for backlit subjects and strong modelling with more opaque subjects. Later in the evening, the colour cast becomes significantly orange or yellow, so it is not a good time for accurate record shots, but still evenings can be suitable for unusual shots especially of pale-coloured flowers.

The foregoing comments all assume that you have a bright sunny day, though of course you often do not. In fact, many people confine their plant photography to sunny days, but are these really best? The type of lighting, affected by the weather, controls the final result and there are more types of lighting than one might at first expect.

Bright sunny days with cloudless skies are fine for general shots, plant-in-habitat shots, trees and other distant subjects. For closer work, they will be found to produce very hard shadows, often unacceptable, since there is little to reflect the light into the shaded areas. Sunny days with cloud about are much better in this respect since the light reflects into the areas of shadow and lessens the contrast. They also look good in shots that include some sky, if the exposure is correct.

Bright hazy days are perfect for most forms of plant photography, especially for close-up work and especially for lighter-coloured flowers. Ideally, you require a distinctly directional but soft light with plenty of

Blue dwarf iris *(Iris kumaonensis)* at 3,600m in the Langtang Valley, Nepal. Use of a wide angle lens (28mm) allows the whole picture to be sharp and gives a wide amount of background in relation to the size of the subject.

The background of mountains (Langtang Liring, 7,300m) to this beautiful shrub, *Viburnum fragrans*, was carefully chosen to show both the plant and the location, and a small aperture (f.16) gave sharpness to both.

The use of a moderate wide-angle (35mm) lens allows the main subject to fill much of the frame whilst showing a reasonable section of the background. Sea samphire *(Crithmum maritimum)*, Cornwall.

reflected light. This allows modelling of features of relief yet allows all the detail in both highlight and shadow areas to show up. White and yellow flowers respond particularly well in this light and every vein and detail of the pattern shows in the final result.

Dull days are not ideal for anything, but they are far from useless, especially if you have a tripod. They are best for shots where you want to show a lot of detail and do not need much sparkle, such as fallen leaves and fruits, or a collection of flowers and lichens on a cliff. They are also suitable times for photographing lichens and fungi (pp. 65 & 61). If it is windy as well as dull, then opportunities are confined to 'still-life' subjects with no natural movement in them.

If it rains, don't give up entirely. Heavy rain makes most photography difficult and uncomfortable, but it is possible to take pictures in light rain and pictures taken immediately after the rain can be exceptionally good. A good lens hood and an umbrella, or a waterproof camera cover

(such as that made by EWA), will make your efforts easier and more rewarding, and you will almost certainly take pictures that do not look stereotyped, even if they are not always perfect! As usual, a tripod is invaluable since light levels are usually low, though a fast film will do.

Special problems

1. *Long exposures* Most films are manufactured to work at their best under average conditions where the exposure is about f.11 at 1/125 sec. Where much longer exposures are required, longer than about 1 second, two things tend to happen. First, the simple law that says that twice as long a shutter speed needs half as large an aperture to keep the exposure constant, breaks down. For example, if your meter indicates $\frac{1}{2}$ second at f.5.6, you would expect to need 1 second for f.8 and 2 seconds for f.11, but in practice you need progressively longer exposures to compensate for the 'reciprocity failure' of the film. This means that, for any long exposure, you need to give rather more light than indicated. Secondly, the film responds less accurately to the colours of the subject and you are likely to find a shift in the final colour balance. This is usually difficult to correct for, though specialist filters may help.

2. *White flowers* White, yellow or other pale flowers look tremendously attractive in bright sunshine, yet so often the pictures taken of them are disappointing. The problem is that a pale-coloured flower, especially if rather shiny, reflects much more light than its surroundings and, even within the flower, the highlights will reflect more light than the other parts. This means that, in sunlight, it is impossible to get all parts of the picture correctly exposed and at least some of the picture will be too dark or – more usually – overexposed. If the picture has to be taken in bright sunshine, it is best to expose for the white flower, rather than the whole picture (p. 52) and accept that the other areas are likely to appear too dark. A reflector to bounce light into the most shaded areas will help to alleviate the problem.

A better solution, if you can, is to take pictures of white flowers in less bright light. Very hazy sunshine is excellent and dull days are usually best for showing most detail, though the results can be rather flat and a tripod may be necessary for support.

3. *Blue and purple flowers* One of the commonest 'bugbears' of the plant photographer is the fact that many blue or purple flowers look gorgeous at the time that the picture was taken but appear quite different when viewed later on film. The problem here is that some shades of blue or purple flowers reflect large quantities of light in non-visible wavelengths that are recorded by the film, and there is no easy answer to the problem. Our main techniques for dealing with this involve:

a) Using Kodachrome 25 film, which copes better than other films, including Kodachrome 64.
b) Photographing the most difficult shades of flower reasonably close to midday when the colour temperature of the light is closest to that for which films are designed.

It is possible to use correcting filters but it is difficult to estimate when they are needed and they affect the other colours in the picture detrimentally anyway. However, the two general rules outlined above will generally produce good results.

Lighting aids

Natural light, as we have seen, is seldom just as you want it to be and, even when it is, you can often improve the final result somewhat with a little manipulation. At its best, this 'manipulation' does not show in the final photograph yet it adds enough detail or sparkle to lift the quality of a picture. In the field, the main aids to lighting – with the exception of ways of casting a shadow – are reflectors and electronic flash, each with a different range of effects.

1. *Reflectors* The general use of reflectors and the types available have already been discussed on p. 29. Despite the fact that they are simply pieces of white or silver material, acquired for a few pence if you make your own, they have a tremendous range of uses in plant photography and are always worth having. Their most obvious use is to bounce back harsh sunlight into

areas of the subject that are in shadow; use them, for example, flat on the ground below the subject to bounce light back onto the underside of a flower when the sun is high overhead; or in front of the subject (but out of the field of view!) when you are using backlighting on a partially opaque subject to give a little detail on the front of the subject.

When working in woodland, where light levels are low, you will often find that judicious manipulation of a reflector will throw a little more light onto the main parts of the subject without looking unreal. In very low light levels, a more reflective surface, such as a mirror (preferably an unbreakable camping one), will be useful.

If you want to use electronic flash to add light to a subject (see below), there are many occasions when flash bounced off a reflector will provide the most effective lighting – this can either be bounced in from one side or, with small subjects, bounced from overhead to surround the subject with light.

Finally, reflectors are very useful when working with water as a background. In sunlight, water is usually a very bright highly reflective medium and the exposure contrast can often be reduced by bouncing some of this light back onto the front of the subject.

2. *Electronic flash* The capabilities of electronic flash have already been outlined on p. 25. Although flash really comes into its own in action photography of insects, birds and mammals, it has two distinct uses in outdoor plant photography: as an adjunct to available natural light, for filling in shadows or providing sparkle, and as a main source of light where daylight levels are very low, or the subject is moving too much to allow a sharp result by daylight alone. We personally prefer not to use flash where natural light is sufficient, though other workers like its consistency and the sharpness it provides.

A small manual electronic flashgun can be a valuable accessory. It can be used in the same way as a reflector, though it is more powerful and controllable, to light up the areas of shadow where natural light does not reach. It must be weaker than the available light, or the results will look 'flashy' and unnatural, and we find that about 2 stops less is usually about right (this can be calculated quite simply from the guide number which will indicate the distance away that you need to hold the flash for a given aperture). A long lead is essential to allow flexibility and some form of support for the flash is useful. A softer light is provided by bouncing the flash off a reflector or holding a diffuser (such as a white handkerchief) in front of it. Pictures taken under very dull lighting conditions will not usually suffer from shadows, but they may appear dull and lifeless; an electronic flash can give a little sparkle and more modelling, but again it should not be too powerful or the subject will be overexposed or the background underexposed.

Where lighting conditions are very poor, a dense beech plantation in dull weather springs to mind, then it may become necessary to use flash as the sole source of light. As discussed on p. 53, under *Coping with windy weather* it may also be useful for stopping subject movement.

The main problems with lighting the subject wholly by flash include the background not being lit by the flash and so appearing dark (making the picture look as though it was taken at night) and the dark shadows cast by a single point source of light.

The dark background problem is often very difficult to overcome, especially with a large subject. Ways that may be tried, according to the situation, include: setting the exposure to underexpose the whole scene by about 1 stop and then using flash to light the main subject, which will give a correctly exposed flashlit subject against a rather darker (but not black) background; if not too much background is visible in the picture, it may be possible to light it with an additional flash, perhaps fired by a slave unit; choosing a viewpoint (normally a higher one) that allows the whole frame – subject and background – to be lit by the flash; and, finally, by using a more powerful flashgun from further away, giving a much wider and deeper area of background lit by the flash.

There are, however, circumstances under which the background will appear dark whatever you do, but this will normally be better than no picture at all!

Gauging the correct exposure

However well you choose your subject and set up your camera, all your efforts will be

(Left) Cross-leaved heath *(Erica tetralix)* photographed in the New Forest, England. Some flowers lend themselves to being photographed against the light and the impact may be increased by a simplified form and an uncluttered background.

(Right) For maximum detail and clarity, white or yellow flowers are best taken in subdued light. In bright sunshine, the highlights 'burn' out and the green areas are too dark, but here every detail is visible. Greater stitchwort *(Stellaria holostea)*

(Right) Germander speedwell *(Veronica chamaedrys)*. Blue flowers are notoriously difficult to portray accurately. This picture was taken in hazy sunshine, giving clear saturated colours and low contrast. Kodachrome 25 film was used.

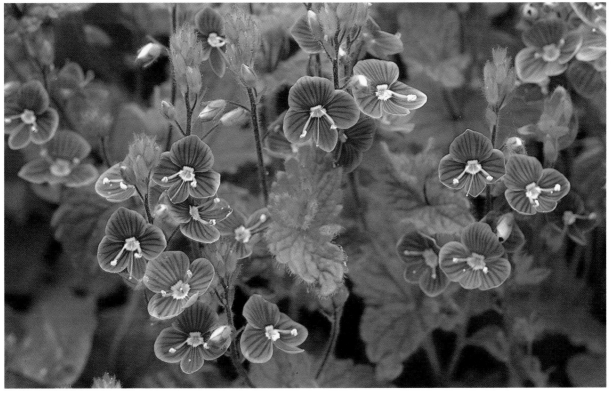

wasted if the picture is not correctly exposed. Under most circumstances, where the subject and background are of broadly similar tone, then exposure assessment is easy and the meter indication can be followed. If, however, you attempt something out of the ordinary, such as a strongly backlit flower, or one that is 'spotlit' by a shaft of sunlight against a shadowy background, or a collection of bright white flowers against a background of dark green foliage, then your problems begin, and many such adventurous shots are ruined by wrong exposure.

Bearing in mind that no film can cope adequately with a wide range of differences in brightness, and remembering also that most light meters seek to bring the tonal rendering of everything as close as possible to the equivalent of a shade of light grey, then the first thing to do is to decide which part of this difficult scene that you are photographing you most want to be correctly exposed. Is it the 'spotlit' orchid spike or is it the dark woodland background? Is it the white flowers or is it the green foliage that is most important . . .? You then need to find out what exposure will be correct for this particular part of the subject.

Most people nowadays use cameras with TTL metering. It would be wrong to assume that such metering systems can cope with these situations, but TTL can nevertheless be a highly useful tool for assessing the correct exposure. The problem is that most meters take an average reading of the whole scene, usually biased towards the centre and base, and, in high contrast situations, it will overexpose the highlights and underexpose the shadow areas. With plants, you can, however, turn your camera into a 'narrow-angle' spot meter by selecting the area that you consider to be the most important element of the picture and then moving the camera in so close that this part fills the frame (it does not matter if it is not in focus). Note the meter reading given and use it for the whole scene, bearing in mind any adjustments needed to accommodate other parts of the picture. At times, it may be preferable to take more than one reading and average them. For white flowers, you have to remember that the meter reading will be trying to push white towards light grey, so about $\frac{1}{2}$ stop extra exposure may give you more

accurate results. For finely branched subjects, such as a delicate grass panicle, spotlit against the light, this technique is less satisfactory. If you can be sure that the light on the subject is direct sunlight (i.e. not filtered through leaves), then use the setting that you would expect to use in full sunlight for the film you are using (e.g. 1/60 second at f.11 for Kodachrome 25), ignoring the meter wholly. Alternatively, you can meter from a more solid object placed in the sun, such as the palm of your hand, and then make any adjustments necessary if the subject is lighter or darker than your hand.

When you are photographing subjects against the sky, or – even worse – against water which is reflecting the sun, the meter may become highly inaccurate and it is essential to overcome this effect. The technique of going in close usually works, but it is helpful to have the ability to take an incident light reading; this involves taking a reading of the light falling on the subject and is made by looking from the subject towards the camera position, using either a hand-held light meter with a diffuser cone or an incident light meter converter for the front of the camera. If you do use such a system, do not forget to make allowances for any extension tubes or similar devices that you may be using and remember to give less exposure for a light subject and more for a dark one.

The difficulties of estimating exposure for such situations can be reduced by using a reflector to light the front of your subject and a polarising filter to enhance the colour of the sky or water and lessen the contrast between the subject and the background.

Composition

There are no hard and fast rules in plant photography and – even if there were – the best pictures would probably be produced by breaking them! However, there are a few general guidelines which are worth considering and mastering, even if you do branch out from them as you progress.

1. Get down to the level of the subject. Unless there is a good photographic reason for not doing so, most pictures of low-growing plants will be better for being taken at their level. A tripod that allows low-level work is invaluable for this technique and a

polythene sack or mat is extremely useful if you are working anywhere wet.

2. Fill the frame with what you want to show – don't waste half the frame unless there is a good reason for it! With flowers that do not really fit the shape of the film, e.g. tall thin spikes or round flowers, it is an excellent idea to look for a small group that allows a better composition, such as two round daisies together, or a group of orchids (see p. 54). Similarly, if you are trying to photograph one of those much-branched spiky plants with scattered small flowers, try going in closer for one shot to show one or two flowers in relation to a small amount of foliage around them.

3. Try using a wide-angle lens (28mm or 35mm) to give a more dramatic 'plant-in-habitat' picture. These can be very impressive, giving an intriguing feel of spaciousness and a good indication of the habitat whilst still maintaining a large image of the main subject.

4. Try to avoid horizons halfway up the frame, cutting across behind the main subject. These are usually very distracting, though just occasionally they can be effective.

5. Look for effective naturally occurring groupings and combinations – a group of flowers pointing in different directions showing all their features, a bee on a flower, a mixture of species around an old stump – and try to make the best of them.

6. 'Gardening'. Many pictures can be improved by carefully moving or cutting extraneous elements out of the way. This may involve removing foreground grass leaves and stems, a dead stalk behind the subject, or even a distracting yellow flower in the background. It is always advisable to do the minimum necessary (some people prefer to do none at all) and the results should not show in the picture. Don't pick or break anything uncommon and don't draw attention to a rarity by clearing around it. If at all uncertain, it is best to tie things back or weight them down with whatever is to hand so that the site can be returned to its previous condition when you leave.

Special circumstances

A number of situations, or types of subject, need special attention or extra effort.

1. *Coping with windy weather* You soon realise when you start to photograph flowers that there are very few really still days, even if you used to think that there were! Regrettably, it does not take much movement to register on the film as a blurred picture and many otherwise good pictures are ruined in this way.

The main ways in which this movement can be overcome are: 'freezing' the movement by the use of flash or a high shutter speed, waiting for a lull in the wind or preventing the subject from moving. A fourth way – coming back on a better day – is rarely practical!

Electronic flash freezes movement quite satisfactorily, if it is the main light source, since the flash duration is usually less than 1/1000 second. However, it leaves one with the problems of dark backgrounds already discussed and there is an additional problem common to both methods of 'freezing' the subject, i.e. when a plant moves in the wind, it rarely moves in one plane, so it tends to move in and out of focus. This means that you have to pick the moment of exposure very carefully and some frames will inevitably be out of focus.

Using a fast shutter speed has a similar effect to flash, without the dark background problem. Most lighting conditions, however, do not allow the use of a really fast shutter speed and you are therefore confined to using a fast film (with a high ASA/DIN rating) with its inherent problems of less good colour rendition and lower sharpness. If you expect to be working for a while in windy conditions – a cliff top perhaps – then it is probably worth considering a faster film.

Waiting for a lull in the wind demands great patience and there are times when a lull never comes. However, if you set the camera up on a tripod, frame the picture, set the exposure and do anything else necessary, you will be ready to take the picture as soon as a lull comes; just check the focus first in case it has come to rest in a different position. Without a tripod, you will almost certainly get fed up before the lull comes and you will not be sure if the plant has moved during exposure or not!

It is possible, in some situations, to prevent your subject from moving. A few ways involve damaging the subject and generally

Tall thin flowers, such as these fly orchids *(Ophrys insectifera)* are often best photographed in a group, rather than singly.

Choice of viewpoint and lens can be all important in deciding the final picture. The picture (right) of bugle *(Ajuga reptans)* was taken with a 28mm lens to show both plant and habitat, while that on the far right was taken with a 135mm lens to concentrate attention on the flower spikes.

these are not to be recommended, though very common species can be treated less carefully and even picked to photograph indoors if that is a possibility. Wind shields of clear perspex or polythene can be placed to one side of a subject, or even all around it for small subjects, and they may – or may not – reduce the wind. There are times when they produce eddies that are worse than the un-adulterated wind, but if you are working with small subjects in a windy situation, then they will probably help.

Some photographers use a form of clamp to steady the plant if it is very flexible. The simplest, and one of the best, involves a length of coathanger wire with a padded crocodile grip soldered to the end. The grip

is attached to a key point on the subject (out of the picture!) and the other end is pushed into the ground.

2. *Water plants* Plants growing in and around water provide some special problems, as well as providing some exciting photographic opportunities. The use of water as a background has already been discussed and some of the problems of exposure when water appears in the picture have been covered.

When shooting aquatics (those plants that are wholly or partially submerged in water), you will find that a polarising filter can greatly improve the results by cutting out all reflection and allowing you to record detail below the water (p. 32). The two difficulties to beware of are: firstly, the 1–2 stop exposure increase that a polarising filter requires; and, secondly, you may find that it shows up too much of what is below water level, making it difficult to distinguish where the water surface is and confusing the final result. For wholly submerged plants, a polarising filter is virtually essential, but needs to be used more circumspectly where

parts of the plant are above water level.

Overall, pictures of plants with water in are usually highly attractive, but they have to be handled thoughtfully to be really successful.

3. *Trees* Everyone loves trees and, well taken, they can make beautiful pictures. There are no clear-cut 'rules' to follow, since circumstances vary so much, but a few guidelines may help.

Generally, trees look best in spring, for about a month after the leaves open, and in autumn as the leaves colour. In high summer, the foliage is often uniformly darker and rather duller. Winter pictures can be interesting and are best for showing the skeletal structure of trees.

A polarising filter can be invaluable; it reduces glare from shiny leaves and reveals their true colours, as well as lessening the exposure contrast between subject and sky.

A short telephoto provides the best perspective for tree portraits since you can move further back and are then not looking up at the tree so much. Conversely, a wide-angle is worst for exaggerating perspective distortion, though the effect can be intriguing. If you take pictures of trees often, you may find it worth investing in a perspective-control lens (really designed for architectural work). This allows you to take pictures of trees from very close to them, yet still be able to correct the perspective (see p. 18). Such lenses are, however, expensive and may be difficult to justify.

Most trees flower in spring (since they are wind-pollinated and there are no leaves to obstruct the pollen transfer), though a few – such as limes – flower in summer. The flowers are often difficult to get at; a telephoto is often inadequate and step-ladders are rarely available when you want them! It pays to look out for good views of trees from bridges, viaducts, upstairs windows and so on, wherever you are – even in central London, the bridges give fine views of plane tree fruits and other trees.

PHOTOGRAPHY IN THE STUDIO

As discussed at the beginning of this chapter, there are occasions when it is difficult, or even impossible, to produce a really good quality picture of something in the wild. This may be because the weather is unsuitable, the flowers are not open (though don't forget that pictures of plants with only buds on can be interesting), you cannot reach them easily with the camera, or because you do not normally see the phenomenon you want to record in the wild. In such circumstances, it makes sense to bring a small amount of material indoors to photograph it there. It bears repeating, though, that rarities should never be picked, it is illegal to dig up most flowers, and that anything that can be (e.g. seeds) should be returned to the wild as soon as possible.

The best studio subjects include dried seed heads, the flowers of trees and grasses, and 'botanical' pictures, such as sections of fruits,

For higher magnifications, such as these ling *(Calluna vulgaris)* flowers taken at 3x life size on the negative, the studio is the best place. Twin flash, 80mm macro lens.

leaf skeletons, root hairs and so on. Extreme close-ups, such as the stamens of a flower, are also most easily taken in the studio and this can be a very rewarding and revealing branch of flower photography.

Special equipment

Most of the equipment is similar to that needed for field photography. In addition, you are likely to need extra flashguns, supports for these (improvised or purchased), some florist's material for supporting plants in the way you want, and some natural-looking backgrounds. Reflectors are always useful and some form of clamp for holding plant material, backgrounds or flashguns will be invaluable. Photofloods can be used instead of flashguns, giving a better idea of the final result, but they are expensive and their high heat output tends to promote wilting of the subject. In addition, most types require the use of artificial light film, or a filter for best results. You will probably be tempted, once you get plant material indoors, to start taking pictures at closer distances than you would in the wild. For this, you will need extension tubes or bellows and, preferably, some form of specialised macro lens (p. 18). A device for reversing the lens may improve definition, unless you are using a bellows macro lens head, and it is not too difficult to use in the studio. Finally, for studio photography, a camera with TTL flash metering (p. 25) is much easier to use than one without.

Techniques

Lighting
Apart from the fact that there should be no subject movement caused by the wind, the greatest asset to be gained from taking pictures in the studio is the ability to have complete control over the lighting. Getting the lighting just right for each subject is also one of the greatest challenges and sources of satisfaction of studio work, since every subject is still different, even though it has been picked and brought indoors.

You will need to experiment to find what lighting you like best and what suits your subject best; the number of options is really almost infinite, especially if you use 'open flash' (p. 25) to 'paint' the subject with light from different directions. The main ways of lighting the subject are described below.

1. *Direct frontal lighting* This will probably be a disappointing waste of opportunity and is unlikely to show the subject at its best, though it may be necessary for deep-throated flowers, such as foxgloves. Ring-flash may be useful in such cases.

2. *Oblique side-lighting* There are various degrees of this, depending upon how oblique the light source is and whether any light comes from the other direction. Single-source very oblique lighting produces strong modelling effects (or harsh shadows, depending on how you look at it) suitable for emphasising some solid objects. Generally, it is better to reflect some light back into the shaded areas or to use a weaker light source to partially counterbalance the main light.

3. *Grazed lighting* In this extreme form of side-lighting, the subject is lit by a light source at right-angles to the optical axis. This type of lighting is excellent for emphasising small-scale relief in, for example, the surface

For delicate, detailed plants, a studio shot may be most successful. Borage *(Borago officinalis)* is difficult to photograph in close-up outside, since there is always slight movement, but an indoor picture, using back flash and a reflector, shows every detail.

Trees are often at their most impressive in winter, when their silhouette stands out starkly against the sky or water. Alder *(Alnus incana)*, mid-winter.

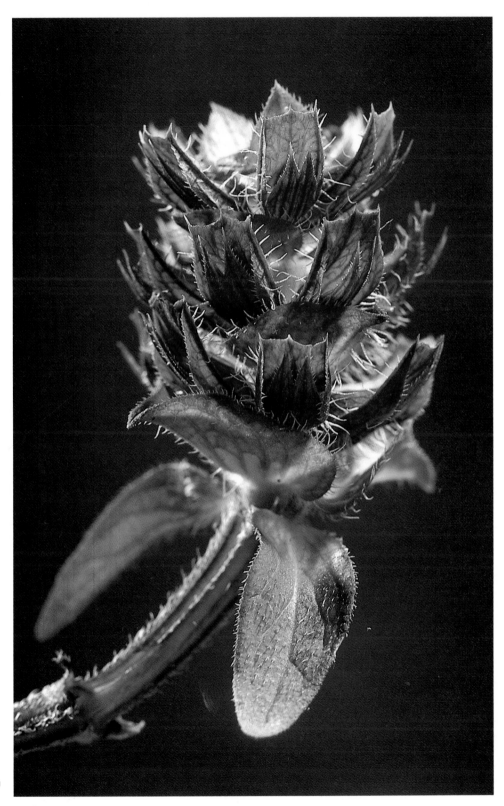

A carefully composed
studio picture of a seed-
head of self-heal *(Prunella
vulgaris)* using a balance
of back and frontal lighting
by flash.

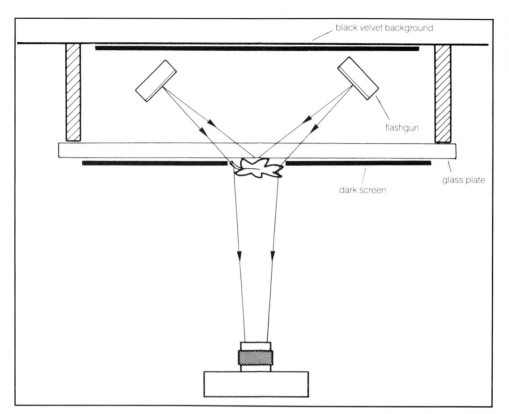

Figure 2.1. General layout of a studio set-up to give 'dark-field' illumination of a translucent object, such as a leaf.

black velvet background

flashgun

dark screen

glass plate

of a fruit. Surprisingly, perhaps, this can also be done very effectively with a flashgun on either side of the subject, and it will still give a modelling effect – if there are a series of depressions – with a more balanced light.

4. *Back lighting* Again this can vary from direct backlighting to oblique backlighting and it can involve one or more light sources. It can be highly successful for translucent subjects or for showing up a fringe of hairs or spines on a more opaque subject. It can even liven up a purely solid opaque subject by highlighting the edge of it. There are two things to bear in mind when trying back-lighting. Firstly, there is a high likelihood of getting 'flare' from light reaching the lens surface, so the chance of this should be reduced by narrowing down the angle of light of your light source with black paper 'lens hoods' and by fitting a lens hood to your lens. Check carefully to see that the light from the flash will not strike the lens surface, and use modelling lights (such as a desk lamp) if necessary. Secondly, make sure that the front of your subject is adequately

lit, especially if all, or parts of it, are opaque. This can be achieved with reflectors to bounce back the backlighting, or another direct light source with less power than the backlight.

5. *Dark field illumination* This is another extreme form of backlighting which can be set up as shown in Figure 2.1. This can be very effective for some 'botanical' shots, such as thin sections of fruits.

It is worth remembering that natural light can still be used indoors, especially for back-lighting by the sun, ad the results can be very pleasing and natural, as well as being more predictable. It can be added to with reflectors or flash, just as in the field, though of course there are many occasions when it is not available or adequate.

'Freezing' action

Keeping plants in controlled conditions in-doors opens up opportunities that would not otherwise be possible or, at the very least, would be much more difficult in the wild. Plants are not normally thought of as highly

active, but, for many species, there are stages in their life cycle that happen very quickly, and these can be captured with some forethought and manipulation in the studio. Wind-pollinated flowers, such as hazel or elm, release clouds of pollen when the tree shakes in the wind; this can be simulated by tapping an appropriately set-up branch and freezing the result using flash, probably backlit.

Seed release may not be too difficult to capture if the seeds are released simply through wind movement, e.g. seeds falling from the slits in a poppy capsule, or the parachutes of dandelion and related species blowing away in the wind. Other examples, such as gorse – which splits explosively when dry enough, or balsam – which splits very explosively when touched, are more of a challenge; a form of remote triggering using an infra-red beam can be used for the most difficult and unpredictable situations (p. 133). The studio also gives you the chance to capture seeds such as those of sycamore, which spiral slowly downwards in mid-air, with a bit of thought and contrivance.

PLANTS REQUIRING SPECIAL TREATMENT

Fungi

Fungi are generally small, nearly always opaque, with a rich variety of subtle colours, and they usually occur in situations with very low light levels. The lighting and situations are by no means uniform, however, and a flexible thoughtful approach will produce the best results.

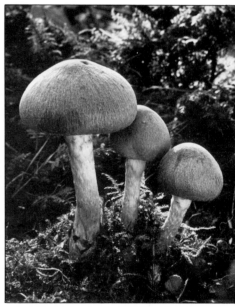

Ferns have an endless variety of forms, both in general structure and in close-ups. These sori (spore-producing structures) on the fronds of maidenhair fern (Adiantum capillus-veneris) were taken by dark-field illumination (see p. 60) with additional light reflected onto the front surface.

The photograph above was taken into the sunlight, using a reflector to light the front of the fungus (Cortinarius crocolitus). A 135mm lens, with extension tube, was used to give a pleasingly-flattened perspective and a less confused background.

(Left) This striking picture of a tiny lichen *(Cladonia macilenta)* was taken by 'painting' with flash, using 16 separate 'open' flashes to build up the light, allowing the TTL flash metering to determine when enough light had been given. More flashes were aimed at the back of the lichen than the front. 1:1 magnification.

(Right) Pollen dispersing from wych elm flowers (studio picture). Taken using flash from behind to highlight pollen grains, leaving the flowers after the branch had been tapped.

(Right) Fungi are usually best taken in subdued light. But occasionally filtered sunlight reaching the woodland floor can give effective results, such as for these fairy clubs *(Clavulinopsis* sp.) in the New Forest, England.

viewpoint also has to be selected carefully to show the particular features that you want – for example, if you want to show the fungi in a ring, you will need a high viewpoint and the same applies if you think that the coloured caps are the most striking feature; many other specimens, such as shaggy ink-caps (*Coprinus comatus*), are best viewed from the side to give good perspective and to show the cap shapes. In a very few cases, such as translucent species growing above the ground on tree-trunks, a viewpoint from below may be best.

Some pictures of larger fungi will benefit from the use of a wide-angle lens, especially where you wish to show the habitat, either because it is of interest or because it makes a good picture. A focal length of between 24mm and 30mm is usually best. The results can be most attractive and informative.

Lighting is, to some extent, a matter of personal preference. Many people always use flash for fungi growing in darker situations, but this is not always best. In late autumn, particularly, fungi can be lit by a beautiful soft light which is destroyed by flash. It is a useful general rule to use available light when it will make a good picture and only to use flash when nothing else can be done. To make the best of natural light, you will need a tripod or other support for long exposures (fungi do not usually move perceptibly in the wind) and a good reflector is invaluable to bounce light from the sky back into the darker parts of the plants, especially below the cap. If the light from the sky shows in the picture, yet the subject is poorly lit, then you may find some fill-in flash useful, bouncing it off the reflector if you want to make it softer. Try to make sure that the flash registers slightly less on the film than the main natural light levels.

Lichens

Lichens can be treated in a broadly similar way to fungi, though they are generally smaller and occur in lighter situations; a few species are translucent, lending themselves to natural backlighting (p. 67). Mosses and liverworts normally live in deep shade and will require diffused oblique flash on a tripod.

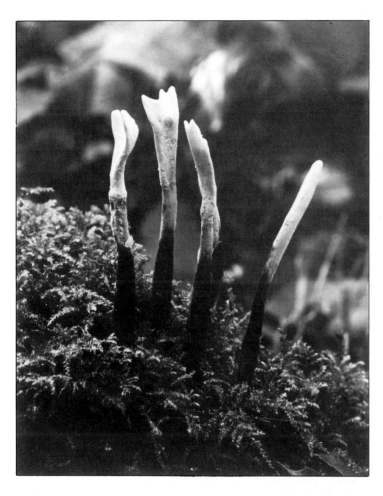

(Above) Candle-snuff fungus *(Xylaria hypoxylon)*. Better composition is achieved with tall thin fungi by finding an attractive group such as this. Individual spikes, though only a few centimetres tall, do not readily fit the shape of the film.

(Left) As discussed on p. 22, a small adjustable-leg tripod can be used horizontally to photograph lichens on tree trunks by available light, even at long exposure times.

First, as with flowers, spend some time looking for the best examples to photograph. Small groups may often look better than single individuals, especially if a range of stages are represented. Some people turn one example on its side to show the gill structure; if your photograph *has* to show all aspects, then this is probably the simplest way to do it and it should do no harm to the population, though it hardly looks natural.

Viewpoint and backgrounds are also crucial to the success of a fungus picture. When photographing fungi in woodlands, you often find that the sky creeps into pictures taken from a low angle; this is best avoided (because it is so much brighter than the subject) by choosing a different angle or specimen, but if it is impossible, then exposure has to be judged very carefully and 1–2 stops extra will probably be required over whatever is indicated on the meter. The

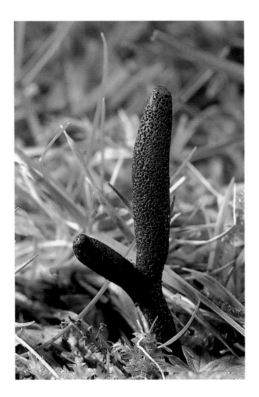

Fungi are so static that there is the opportunity to treat them as outdoor 'studio' shots. These earth-tongue fungi *(Geoglossum cookeianum)* were taken using two flashguns placed opposite and very obliquely to show up the surface relief, which would be barely visible in more even light.

The largest lichens can make fine pictorial available light pictures, such as these examples of *Usnea longissima* taken in the evening against the light at 4,000m on the slopes of Everest.

3
Birds

Bird photography is one of the most exciting and rewarding branches of natural history photography and 'shooting' birds with a camera has long been considered to be a substitute for field sports.

Because all birds spend a part of the year laying eggs and rearing young from some form of nest, a great deal of bird photography is carried out at or close to the nest and most portraits of birds are obtained in this way. Such photography is almost invariably done from a moveable hide or blind and we discuss in detail the setting-up and use of such a device (p. 72). Today, there is an increasing trend towards taking pictures of birds away from the nest, whether it is in your garden or in an estuary, and we have treated these forms of bird photography separately as the techniques are entirely different.

BIRDS AT THE NEST

Few forms of natural history photography demand more hours of preparation than nest photography for the number of good photographs taken. Careful preparation is the key to good bird-at-the-nest photographs.

Birds are sensitive, highly mobile subjects with interesting and individual life histories and habits. It is therefore essential to do some research on the species to be photographed. First, read the standard reference works to get to know the likely breeding dates, normal breeding sites and as much general information as possible and, secondly, read the work of other bird photographers who have written about their experiences.

As in many things, there is no substitute for practical experience and you must learn to recognise the various peculiarities of your subjects which will greatly assist in getting the best photographs and also in making the best possible use of the hours of preparation.

For instance, whitethroats will often give a gentle 'churr' when a few yards from the nest. The young become excited and, in the first few days after hatching, when they are blind, beg vertically, but when their eyes have opened, they beg in the direction of the approaching adult. This is a good indication to be ready to take pictures if the adult is arriving from the expected direction and into the pre-focused area.

There are a few general points for a bird photographer to be aware of. Most bird photography is done from a hide. Unfortunately, hides often seem to attract more attention from people than from birds. It is essential that hides be sited in quiet places where attention will not be drawn to either the hide or the nest. Permission for photography in any area should always be gained before any preparation for photography is made. Even in out of the way places, hides should not be placed near paths 'or be in any way obtrusive.

It is essential that if a species is on any restricted list the relevant licences should be obtained.

Characteristics of nesting birds

Nesting birds can be broadly classified into two groups. The *nidicolous* birds have young which hatch in a relatively undeveloped state and remain in the nest for several weeks. This group includes small birds, such as the blackbird, with incubation periods of between 10 and 15 days and fledging in 10–14 days, and larger birds, such as herons, with an incubation period of about 25 days and fledging in 50–55 days.

The second group, the *nidifugous* birds, has, in general, larger eggs for the size of the bird, a longer incubation period, e.g. about 22 days for the common sandpiper or 25 days for the pheasant. However, the most important thing for the photographer is that their young leave the nest within an hour or two of hatching.

Most birds, if disturbed, will desert their nest during building or in the early egg-laying stages, but will do so less readily as the time for the eggs to hatch approaches, and very seldom when they have young. Most interesting photographs of birds at the nests show some activity, either with the adults feeding the young or the male feeding the brooding female. It follows then that the approach to photographing nidifugous and nidicolous species must differ slightly. In the interests of the bird, hides are seldom introduced before the eggs have hatched, though this obviously is of little use when the species has young which walk away from the nest soon after hatching; with these species it is usually the aim to have the hide ready for photography when the eggs are just chipping. Then all the photography is crammed into 24–48 hours, when many interesting pictures can be taken of the egg shells being taken out of the nest and the non-incubating parent visiting the nest to walk each of the newly hatched and dried young away from the nesting area.

With some of the larger waders, the last egg hatches about 72 hours after the first, so, with a little luck, 3 days of photography may be had. With some of the larger nidicolous birds, such as the herons and raptors, the young are left for longer and longer periods between feeds as they get older. Therefore it is best to be in a position to photograph them during the first 2 weeks after hatching, when not only will the feeds be more frequent, but one parent will usually be in attendance, whether brooding the young, or just standing over the chicks, shielding them from the sun or wind. Some other species too are best photographed soon after the eggs have hatched; some adult finches take away the faecal sacs during the first week after hatching, but thereafter the young's white droppings, which are deposited all round the nest rim, are not removed – this is interesting but not exactly pleasing aesthetically.

Photographic equipment

Cameras

The photographic equipment needed for bird photography, whilst conforming to the criteria necessary for other branches of natural history photography that were discussed in Chapter 1, does have one or two extra requirements that tend to further limit the choice of camera and lens. There is little point in looking beyond the SLR camera but it is as well to be aware of two unfortunate characteristics that modify one's choice of camera.

The first undeniable disadvantage of the SLR is noise. Noise is generated twice each time a picture is taken, once when the shutter is released and again as the film is wound on. Nothing is more disturbing to a bird than a nearby sudden sharp noise and the SLR produces just that sort of sound when the shutter is fired. All birds notice this noise but most get used to it, even when the camera is only 1.25–1.5m away, as it often is when photographing small birds. The noise of the shutter being fired is responsible for many blurred pictures, especially those taken at 1/60 second or slower. The problem is greatest with small birds whose reactions are so quick that, even when they seem to have accepted the shutter noise, they will be found, on critically examining the final photograph, to have moved their heads very slightly. This is especially noticeable in the fine feather detail around the eye and side of the head, and the problem gets worse the nearer the camera is to the subject. The quietest camera shutter is probably the Leica, which is also the most expensive and has fewest independent maker's accessories. Between the rest of the cameras recommended in Chapter 1, there is little to choose for shutter noise. Wind-on noise is a different matter, for although the noise level is much lower than the shutter, it can, on some cameras, be accompanied by a series of clicks which birds find much more disturbing than the single noise of the shutter firing. The largest amount of noise that can be made during winding on is made by letting the lever wind return on its own, but this is avoidable and great pains should be taken to

wind on as quietly as possible. We have seen birds which tolerated shutter noise but which showed great unrest as the film was wound on.

Motordrives should be used only in exceptional circumstances where the bird has been gradually accustomed to the noise for some specialist purpose. It seems that it is not the peak noise level which worries birds, but rather its duration and fluctuations. Wind-on noise can be minimised either by waiting for the bird to depart from the nesting area and then winding on, or by very slowly inching the lever over and slowly returning it to the rest position. On no account should the lever wind be allowed to fly back on its own as the resultant noise seems much louder than the shutter firing. The best cameras we have found for consistently giving the least film wind-on noise are the Nikons.

Some cameras are much easier to use than others in a hide and those with viewfinders which display both shutter speed and aperture are much to be preferred, as these are frequently difficult to see and set correctly in the dim interior of a hide. It is less of a fiddle to reach a shutter speed dial on the top plate of the camera than to try to change a shutter speed located round the throat of the lens. It is also much easier if the depth of field preview lever is located on the camera body rather than the lens since it is much easier to locate and use.

Sometime during a photographic session in a hide you are going to need to rewind and reload the film. Cameras with a rewind button located on the top plate would be ideal, but the majority have this button located on the base plate and, when putting the camera on the tripod head, care is needed to ensure that the rewind button is left clear for easy and quiet rewinding, which should be done when the bird is absent. Some cameras have the rewind button on the front and it can be very difficult both to locate and to use in a hide.

If you are going to use flash for bird photography, and your scope is much extended if you do, then a camera with a high flash synchronisation speed should be chosen. The normal SLR has a synchronisation speed of 1/60 second and this is too slow when using anything but very high power units with several flash heads where the aperture is small enough for ambient light to be discounted (see pp. 84–85).

Lenses

Apart from photographing the eggs, chicks and surroundings, when the standard lens of 50mm or wide-angle lenses of 28mm or 35mm is useful, the best lens for bird photography is the medium to long telephoto. Such a lens, of 135mm or 200mm, will be used for 90% of all normal hide photography.

If we had to make a choice, then we would be happiest with a lens of 200mm focal length. Such lenses should be chosen with great care from the wide range available. The ideal lens would have a very high definition, built-in lens hood, an independent tripod mounting bush and the ability to focus down to a metre. A tripod mounting bush on the lens is a great asset since it enables one to change the camera leaving the lens in place without disturbing the bird. Some extension tubes have a rotating ring with a tripod bush that can be locked in position. This is a most useful feature, since the camera can be moved from horizontal to vertical without the lens moving across the front of the hide – which happens when a pan-and-tilt head or ball-and-socket is used. Tamron also make a very useful tripod mounting ring for some of their telephoto lenses. A few years ago, we would have hesitated to recommend zoom lenses for bird photography, but our recent experience with them has shown that the better quality ones are well worth considering. Those from independent makers usually focus much closer than the camera makers' own and this is a very useful feature. Using one of the longer zooms, like the Tamron 70–210mm, one can focus down to 1.2m, to include, say, just a reedwarbler and nest, without using any other accessories. As with all camera equipment, careful choice of zoom lenses is necessary. One-touch zoom lenses tend to lose focus when pointed downwards and we much prefer lenses where the focusing and zoom controls are on two separate rings.

One of the great advantages with a zoom is the ability to take advantage of unexpected or infrequent events without the need for changing lenses and specially setting-up for just these events, such as both parents arriv-

Black-tailed godwit photographed from a hide, close to its nest in Hungary. A 300mm lens and a 2x converter were taken to the hide especially for this sort of opportunity, while the birds were further away from the nest.

ing together and displaying close to the nest.

Zoom lenses have another great advantage. Normally, when photographing small birds, the hide must be positioned fairly precisely to within a few centimetres, but providing the zoom is not set to its maximum focal length when deciding the final position for the hide, one has more leeway for positional error or accommodating a friend's camera and lens system.

Fashions change in bird photography like everything else. Some years ago the bird and nest or chicks were expected to occupy about a fifth of the finished photograph. Nowadays, unless the picture can really be excellently designed, then the bird and nest is expected to occupy about one-third to half of the picture area. This is why we now recommend lenses of 200mm rather than 135mm. Lenses of longer focal length are used very infrequently and the very good ones are expensive, so it may be better to buy a high quality 2x converter. Once, when photographing black-tailed godwits, we used a 200mm lens to photograph the sitting bird

and a 300mm with a 2x converter to photograph the other bird which was looking after the newly hatched chicks, walking them some 25–30m from the nest. We took some very interesting pictures, but the opportunities do not happen very often. On this occasion, experience with other waders had made us aware of the possibilities, otherwise we would not have had extra tripod, camera, 200mm and 300mm lenses and 2x converter in the hide.

Tripods

There is little point in spending a small fortune on camera and lenses and skimping on a tripod. The tripod is there to support the camera rigidly in the desired position and the fewer extensions on the legs, and the shorter the centre column, the steadier your tripod. Weight is most important and a tripod needs to be heavy: 2.5–3kg in weight is the best compromise between portability and steadiness. A bird photographer's tripod does not need to close down to pocket size since it will almost always be used at 1–

1.2m. Nor is a long centre column necessary, though 10–15cm extension is a great help. Tripods will need to withstand salt water so be careful of some aluminium alloys. Corrosion can be a problem with all metals, particularly at aluminium/steel interfaces in salt water. The best tripods we have found so far are the heavier Velbon AEF-3 or similar, which is really in the lightweight class for bird photography but is very versatile and robust, or the Kennett Benbo. The latter, whilst rather unorthodox in design, is very useful because its legs are sealed at the bottom and the section legs slide at the top; the bottom section is longer than the average wellington boot so you usually get wet feet before the tripod does. The Benbo is also most useful when working in wet or muddy places since all the locking screws are well above the water level, and therefore relatively safe from damage, and can be easily adjusted.

Cameras are usually mounted on the tripod via a pan-and-tilt head or ball-and-socket head. Pan-and-tilt heads are very good and those with a tilt handle which also twists to lock the tilt are the most convenient to use. There is an advantage in the camera plate having an independent hinge, so the camera can be swung from horizontal to vertical without the use of the tilt and rotation usually employed. It is helpful too if the camera-retaining screw is captive in the camera platform and has a large locking ring round it. Ball-and-socket heads always seem very heavy for their size but if you get one, get a large precision-made one; small cheap ones are annoying because, on being tightened, they invariably move the camera slightly and are unable to hold a heavy camera and lens safely. A cable-release will be needed for use with the tripod and here, as in other things, you should make a very careful choice. One of 35–45cm is best, so that it naturally comes to hand and can be held in a comfortable position whilst waiting for the exact moment to take the picture. If you have to buy one with some sort of locking device, choose the ones which have a screw on the side, so that you have to make a conscious effort to tighten for time exposures, and not one where there is a concentric locking collar around the plunger. The latter can be clicked on inadvertently and, with most cameras, the film cannot be wound on whilst the release is held in, which can lead to a frantic search for the reason why the camera has jammed!

The hide

A hide or blind is no more than a hiding place for the bird photographer which enables him to operate without being seen by his subject. From the point of view of the bird, it does not need to be elaborate nor does it often need to be camouflaged. The material should be lightweight and just thick enough to prevent a low-angled sun, coming from behind, throwing a disturbing moving shadow of the photographer on the front wall. As noted earlier, hides inevitably attract people's attention and, apart from exceptional circumstances, it is for this reason only that they need to be camouflaged, Hides should be considered as disposable items and the material expected to be written off at least after three or four seasons of use.

The ground hide described here is suitable for both birds at the nest and birds away from the nest, with the possible exception of the Dexion framework, which, if left for more than a couple of weeks in muddy water in a wait-and-see situation, will be very difficult to dismantle due to the rusting up of the nuts and bolts.

It takes no more than a few hours in a hide to realise that it should be made as large as possible. The basic requirements of tripod, telephoto lens and seat seem to take up an enormous amount of room. Add to this a 1.8m photographer, camera gadget bag, flash control box, food and Thermos flask and you will realise that even a metre square hide is none too large.

Construction

A practical hide made from easily obtainable materials and simple to construct is $1m^2$ square and 2m high. Such a hide can be made with the least fuss and expense by having two strips of unbleached calico material, each 5m long. These are sewn into a cross with equal arms, making a double layer for the roof; then three of the sides are sewn together (Figure 3.1). The two edges of the fourth side should have 10cm lengths of strong tape sewn down each edge at 25cm intervals. The

The component parts of a standard ground hide, showing the folded material, guys and pegs, four poles showing different length sections to cope with uneven ground, and various lengths of cord to prevent materials from flapping in the wind. Normally all the pieces would be wrapped up in the material for transport.

Figure 3.1. Diagrammatic method of making hide material: sew sides AA/AA, BB/BB and CC/CC together. On remaining two sides, sew tapes at approximately 20–25cm apart, to allow for entry point.

top roof corners will need strengthening by a few lines of stitches across the corners at about 4cm out. Through these top corners a hole can be pushed. This can be left as it is but, to save too much wear, a brass eyelet can be put in with a small cheap punch obtained from camping shops. A hole for the lens can be made in one side about 30cm from the top and 10cm across – round or square. 30cm may seem overgenerous but is often needed to accommodate the long handle of a pan-and-tilt head when the camera is turned vertically (p. 70). As an added refinement, 10 x 2.5cm horizontal viewing slots can be cut into the sides and back but they will need some flap arrangement to obscure movement from within.

Such a hide will be about 2m tall and large enough for protracted sessions on nesting birds from ground level to about 1.5m. With ground nesting birds, the hide is not put up to full height, since the camera will only be at about 1m. Surplus material is just tucked under or, in open windy conditions, stones are put on the surplus, helping to steady the

Great spotted
woodpecker at nest hole,
photographed from a
tower hide made of Dexion
at about 3m above ground
level. Flash, balanced with
daylight.

Figure 3.2. Hide poles showing unequal middle and upper sections giving flexibility for levelling on uneven ground. See also p. 73 for photograph of hide components.

quarter of the cost, so their loss for one reason or another is not so hard on the pocket.

The fabric of the hides will need supporting. We have used a variety of poles and frames and found none greatly superior to any other. However, the poles should be lightweight and sectional. If the hide has to be backpacked very far then poles made of 20mm diameter dowel rod divided into three sections with the bottom section pointed are best. It also helps in setting up a neat level hide on uneven ground if one pair of poles has its middle and upper sections made into different lengths to the other pair, though equal in total (see Figure 3.2)., It is much better for stability, however, if the poles are in two sections only. The top sections of wooden poles should be drilled down through the top and short lengths of metal rod glued in so that about 2.5cm projects.

If the hide is up for any length of time in rain, the roof of a fabric hide will either bow inwards to form a leaky pool above your head or just drip uncomfortably on you and the photographic gear. An easy and light-weight solution is to use two diagonal cross-wires, bent into rings at each end; the rings can be slipped over the metal inserts in the top of the poles and the wires tied in the middle for stability. They should be made long enough to be bowed upwards. This is also very good for giving that little bit of extra headroom. Two other lengths of wire can be fastened between the top poles at the sides to give extra support; they will also help to get the pole distance correct when setting up. Such supporting wires should not be used at the front because they will inevitably be in the way of the tripod's pan-and-tilt handle. When erected, the corner poles of the hide will need supporting guys. Such guys are usually made of strong nylon cord with adjusters – both can be obtained from camping shops, as can the guy pegs. If the poles can be pushed fairly well into the ground, then only one guy will be needed at each corner. It is surprising, though, how often the hide poles can be pushed only a couple of centimetres or so into hardpacked or sunbaked ground. In these cases, and in windy exposed sites, two guys at each corner will be needed.

whole structure. In the days before the SLRs took over as the camera of preference for nature photography, it was necessary to make another peep hole in the front, so that the photographer could see what was happening, but nowadays many photographers rely on the view through the lens. However, this is restricted only to the angle of view of the lens and gives no idea of what is happening outside the field of view. We therefore like to get settled in the hide and, before photography starts and the companion departs, we make a small hole with a pencil at a comfortable height and place so that, by gently moving the head, a good view can be had of the nest and surroundings. Separate holes will also have to be made for power and synchronising cables if flash is to be used.

Commercially made hides are available but, though very good, and complete with poles and holdall, they are expensive. The hides described here can be made for about a

A rough-and-ready hide can be made from sticks cut from the hedgerow – hazel is ideal,

especially if the rods have a fork at the top so that cross-pieces can be tied in easily – plus some suitable material.

A hide on extendable poles, suitably guyed, can normally cope with nests from ground level to 1.5 to 1.8m. Above this height, some form of pylon-type support must be erected. The cheapest way is to cut poles locally and chop flats on the ends of suitably cut lengths and nail these supports to uprights, though it is a time-consuming and often frustrating business. Modern bird photographers use either a light portable 1.2m scaffold of the type used by house painters, or a purpose-designed light tower. The first type, of light scaffolding made of pre-constructed sections, can get up to 12 or 14m, with wire guys, nylon ropes or long normal scaffolding poles as outrigger supports. A small lorry or large van is needed to transport it. The purpose-built type, however, can be put up to 18m and, since it is usually made of light tubular steel, can be carried in the family saloon; it is, however, only available custom-built and is therefore very expensive. A very useful compromise of weight, cost, height and availability can be achieved by using Dexion. This is available in precise pre-drilled 'L'-section lengths of metal in various weights, widths and lengths. The lightweight types are very good for

Figure 3.4. Dexion tower base, showing H-shaped internal braces and outrigger stabilisers.

building ground hides or hides in shallow water, where a framework can be prebuilt and carried into position. the sections are bolted together and we have used the 40mm Dexion sections for tower hides up to 7.6m. (Figures 3.3, 3.4 & 3.5).

Dexion has many advantages as camera supports, seats, and extra supports for equipment can be bolted on. Enough Dexion can be carried in a normal family saloon for a 7.6m hide, though a roof rack is useful if the economical 2.75m lengths are being used. A great disadvantage of Dexion is the difficulty of diagonal internal bracing; this is needed to stop the sides bowing out, though it can be partly avoided by internal horizontal cross-braces. To save weight, the hides on top of a pylon are normally much smaller than a ground hide, usually only about 0.6m² and often without a floor. We prefer to use a normal-sized hide and to put a floor in. We have a two-part light blockboard floor that fits tightly between the Dexion uprights with 25cm projecting out at the front. This is a great aid to stability and enables a normal tripod to be used. It is also possible to accommodate much more baggage, as well as being more comfortable to shift around in during periods of inactivity. The floor in a pylon hide should be put in at about the same level as the nest. This will enable you to look down on a sitting bird and to be in a suitable

Figure 3.3. Dexion tower base section, with one elevating section added. One side only shown for clarity.

position to photograph larger birds, like herons, when they stand up (see p. 86).

Dexion can, of course, be used for ground hide frames and, where working not too far from a car, it has become our usual hide framework; we use two 0.9m squares bolted onto 1.8m uprights. The upper square is bolted on round the top and the lower one bolted 15cm or so from the bottom, to allow the uprights to be pushed into the ground. Two side members can be bolted on at a suitable height to support a cross-piece about 25cm from the back for a seat. The whole thing can be built very quickly and easily, but is somewhat heavy to carry over long distances.

Accessories

Before we go on to discuss introducing the hide to the bird, there are a few essential items which go with the hide that should be mentioned.

First, for the front of the hide, a 'nurse's sleeve' is needed for the lens. This a tube of material, 20–25cm long and about 15–20cm in diameter at one end, narrowing down to 10cm at the other, with the narrow end being

elasticated to fit round the lens just behind the lens hood. The wider end is pinned to the inside of the lens hole in the hide front. This essential little item enables the photographer to make adjustments to the camera and lens without the bird seeing the movement within the hide. We also have a piece of green camouflage netting which can be pinned across the back of the hide to obscure any movement that may be noticed through the peep holes. If thin material is used and there is strong side lighting, it can also be used to break up the photographer's shadow, but most commonly it is pinned over the entrance corner, where there are inevitable gaps.

Pinning has been mentioned several times. Large, strong safety pins are needed – 'nappy pins' are much the best – and there never seems to be enough of them in a hide. Everything seems to need safety pins – we keep two for each inside wall of the hide, just to anchor a spare nylon guy whenever it is windy.

Strong elastic bands are most useful for keeping the hide material in a tight roll and the poles together.

(Below right) Hide as set up for garden warbler's nest (p. 87) from the front, showing two flashguns mounted on poles externally, with a connector outside, leaving one lead to feed into the camera. The lens is emerging from a nurse's sleeve as described.

Figure 3.5. Dexion base section, plan view from above. The dotted lines are outrigger supports.

(Far left) Hide set up at ½ height on warbler's nest to help speed up the process of accustoming the bird to the hide. It has not been set up well enough to leave for a long period and, shortly after this, it was re-erected at full height.

(Left) Camouflaged hide set up for garden warbler's nest. Note externally-mounted flashgun on pole and cord around the hide to stop the material from flapping.

Nylon cord will be needed in two lengths of 6m for extra guys in windy weather, or for tying round the hide when you leave it, though for this latter job, especially when using Dexion, we now use the elastic ropes with hooks on each end usually used for holding things on car roof racks. These are quicker and easier to hook together and do not slip out of place.

The hide seat deserves a lot of consideration. It must be comfortable and at the right height, not only to get the photographer's eye easily to the eyepiece of the camera, but also to allow for the length of your legs. Too low a seat for tall people is most uncomfortable if the legs cannot be frequently stretched out in front – something usually impossible in normal hides. The sort which has the two front and two back legs made from one piece of tube bent in a 'U'-shape is best on soft ground and you can prevent it from sinking in by putting locally-cut vegetation under the legs. In a Dexion hide, an 'H' can be made and put in horizontally at the most convenient height, and a short plank with a thick bit of foam plastic on top will ensure great comfort. Where transport and weight are no problem, we much prefer a wooden box of 50 x 35 x 15cm dimensions, open at the top and bottom. With this

box and a piece of plastic foam, it is possible to be comfortable at a range of heights to suit ground-nesting birds and birds nesting up to about 1.7m, depending on which side of the box one sits. The essential feature of any seat is that it must bring the eye to camera level without any excessive bending or stretching. Seat height is dependent on camera height though in any form of pylon tower hide, the floor level can be adjusted to give room for legs to stretch.

Introducing the hide

There are two accepted methods of introducing the hide to the nest. Firstly, the hide can be built gradually, at the the right distance for photography, making sure that each stage is accepted by the birds. To do this, the camera and telephoto lenses are taken along at the start to determine the working distance. Four short poles – the bottom sections of the uprights – are placed in the correct position and the hide material put on the ground across the back. The bird is then watched from a suitable distance to see whether all is well and the chicks are being fed. The next stage is to make the hide more three-dimensional by arranging the hide material around the four short sections. Thereafter, the hide material is gradually

raised, in three or four stages, until it reaches the required height. The speed at which this can be done differs with the species and is probably dependent on feeding rates. Small warblers, which bring single prey items to the nest every minute or so, accept hides very quickly, whilst thrushes, which feed at longer intervals, need more time. It is best to spend as long as possible putting up the hide since the bird will be more likely to accept it and be less nervous at the start of photography. Hides for warblers can often be put up in 1 day by this method, though usually it takes longer and for larger birds, such as hawks and herons, a week or 10 days is not too long. Tower hides have to be built *in situ*, of course. The biggest disadvantage of this method is the need for repeated visits to the actual nest site, with the consequent frequent disturbance and trampling of the vegetation and, often, the difficulty of observing the birds' reactions.

The second method, and the one we prefer to use where possible, is to erect the complete hide some distance away from the nest and gradually move it closer. This is more easily done with hides on a solid Dexion framework and even small tower hides up to 3m can, with help, be moved gradually into position. Often, and particularly with birds nesting in the open, like lapwings, photography can start before the hide is in its final position. Longer telephoto lenses will be needed, and the results will not be as good as when you get closer, but you will be accustoming the bird to the lens and shutter noises as well as getting to know your subject's idiosyncrasies. This will all help to get better pictures later on. Using this second method, we have introduced a hide to warblers in half a day and commenced photography the day after. It is much easier to observe the effect on the bird and less damage is done to the vegetation. It is also easy to back off if the bird does become overanxious, with the opportunity to move closer later. A combination of the two methods can be used.

The nest site will often dictate the final hide position, but if possible you should site

Pratincole photographed against the light without fill-in flash, giving an attractive effect, but note the absence of catchlight in the eye. 200mm Nikon plus extension tube.

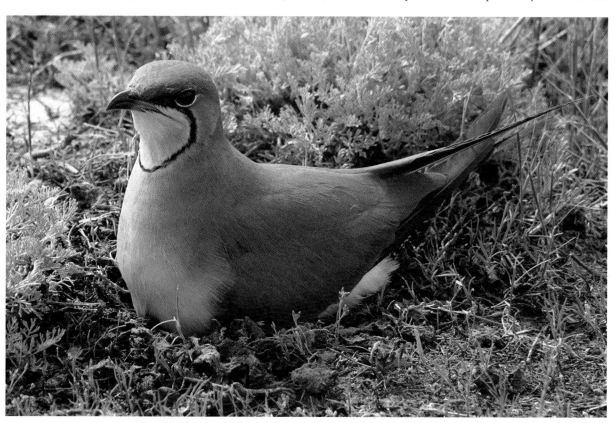

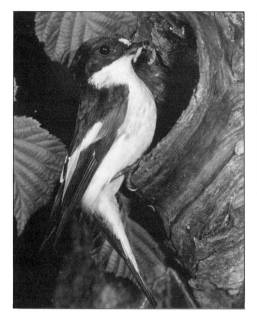

Male and female pied flycatchers used different parts of the hole to perch on when feeding the young. The male (far left) perched at the base whilst the female perched halfway up the nearside, where the white scratches are visible (left). Advance planning was necessary to frame and focus correctly according to which bird was visiting.

the hide to make best use of the sunlight at the time you will be able to do any photography. It is not much use siting a hide on the west side of a nest if you can only manage to photograph in the evenings, when the hide's shadow will be over the nest. With experience, you will learn to site hides for some interesting lighting effects. There were no site-dictating factors for the hide on the pratincole (see p. 79), so the hide was deliberately placed to backlight the bird during the morning, so as to have a more conventional front light during the afternoon. With a backlit subject, the sun has to be in exactly the right place, otherwise some very distracting shadows are produced, and the effects on the surrounding vegetation need to be carefully considered. The effect one is seeking is often only available for a short time, but the results were certainly worth the loss of photographic time on the pratincole.

With birds with a totally white plumage, the best results are obtained by photographing from the shadow side in hazy sun. Backlighting too can often produce a picture without a catchlight in the eye, and here a flash can help (see lapwing, p. 87).

With hole-nesting birds, the hide should be sited to one side of the hole, otherwise you will only get back views of the birds. Most birds with open-topped nests prefer to return to the nest from the back, i.e. they come to the nest facing the hide. This presents few opportunities for really good pictures, so where you have the chance a nest should be chosen that to some extent restricts the bird to approaching from the side; an obvious example is a nest against a tree-trunk. The final position of the hide is also influenced by the focal length of the lens being used. The focal length dictates not only the distance, but also the height above the subject (see p. 82).

Techniques

General

Once the hide is in position, photographic sessions can start. The first job will be to 'garden' the area around the nest, i.e. to tidy up loose bits of vegetation that might flap across the view and spoil the picture. If at all possible, tie plants out of the way rather than removing them entirely. Our hide kit contains short lengths of green plastic-covered wire used by gardeners, which we find much easier and quicker to use to hold back vegetation than lots of bits of string. After a photographic session, the vegetation can be replaced and the wire left attached, ready to

be used when photography starts again, or removed entirely when photography is finished. Almost always there will be distracting light bits of grass, leaves etc. built into, or projecting from, the nests of small birds, and these should be very carefully removed. Do not overtidy the nest or surrounds and remember that the vegetation must be replaced exactly after each photographic session to prevent predators from finding the nest. With birds nesting on the ground, just as much care is needed. Birds on shingle or relatively bare ground often position their nests next to some minor feature – a piece of wood or a large shell, for example, which you may think necessary to remove. In the picture of the little ringed plover (p. 82) the large mussel shell was such a feature in the immediate nesting area that it was thought best to leave it in place.

It is as well to take into the hide as little equipment as possible; tripod, camera, lens, cable-release, spare film, notebook and seat are the only essential items. Unless you are in for an extended stay, food and drink can be dispensed with. However, if the weather is hot and the hide is in an exposed position, then take in plenty to drink. In hot weather it is best to get up very early and get photographic sessions over by 10 a.m.

You must have a companion to 'put you in the hide' and to fetch you out again for, whilst most birds seem unable to count, they do recognise people as danger and, as such, danger must be seen to be going away from the hide. So for most birds, and especially those considered more intelligent, or those who can keep the hide in view the whole time, it is necessary to have someone to accompany you to the hide and then be seen walking away from it. With some birds, you can, with caution, manage to get into a hide by yourself; wrens and some warblers can be very confiding but, even so, being put in the hide by a companion will shorten the time taken for the birds to settle down to a normal routine. Whilst your companion is there, he or she can help with the final minor tidying up and prefocusing. Before the helper leaves, arrangements must be made for his return; a time should be agreed and, importantly, a signalling system, so that he or she will not turn up just as something interesting is happening. We usually arrange a time and

have a white handkerchief poked out of the back of the hide if we are ready to come out; if there is no handkerchief showing, the helper waits at a safe distance until it appears. Such a system works very well and often your companion can keep watch from several hundred yards away until the required signal is seen. We have tried more sophisticated communication systems, such as CB radio, but it is too noisy.

Once your helper has gone away, note the time in the notebook; if setting up the hide has gone very well, then the final introduction of the lens showing from the hide and the 'gardening' will be quickly accepted and you should not have long to wait before the bird returns. It is best to get the helper to check the back of the hide for a signal after half an hour or so at the first session, to make sure things are going well. When the bird arrives for the first time, do not take any photographs. The bird will usually be far too nervous, and not in the prefocused place, but more importantly will need to feed the young or brood with no interruption after the delay you have caused in getting into the hide. If the first feed goes well, you will have been able to observe, through the lens, the exact place on the nest rim from where the bird feeds the young. Do not start focusing whilst the bird is there and, if it is possible to distinguish between the adults, then don't take any pictures when the other bird first arrives at the nest, as it too needs to get used to the lens and extra disturbance. This caution pays dividends, though it is sometimes very difficult to repress the urge to take photographs immediately. Note the time of the first and subsequent visits, and which adult is visiting. This diary will stand you in good stead later. Once the time of nest visits are known, you will be able to plan how many pictures can be taken at each session and plan sessions for different types of film. You can also note the type of food being brought in. Once, when photographing a bluethroat on the edge of a reed bed, we became so interested, because the adults were bringing in dragonfly larvae, that we waited too long each time and the larvae were fed to the young before we took a photograph!

In photographing birds, as any other animal, the eye and as much of the body as possible, particularly those parts nearest the

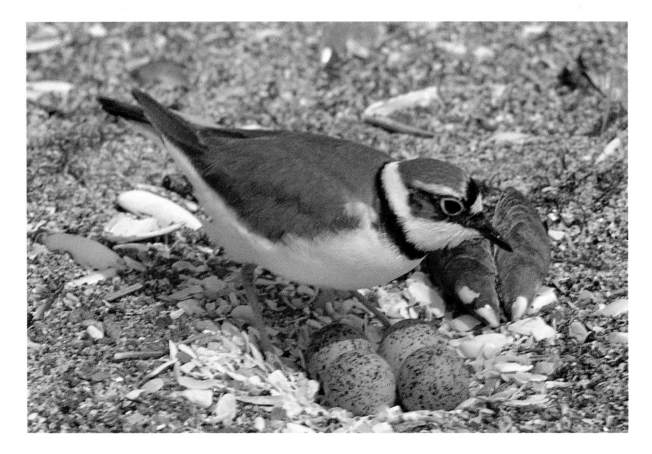

camera, must be really sharp. When a bird is sitting broadside on, then the plane of sharp focus should pass through the eye and the 'shoulder' (carpal joint) of the near wing. This plane of focus usually brings into focus the near edge of the nest. You will have to adjust camera height in relation to the available or selected aperture to achieve this. You may also have to change lenses and reduce the image size to get enough depth of field. At the same distance and using the same aperture, the longer the telephoto lens you use, the higher and more angled down you will need to have the camera. The aperture used will depend on the light levels and the minimum shutter speed you judge necessary to stop the bird's movement. A zoom lens will, of course, greatly assist in adjusting depth of field in response to varying light levels, with the corresponding reduction in image size easily achieved. With hole-nesting birds, a three-quarter view of the hole will make the maximum use of available depth of field. If you do need a back view of a bird at

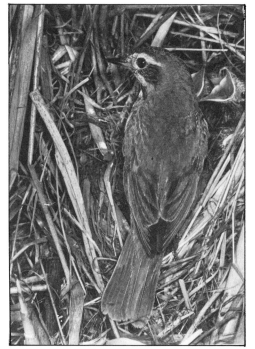

Little ringed plover photographed at nest on the Black Sea coast from a hide, using 200mm lens on Agfa 50S film. The mussel shell behind the bird's beak was left as it obviously formed a nest 'marker' for the parents.

Bluethroat (white-spotted form) at nest in Hungary. The situation of the nest prevented a side view from being obtained, so a back view was necessary, with a long wait for the bird to turn its head sideways. The camera is slightly above the nest to allow the film to be parallel to the back of the bird, giving maximum depth of field.

Mistle thrush, photographed just as the adult is about to feed the chicks, using flash at 1/60 second, which allowed the background to be correctly exposed. The camera was set up somewhat below the nest to give a more dramatic shot and to make the best use of the depth of field.

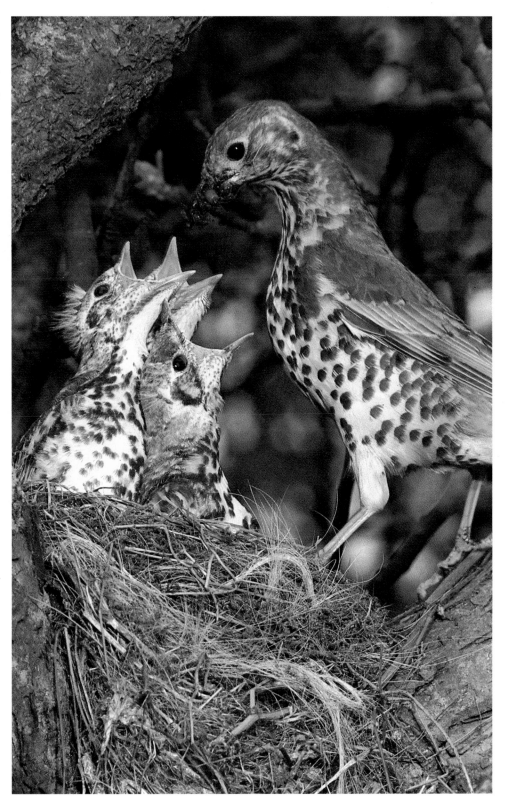

the nest hole, then, with the camera held vertically, the bottom of the camera will have to slope inwards to get the whole back in focus, i.e. the camera back will then be parallel with the back of the bird.

When starting in bird photography, it is best to attempt the common birds first, especially hole-nesting species, since with these there is no difficulty in deciding where they will perch and, therefore, little difficulty in deciding where to focus.

Common birds make ideal first-time subjects and you will learn a lot in a short time about where to focus and timing of the exposure. Years ago, when plate cameras were used and photographers went into the hide with only ten or so slow-speed plates, great attention had to be paid to the exact timing of the exposure. More often than not, the exposure was made in a brief moment when everything was as still as possible – usually just after the parent bird had fed the chicks and was pausing to watch the food being taken down. Bird photographers still have to develop a good sense of timing, but now, with fast films and electronic flash, it is possible to time the exposure for the high point of action. There is a moment with most small birds being fed in the nest when the adults have to stretch up with a beak full of food to get enough height to push the grubs down the throats of the vertically-begging nestlings. There is often much wing flapping and excitement, a great moment to be caught on film. This, of course, happens only with birds with open nests; with birds which breed in holes you will have to wait until the chicks are quite old before they poke their heads out to be fed.

With careful observation, it is often possible to see that each parent bird has its own feeding position at the nest, so once the feeding routine has been established – again the notebook is an invaluable record for this – then you can have the camera focused and ready. When we were photographing the pied flycatcher (see p. 80), it was even possible to see two different sets of scratch marks on the nest hole rim where each adult had its preferred landing place, and which it used most frequently; noting this made prefocusing very much easier, as birds are often very consistent and predictable in their behaviour.

Lighting

Where possible, make the best use of available light. The best light is a hazy sun, which casts soft shadows and keeps the contrast range within the film capabilities. Strong sunlight from a cloudless sky presents many difficulties, and the only solutions we have found to this problem are to use a fill-in flash on the shadow side or to deliberately site the hide so that we are photographing straight into the sunlight, and therefore looking for a more pictorial effect; the opportunity then arises, as the sun moves over, to use flat frontal lighting. Backlighting can be most effective and is the only way of dealing with predominantly white birds in full sun – if you cannot get up early enough to catch the early morning light. If you are photographing into the light, you have the option of making no exposure compensations and getting a rim-lit bird – an effect that can be very beautiful – against a darkish background, or giving a longer exposure than the meter suggests and exposing for the shadow side of the bird (though this often burns out the background).

White birds, or very light-coloured birds like the silvery grey terns and gulls, need more exposure compensation and also very careful metering if they do not fill much of the frame. If you are photographing into the light, you seldom get a catchlight in the eye, and the bird can look very dull. A small electronic flash can work wonders and we often use one on dull days to provide a catchlight in the eye. If flash is used with sunlight, then very great care has to be taken not to overlight the bird with the flash and provide an extra set of shadows. First set the correct flash synchronisation speed and then adjust the aperture for the correct sunlight exposure at that speed. Then position the flash, set on manual, at a distance calculated from the flash factor so that it is lighting the subject's shadow side at $\frac{1}{2}$ or 1 stop less than needed for the sun. For example, if f.11 is needed for the sunlight exposure, then move the flash back until it is giving a correct exposure at f.8 or between f.8 and f.11. You have to remember that any adjustment for the sunlight exposure has to be done using the aperture since you will have to keep the shutter at the highest possible flash synchronising speed. The is usually 1/60 second

which is not really fast enough in bright sun using low-power flash units since it is possible to get two images – an underexposed one by the flash partially outlining the correctly exposed sunlit image taken fractionally after the bird's reaction to the flash. Cameras are available with flash synchronising speeds of 1/125 and 1/250 seconds and, if you are going to do a lot of flash photography, then this may influence your choice of camera.

Flash is the answer to many problems in bird photography. Many nests are found in dark situations that would be very difficult to photograph with available light and photographing nocturnal birds would be almost impossible without flash. If flash is to be the sole source of light on a bird, then the background and immediate surroundings must also be adequately lit. The temptation is to use flash all the time, thus getting over the problem of the long exposures so often needed for daylight and the consequent problem of subject movement, but it is not an ideal solution. Lighting the background can be difficult and sometimes impossible. The nearer the background is to the bird the easier it is to light. In the most extreme situations, the background will be so far away that the flashes set for the bird will have no visible effect on the background and there will be a correctly exposed bird against a black background – most unnatural for diurnal birds. The problem is made worse by the use of slow films; faster films will record some background detail and colour at the apertures used for flash whereas the ambient light may not be enough to record on a slow film.

Elaborate lighting set-ups are not needed for the majority of bird photographs at the nest site. Only one flash will be needed if the sunlight can be used, or two flash heads if flash is to be the main light source, though on rare occasions we have used a third light on the background. Our flash heads are either mounted on the Dexion frame of the hide, using small ball-and-socket heads, or strapped on the pointed stakes with strong elastic bands. Spare tripods have also been pressed into service and, in the last few years, we have adapted three light-weight photoflood lighting stands. Flash heads are always positioned above the nest, one near the camera and a less powerful one at approxi-

mately 45° on the opposite side, to soften the shadows of the main light. If the second flash is of the same power as the main light, either it can be positioned half a metre or so further back, or a piece of diffusing material can placed over the reflector. This not only softens the shadows cast by the main light but also throws light onto the background. Electronic flash units come in three basic types: large studio models which are usually inappropriate in the field: 'professional' portable separate power pack units; and smaller self-contained amateur units primarily designed for mounting on the camera *via* the accessory shoe. Except in the cheaper models, the last two now invariably have some form of sensor for automatic flash. The more expensive amateur units are almost as powerful as the two-piece units and, in their more specialist forms, as produced by several camera manufacturers, can be linked together to provide sophisticated lighting set-ups.

The best flash units for the bird photographer are the more powerful professional types with a separate power pack and the ability to use one or two extra flash heads. Such flash units are now very expensive and, with the modern tendency to put all controls on the flash head rather than on the power pack, they are getting less convenient to use. The ideal flash unit is one with a rechargeable power pack with sufficient capacity for 200 flashes to three flash heads and with the on/off and halfpower switches on the power pack, so that it can be controlled from within the hide. Such units were made by Braun and Metz a few years ago but, with the present accent on convenience for 99% of the photographic world, the controls have now been put on the separate flash heads. We have, therefore, had to resort to modifying some modern flash units so that they are more convenient to use for bird photography. We have personalised two systems. The simplest modification was to replace the battery pack in two Vivitar 283 units with pieces of wooden dowel rod of the size and thickness of the batteries. Metal ends (drawing pins) were attached to the dowel ends and wired up to an external 6 volt rechargeable battery that can be switched on and off in the hide. Our second customised unit is much more complex. We have a power pack, recharge-

Night heron at nest. Frequently the background is brighter than the bird and exposure, according to the meter, gives an underexposed subject (see left). In this case, the air was hazy and the front of the bird is light-coloured, so 1 stop extra light gave a correct result (below), though in more extreme lighting, greater compensation would be needed.

(Right) Lapwing at nest, photographed into the light to give an attractive appearance and fill-in flash (at about 1 stop less than the natural light) was used to light the front of the bird and add a catchlight to the eye.

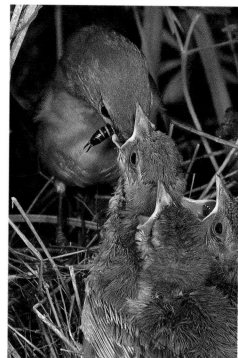

(Far right) Garden warbler feeding earwig to nestlings. The nest was in a dense nettle patch and two flashguns were necessary to light the scene adequately. The high flash speed also allowed this moment of action to be captured sharply. (See also pp. 77 & 78.)

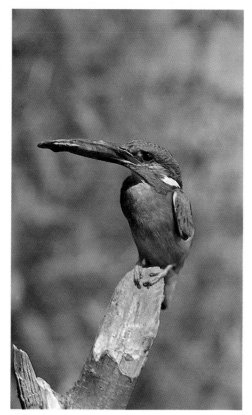

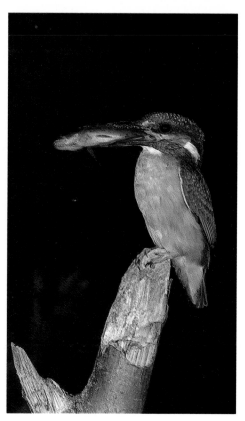

These two pictures of a kingfisher are taken in different ways: the right hand one was taken on 200 ASA film using daylight as the main light source, with some fill-in flash, allowing the background to appear natural; that on the far right was taken on Kodachrome 25, lit wholly by flash to stop subject movement. The background does not register at all, giving an unnatural picture, despite the greater sharpness of this film.

able from mains electricity or the car cigar lighter socket, comprising four 6 volt batteries and electronic circuitry to provide the correct voltage for the mains input socket on four separately switched Olympus T32 dedicated flash guns. The Vivitar units are either linked together with flash extension leads or used with a small slave triggering unit. The Olympus units are linked to an OM2N with their special cables to provide auto off-the-film metering of the flash. Both systems work well on auto, the Vivitars providing enough power for f.8 at 1.5m with 50 ASA film, and the Olympus set-up at any aperture from f.4 to f.16 on the same speed film. Both are used with the telephoto attachments to the flash heads, which considerably increases the light over the small area being photographed. If you are thinking of adapting your flash equipment, then it is as well to remember that any modification will invalidate the manufacturer's guarantees, and any work on the flash units should be done by a competent electronics engineer, since the capacitors even in small units can be extremely dangerous. We modified our electronic flashes to give us enough battery capacity for a 4–5 hour stay in the hide. With units where the on/off switch is combined in the flash head, these have to be switched on before going into the hide and left on the whole time, whether they are being used or not. This is expensive on batteries and most small units run down quickly, limiting the useful stay in the hide to about 2 hours. If you do not modify your flash equipment for greater capacity, then we would suggest using rechargeable Nicad batteries, which, although initially more expensive to buy complete with charger, work out much cheaper in the long run.

We normally use a separate slave unit (see Chapter 1) on the second independent flash, and, if a third flash is used, link this to the slave with a small 3-way flash connector. Most of our flash failures have been traced to breaks in these extension leads, so spare leads should be carried in the kit. It is best if the leads are about 2m long and of the simple straight variety; the coiled telephone cable type exerts steady pull between flashguns and can pull them out of line. Take care when directing flash units at the nest, especially if the angle-narrowing attachments are being used. Stand behind the flash unit and carefully sight it at the subject. Do not try to do it from the camera position. The light beam with the telephoto attachment is very narrow and it is easy to miss the area being photographed. Some flash units now have these angle-narrowing devices built-in as parts of the reflectors and should usually be set at the telephoto setting to give a faster recycling time or a smaller aperture.

BIRDS AWAY FROM THE NEST

General points

Birds are very mobile creatures and the first impression is that trying to photograph them away from the nest will prove extremely difficult. However, birds do have very specific requirements which often result in very set behaviour patterns and habits. Knowing these goes at least halfway to getting near enough for worthwhile photographs.

One of the easiest set patterns of behaviour to exploit is the route a bird takes in order to feed its chick; many birds regularly take the same pathway to a nest. Small passerines often hop through the vegetation, landing within a few millimetres of the same place each time. This is how the photograph of the pied flycatcher (p. 90) was taken. At other times, one can put a hide near a small patch of mud and wait for waders to come to feed. Here you can weight the odds a little more in your favour by studying local bird reports for likely sites and dates. At the right time, say in November, a hide placed near a suitable patch of mud will provide picture opportunities during a comparative slack time in the bird photographer's calendar. During the winter, when there is a spell of hard frost, any area of open water or mud presents first-class opportunities for a well-insulated photographer. Great care should be taken when siting hides on the coast and tide tables need to be carefully studied. When photographing waders, one of the best places to be is where they come to roost for the period over high tides. Careful

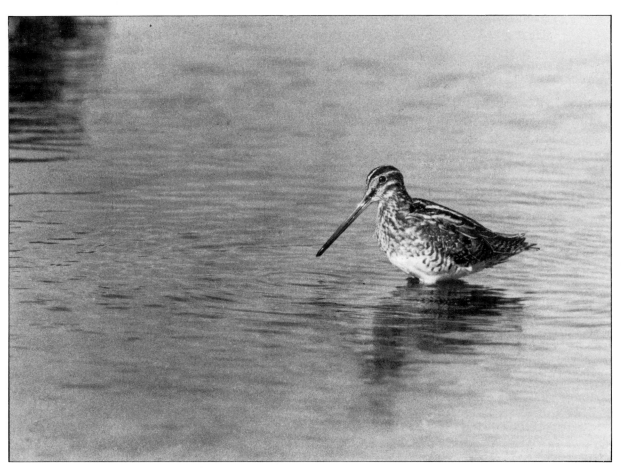

Snipe feeding in shallow water. Well-sited permanent hides, now found in many reserves and refuges, allow ample opportunity for this type of picture to be taken, providing you have a telephoto with a focal length of 300mm upwards.

observation is needed to select the right place to site a hide. Setting-up the hide should be done several hours beforehand and, ideally, it should be in place for one or two tides before the one chosen for photography. The effects can be watched from a safe distance – and the hide re-sited if necessary for greater safety or better view. Medium to high tides are best, as the very high tides often cover all available roosting areas on the shore and the waders have to fly inland for the few hours over high tide.

Food is, of course, a great attraction. Baiting an area in front of the camera has been tried with great success for all kinds of birds, from raptors to sparrows. A dead rabbit, well displayed and unobtrusively pegged down on a grassy slope in upland areas, will attract crows, ravens and, if sited in a buzzard's territory, may well provide a chance to get some striking pictures of one tearing at the food. It may be necessary to bait an area for several days or weeks beforehand and, as always, careful preparation will increase the chances of getting good photographs.

For taking photographs of birds away from the nest, the garden is easily the best place to start; not only can the exact place be kept well baited but the birds are often much more accustomed to people and tend to be less wary of photographic equipment. In a garden, a hide can often be dispensed with and photography done from a garden shed or a suitably screened kitchen or lounge window. Photography through glass is not recommended, though opened windows during winter need the co-operation and tolerance of other members of the family.

We have used a greenhouse as a hide now for several winters. Three sheets of glass are taken out between two uprights and thin plywood with suitably cut holes for lenses substituted. A bird table nearby is kept well

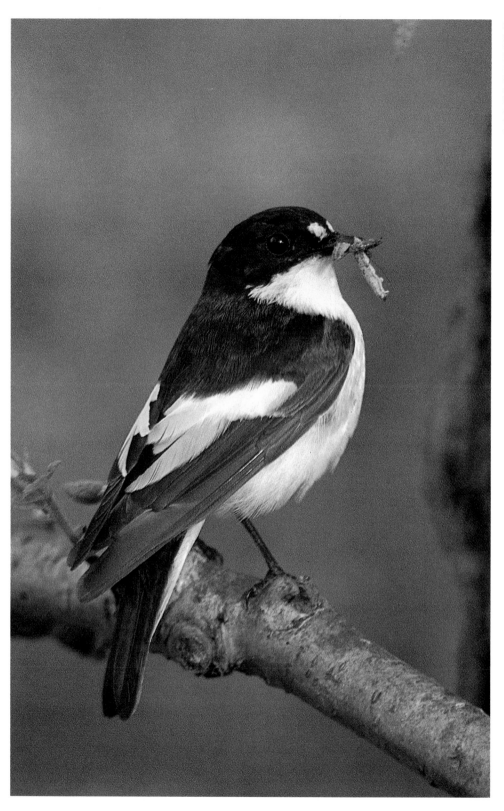

Male pied flycatcher, photographed on its way to the nest, using available light to give a pleasing natural effect (though causing a high percentage of failures through blurring). The camera could be pre-focused as the bird invariably followed the same path to the nest.

(Right) Dipper photographed on a rock in mid-stream, on its way to the nest. The perch was provided by the photographer, as previously the bird was flying straight into the nest with no opportunity for photographs.

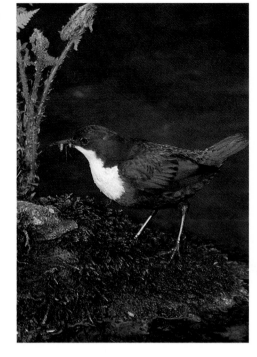

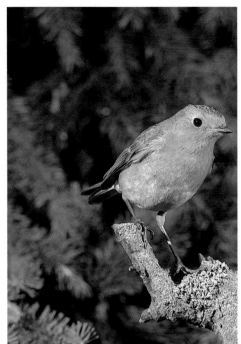

(Far right) Garden birds provide endless opportunities for photography. This robin was photographed on an especially-provided perch, using flash, from a greenhouse as described on p. 89.

supplied with food. During the course of a winter, at least ten species can be photographed, and many more in favourably located country areas. Photography in the garden need not be confined to winter, since during summer, water can be a great attractant, especially if it is safe for washing and preening in. A small shallow pool half a metre or so across can easily be constructed, and the edges lined with moss, leaf mould etc.

Photographing at home gives one a much better chance to put food in the right place and arrange a suitable background of greenery. If your garden is not in a suitable area, try to get permission to bait a stump regularly in a local wood or spinney. Woodpeckers and nuthatches soon get used to coming to a regular food supply and a hide is easily introduced. There are other ways of bringing birds closer to the camera. We have seen some excellent pictures of a marsh harrier which kept coming to a specially provided pile of cut reeds, which it used for nesting material. Try hanging a string bag full of feathers and fluff in your garden early in spring. You won't get marsh harriers but you will get all the local sparrows! Providing a suitable perch where none is available can

often bring surprising results and it increases your chances of bringing birds into your viewfinder.

Photographing birds away from the nest needs a slight change of tactics. Usually flash cannot be used, so a faster film is recommended. Unless you are photographing large birds, such as ducks and swans, you will also need a lens of about 300mm since you will be photographing from further away than if you were photographing at the nest. This is because the bird has not got the same incentive to come and stay in the field of view if your lens and hide make it nervous, as there are usually other similar places to which it can fly. Consequently, you have to work that much harder and be that much more unobtrusive.

Stalking birds

Stalking birds is like stalking large mammals – you have to put in a lot of time and effort for very little return.

Automatic metering cameras are an advantage, since if you are close enough for worthwhile pictures then any extra movements of the hands can put a nervous bird to

flight, and you will not want to be changing shutter speeds at the same time as trying to focus and keeping the camera steady. For stalking birds, the longer telephoto lenses from 400mm upwards are the most useful.

A lens in the 400–600mm range will need some sort of support since they cannot be hand-held for really sharp pictures, except in the brightest conditions with a fast film when a shutter speed in excess of 1/500 second can be used.

Some hints

Wear dull clothes, not necessarily camouflaged, and dull down all bright parts of your equipment. If you intend to specialise in this branch of photography, it may be worth paying the extra for a black-bodied camera. Darken your face for really wary subjects. The face is often the brightest area of a stalking photographer and it is the first thing we notice if people are wearing dark clothes, so other animals must notice it too.

Keep arms close to the body to present as small an outline as possible and try to keep all hand and arm movements within the body's outline. Move slowly and smoothly; sudden jerky movements soon draw attention – stop moving if your subject stops, moving on only when it starts its activity again. Try to move towards your subject from behind if it is intent on feeding, for although most birds have a wide range of vision, coming from behind often gives one the best chances. You will have to make best use of creeks, hummocks and bushes, always trying to keep some cover between you and your subject. Never peer over the top of a bush or rock – always come round the side, so that your outline never appears on the skyline. Unlike stalking large mammals, it is seldom that one can approach birds without their being aware of your presence; it is often a matter of presenting a moving shape of an unrecognisable human outline.

Birds, like mammals, have a definite human tolerance distance which varies for each species and, within narrow limits, between individuals. Once you trespass inside that limit, the birds will move off. For example, on open coastal salt marshes, curlews will flush at 70–90m, but skylarks in the same habitat will flush at 20m; usually the larger the bird, the greater the flushing distance. If a bird tolerates you much closer than you would expect for the species, then it is probably either sick, injured or exhausted after a long migration. It is often best to stalk birds either in a line of bushes or reeds or along a shore line. Here the birds will move away in one direction and can more easily be followed and kept in focus. The means of holding and supporting the camera have been dealt with in Chapter 1. Generally, for stalking birds, we find a rifle-grip to be the most useful and flexible.

BIRDS IN FLIGHT

Here we are discussing the technique of photographing birds in flight using a hand-held camera and not the methods using sophisticated electronic devices. Photographing birds in flight must waste more film than any other forms of bird photography,

It always pays to have a camera and telephoto ready for use, set at roughly the right settings for action. This Indian common mynah was taken with a 300mm lens one early morning in a Himalayan village.

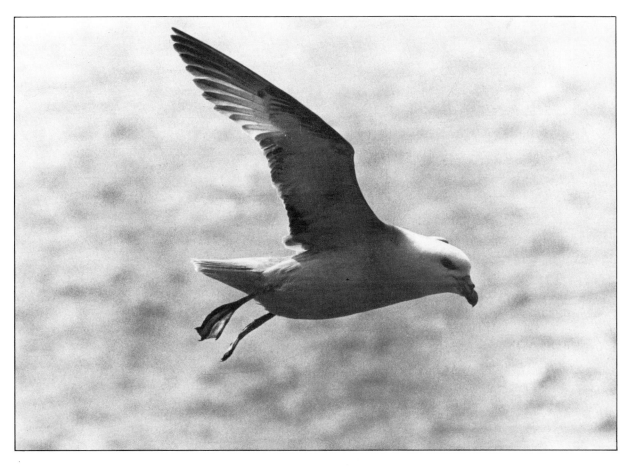

Fulmars fly by interspersing periods of flapping with periods of gliding, making them relatively easy to photograph, especially at breeding sites where their flight patterns tend to be regular.

but we hope our suggestions will minimise the expense on film and lead to a higher percentage of acceptable results. Opportunities to photograph birds in flight do not occur very often. The best places to try are at nesting colonies of seabirds, at feeding sites, such as waste tips and fishing harbours, or in migration corridors, such as Hawk Mountain, in the Appalachians.

The main causes of poor flight photographs are: subject out of focus, blurring due to subject movement, wrong exposure and poor lighting. The first two can be helped by spending time observing your subject and correctly choosing the shutter speed and lens. Let us take a typical example of trying to photograph gulls flying around their sea-cliff nesting colonies. Before you start taking photographs, sit and watch the birds' flight paths. You may even be able to concentrate on one individual. It will soon be apparent that there are some birds passing by regularly, at approximately the same distance

from you. This will help with choosing the correct telephoto lens, if you have several, or choosing the best focal length on a zoom. For this sort of photography, we have found focal lengths of between 105mm and 200mm much the best and, if we had to make do with one, we would choose the 135mm. A common mistake is to try and get too large an image. The aim should be to get the bird filling a third of the length of a 35mm frame; only exceptionally will you have the chance to do better than this.

Having fitted the telephoto, try some practise runs without exposing. First, prefocus on what you think is the correct distance, then pick the bird up in the viewfinder as it comes towards you and follow it, adjusting the focus if you can. If the bird is moving too fast you will not have a chance to adjust the focus, but you will be able to see if your prefocusing was correct; if it was not, refocus and try again. Eventually you will get the bird in focus, as well as having an idea of

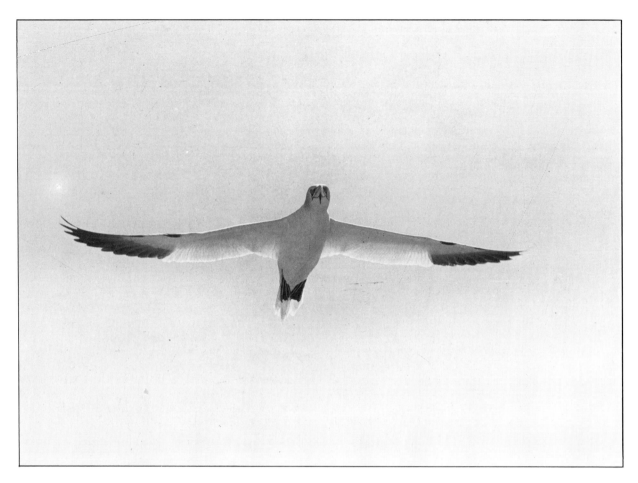

when to time the exposure to avoid any obstacles such as radio masts, buildings or trees. Next time round, take your picture by pressing the release just before the bird is in focus and in the correct position. Because of the time lapse between pressing the release and the shutter firing, if you wait until you see the bird in focus, it will be past the best point before the exposure takes place. Do not stop panning round to fire the shutter, but press it as you follow the bird. There is a tendency with an SLR camera to stop panning when the screen momentarily blacks out as the mirror flips up and back; this 'blink' in the viewfinder should be disregarded and the panning carried smoothly through. We have tried a rifle-type grip to support the camera whilst panning but it takes a lot of getting used to and we think it more natural to hand-hold the camera normally.

You will usually need shutter speeds of 1/250 second or faster, so you will need a fast film, but in good lighting conditions 100 ASA films are adequate. Try to avoid really fast films since backgrounds are often plain and the grain becomes obtrusive. How much of the background is recognisable under these circumstances depends on the shutter speed and how fast you have to pan the subject. The slower the panning and the faster the shutter speed, the more detail there will be in the background. You must develop a sense of timing, hence the advice to have some practise before exposing. Some birds, such as fulmars, have a 'flap, flap, glide' style of flight and you will soon learn to expose during the glide. The fulmar is an excellent bird to start with and is common on most bird cliffs in Britain. If you are photographing on top of the cliffs, be very, very careful as it is only too easy to be so engrossed in photography that you wander very near the edge. Other sea bird colonies present slightly different problems; auks seem to hurtle by

Gannet in flight, photographed head-on, using the techniques described. The similar tones of the plumage and the sky in this instance obviated the need for exposure compensation.

but they also often keep to fairly rigid flight paths and provide endless opportunities, but your reactions will have to be quicker since they move much faster than soaring gulls. A much faster shutter speed is needed too, since they fly quickly and have rapid wing beats – 1/500 second is too slow to stop the wing tip movement of puffins and 1/1000 second is better. A few cameras have a top shutter speed of 1/2000 second and this is one of the few times in natural history photography when this high shutter speed can be used with advantage. However, if you choose a windy day, there will be places in the flight path where even puffins will glide by on outstretched wings. If you are lucky enough to visit a gannet colony, then you will be sure of some excellent chances for good flight pictures of these large birds. Usually, you will have a choice of viewpoint, so you can take them from either below or above. In stiff breezes, gannets will sometimes hang in the air without moving and, as with gulls, such chances should be made the most of.

Not enough attention is given to the lighting of flight pictures. The best times for in-flight pictures are early and late in the day when the under side of the bird is well lit, as the upper side usually gets plenty of light anyway. If you are photographing the bird from below, as is often the case, then you must allow $\frac{1}{2}$ or 1 stop more exposure since the background of bright sky over-influences the camera's meter and, without adjustment you will get a dark bird against a correctly exposed sky. If you take flight pictures early or late in the day, the chances are that the exposure of the under side of the bird will more nearly approximate to that of the sky and both will be correctly exposed.

You do not have to go to exotic places to photograph birds in flight. Often there are two or three species of gull on ornamental public lakes that only need a few pieces of bread to attract them within range of the camera and here one has the chance to pre-select the viewpoint and often the flight path. The chances are usually much better in winter when there are few other chances of flight photography. You can also try baiting and waiting. We have seen some excellent photographs of sea eagle in flight taken at a large fish-breeding pond regularly baited in winter with dead fish. So, there is no short-age of opportunities, especially in wetland and coastal areas, and successful results will amply repay the effort expended.

4
Insects and Other Invertebrates

For many people, the word 'insects' sends shudders down their spine, while the word 'invertebrates' means nothing at all! Yet the invertebrates as a whole (which include the insects) are the most dominant and abundant form of animal life in the world with literally millions of species, many of them still undescribed.

Because of the basic similarity of approach required for all these species, we are including them together, though most people tend to concentrate on the insects rather than other non-insect invertebrates, such as spiders, millipedes or woodlice. The insects are generally six-legged and have two or four wings, while the other invertebrates that we are concerned with here have eight or more legs and no wings or – in the case of molluscs – none of either. The insects include butterflies, dragonflies, moths, beetles, bees, wasps, flies and bugs, while among the other invertebrates are, for example, scorpions, spiders, centipedes, mites and snails.

PHOTOGRAPHY IN THE FIELD

The range of photographic possibilities is enormous and we find it one of the most challenging and rewarding branches of photography. All insects are small, but there is a tremendous difference between, say, a pair of mating butterflies on a flower, a mosquito laying eggs in a pond and a tiny velvet mite on the garden wall, and each requires an individual approach. Most people come into insect photography through 'having a go' at butterflies in the garden, but many will soon broaden their range to include dragonflies and damselflies, grasshoppers, crickets and any other large or spectacular species. Eventually this may lead on to the smaller

species in all stages of their life-cycle and then there really is a wealth of possibilities all the year round.

Until recently, most insect photography concentrated on portraits showing one insect at its best. Nowadays, however, there is a tremendous interest in all aspects of insect behaviour – mating, egg-laying, courtship, feeding, flight and so on – and the advent of higher speed flashes and better macro lenses has opened up many possibilities. Consequently, many fine and highly informative pictures of insects have been taken in recent years.

Photographing insects and their relatives can take you into a whole new world of close-up beauty and we hope that this chapter will stimulate a few more people to get out and take up the challenge.

Special equipment

The equipment for photographing most insects is relatively simple, since it all has to be carried and held by hand, though there are various special items for special circumstances. The basic equipment is an SLR with through-the-lens metering (see p. 12), a macro lens or other close-up equipment, one or two electronic flashguns and a bracket to put them on (pp. 104–8). It is helpful to have a macro lens of about 100mm focal length (e.g. the Nikon 105mm micro, the Tamron 90mm SP macro, or the Olympus 135mm macro) though a 50mm lens will do and, even with a 'macro', you will be glad of extra extension tubes. An autowinder is very useful to avoid moving your hands while working on a subject, though it adds to cost and weight, and, if you have interchangeable focus screens in your camera, select one recommended for close-up work rather than the all-purpose one fitted as standard. For

daylight work, a rifle-grip will be very useful, whilst a tripod is only occasionally useful, e.g. with immobile subjects.

There are advantages in working with bellows and bellows-head lenses for insect photography since their range of magnifications is very wide without the need to stop and add or remove anything, e.g. from $2\times$ to $1/10\times$ life size or more with a long set of bellows, which allows you to go directly from mosquitoes to lizards, should the need arise! More bellows are now genuinely automatic and these are ideal, though a double cable-release system makes a moderately good substitute.

Techniques

There are various special techniques required to photograph insects successfully. The main requirements are to get close enough to the subject, to stop subject movement, to get adequate light and to make the best use of the depth of field. Refinements include good composition, a good background, an unusual behavioural activity as subject and attractive lighting to show the particular insect at its best. Although they are all small, insects and their allies vary enormously and some different techniques apply to each. Each of the major groups is referred to where a special technique is demanded or special opportunities present themselves.

Getting close enough to the subject

There is one question that we get asked more than any other about insect photography and that is: 'How do you get so close? When I try to photograph insects, they fly away!' There is no doubt that this is one of the major obstacles to successful insect photography for many people and all the other techniques become irrelevant if you cannot get close enough to the subject.

There is an enormous variation in the approachability of insects, not only between species but also between different individuals, and according to the time of day, weather conditions and many other factors. There is no guaranteed way of approaching any one individual insect – all you can do is increase your chances of success and make the best of the opportunities that you do get.

Insects' eyes consist of numerous separate light receptors and most of them are best able to detect movement across the field of view rather than detail of form. Although they are sensitive to colour, albeit in a rather different way to us, they are not seriously affected by the clothes you wear, except that they are more likely to respond to very light-coloured clothes, though again it depends on the insect.

It follows, therefore, that the best way to approach insects is slowly and steadily in as straight a line as possible. To do this successfully, you need to decide on your angle of approach while still well away from the insect's 'panic' zone and then approach directly from there. When getting close to the insect, it is advisable to ensure that your feet are in a position suitable for crouching, bending or whatever will be necessary for a good picture – if you have to move your feet at the last minute it often scares the insect away. There will, of course, be occasions when an insect changes its position during your approach; it may then be best to move round once you are close enough, or start again if you are sure that it has settled.

Frequently, once you get very close to an insect, they will cease to regard you as a threat, but you need to take great care not to move your hands or the camera too jerkily. It is easy to relax at this stage and forget this; the commonest problem is when winding on or refocusing, and it is at this stage that an autowinder can be so useful since no movement is necessary. Always remember to set the focus as near as possible to what you will want before you start to get close, using an object of similar size to get it roughly right. It pays to have a spare extension tube or two with you in case you are wildly wrong, though you may not get the chance to change them over. There will be times when you get close to an insect but find that it is too far into the bush or out on the water to get as close as you would like without causing disturbance; a useful point to remember here is that you do not need to have your eye to the viewfinder to focus; we have often taken difficult pictures with the camera held up to half a metre in front of us – you can still focus by what you can see in the viewfinder aperture, though the composition is occasionally

a bit awry! If you are using available light rather than flash, you have to be aware that some cameras' meters respond to light entering back through the viewfinder; off-the-film metering is best in this respect.

Two other points should be borne in mind; try not to cast your shadow over an insect – this will cause it to either fly off or alter its position; and try not to breathe too hard on your subject when you are close up – they will not like it, regardless of whether you have cleaned your teeth or not!

It is often suggested that it is wise to take 'insurance' shots of an insect as soon as you get within reasonable range but before you are as close as you would like to be. This must depend on your personal requirements, but we have concluded that this is often a waste of time and film. If you must have a picture of a particular insect, and it is your only chance, then take insurance shots; otherwise, consider whether you really want lots of second-rate pictures and what you will do with them when you have them. It may be

Butterflies do not always have to be taken from above! We decided that this dingy skipper *(Erynnis tages)*, resting on a chalky bank, might look better from below to show its proboscis, hairy face and underwings. 1:2.

The difference between using electronic flash and daylight for insect photography can be striking, though it may be minimised by good technique and appropriate choice of subject. In this pair of pictures, the one above was taken in available light and it is generally much more attractive, though noticeably less sharp, than the one below, which was taken with twin electronic flashes at a smaller aperture. Golden-ringed dragonfly *(Cordulegaster boltonii)*. 90mm macro lens.

The larger spiders, such as this striking *Argiope bruenichii* can be taken by available light if they stay on their web. This was taken near the coast on a very windy day, so the camera was set up on a tripod while a coat was held to shield the subject. The picture was then taken without the need to look through the viewfinder when the wind was at a minimum. 1:2.

best to concentrate on getting just a few really good pictures. If you do get really close to an obliging individual insect, then make sure you make full use of the chance and take all the angles and magnifications that you ever wanted to take! One final point, that may seem obvious but is often overlooked: make sure that you have more than one frame left before stalking an insect, imagine taking that second-rate 'insurance' shot, only to find that it was the last frame of the film and the rest is back in your bag!

Lighting

Natural light
Sadly, there are considerable difficulties involved in taking good pictures of insects by

Even very small insects can be photographed in daylight at about life size (1:1 magnification) if they are on the ground, by supporting the camera on a bean-bag and adjusting its position as necessary. The photograph (left) of a wood tiger-beetle was taken in this way without flash. The lens is an 80mm bellows-head lens mounted on a variable extension tube.

Wood tiger-beetle (*Cicindela sylvatica*) photographed at life size with the set-up shown above, using available light only. 1/15 second, at f.16.

available light. Almost all insects move, often rapidly, and thus a fast shutter speed is required, and even if they do not, then a fast shutter speed is needed to stop camera shake at high magnifications and extensions. In addition, insects have a surprising depth to them, even butterflies with their wings folded (their antennae branch out in a different plane), and this means that a relatively small aperture is required to get enough in focus.

In essence, it depends on your priorities and what is most important to you in a picture; for example, some people would prefer an attractive natural-looking picture taken in sunlight, albeit not fully sharp, to a pin-sharp picture taken by flash, and one thing that you can rarely do with flash is to backlight the subject, except in the studio.

Nevertheless, despite variations in personal preferences, available light pictures are really confined to pictures of the largest insects, especially butterflies and dragonflies. Both of these groups can make excellent natural light subjects if taken with care.

The problem of stopping subject movement has to be solved by using a shutter speed of at least 1/125 second, preferably faster; a tripod is extremely difficult to use in practice except with very still subjects or with 'wait-and-see' photography (below), since it is almost impossible to get the camera into the right position without disturbing the insect. A monopod or rifle-grip is a useful aid to reducing camera shake at speeds down to 1/60 or 1/30 second, though it is relatively rare to find a subject that will not move during this period, so these aids often do not help, except when you are using a long or heavy lens.

The best way to use available light is to look out for chances that really make use of the natural lighting. If you are trying to use it just to give sharp close-up portraits, then you will almost certainly find that flash techniques are more successful. So, look for the butterfly backlit by the sun, or the dragonfly on a perch with sunlit water behind, or the mating pair of butterflies framed by flowers, and take these instead. The best thing to do is put a medium speed film in your camera (50–100 ASA), fit a short telephoto with an extension tube or a 100mm macro lens, put the whole lot on a rifle-grip and start looking

for subjects. Remember that it does not always pay to go in really close, especially where the surroundings can contribute to the picture and its atmosphere. Good pictures of insects in their habitat are very rare, largely because so many people use flash.

It is also possible to carry out some 'wait-and-see' photography by natural light and our favourite subjects for this are the dragonflies. Most larger dragonflies are territorial and will maintain a definite beat, returning time after time to one spot. Within this area, they will have definite perches from which they make forays or stop to eat prey, and if none are suitable, try providing one. Set up your camera on a tripod and fit the appropriate lens to give you the field of view you want. We find the Tamron 300mm SP lens and also mirror lenses are ideal in this respect since they focus so close. You then wait until the insect returns to its perch and you can start taking some excellent pictures. If necessary, it is not difficult to use fill-in flash, but do not use flash as the main light in these situations or you will waste the natural setting. A similar technique can be employed for butterflies on favoured foodplants, or other insects on flowers such as hogweed and angelica. You can try putting bags over other flowers in the area to concentrate the insects on your target flowers, but do not do it for too long and never leave them on.

Flash

'I hate using flash for insects because it makes the pictures look as though they are taken at night.' How often we have heard this lament! There is more than an element of truth in it, yet the opportunities for superb pictures taken by flash are endless and, in most cases, there is no need for the result to look anything but natural (pp. 98, 102, 107 & 110).

Modern electronic flash has various excellent advantages in insect photography – and a few disadvantages, most of which can be overcome – and we urge you to give the techniques outlined in this section a fair try. Many early flash pictures of insects, and indeed many pictures taken today using poor techniques or equipment, are visually disappointing, showing a rather over-exposed insect, often with very bright highlights, against a black background. Techniques

(Far left) Occasionally even butterflies become too involved with other things to worry about photographers; this gives the chance of a more pictorial approach using available light, such as was used for this mating pair of small white butterflies *(Pieris rapae)*.

(Left) Most insects, especially larger ones, are inactive on cold, dull days, though they are then usually difficult to locate. Once found, they can be treated as static subjects, using available light, and a tripod if required, as was this marsh fritillary *(Euphydryas aurinia)* feeding on a thistle on a cold June day.

Ring flash can be used satisfactorily for very small non-reflective subjects, such as these tiny spiderlings of the garden spider *(Araneus diadematus)*. Though flat, the ring lighting is perfectly acceptable for this type of picture and is easy to handle, with no danger of projecting flashguns touching the web or vegetation. 2:1.

Pictures taken by flash can look satisfyingly natural, even when taken rapidly in the field – e.g. this large skipper *(Ochlodes venatus)* feeding on a thistle – if the guidelines given in this chapter are followed. Twin flash on bracket.

have not, however, stood still and it is now quite possible to make the majority of your flash pictures of insects look as though they were taken by natural light, except that they will be sharper and better!

The great advantages of flash are: you can use as much or as little light as you require, the flash duration is so short that virtually all movement is stopped, and you can put light onto whatever part of the subject you like. In effect, therefore, you can take pictures at f.22 at 1/2000 second in ideal light, which would be impossible by natural light. The disadvantages are: your subject may be better lit than its background; you overpower any pleasing effects of the natural light; you have to carry the flashguns and accessories around with you; and there is a danger of your pictures becoming too standardised. In most cases, though, and especially with smaller insects, it is well worthwhile making the effort.

GENERAL CONSIDERATIONS Getting successful results with flash does demand a good deal of thought and time, as well as a certain amount of flexibility of approach. Most

books tend to suggest mounting your flashgun(s) on brackets and going out to try your luck, but in reality it is much more subtle than this, and good preparation and choice of equipment can make all the difference. The main factors to consider are:

a) Light from a source such as a flashgun (or indeed the sun) decreases by the square of the distance, e.g. the light at 2m will only be a quarter of that at 1m from the source. With a powerful distant source of light, like the sun, another few metres from the subject to its background makes little difference and both will be equally lit; in contrast, for a small flashgun placed 10cm from the subject, a background 50cm away will receive only one twenty-fifth of the light reaching the subject and hence it appears dark. If, in the same situation, you used a more powerful flashgun placed 50cm from the subject, then the background would receive a quarter as much light and this would show up on the film, albeit rather darker than the main subject. So, the power of the flashgun is important, and its distance from the subject.

b) The flashgun will become the dominant light source in most flash pictures and the existing light will not show up at all. Therefore, you need to imagine that you are lighting the subject with, say, torches in the dark and that your light sources will cast strong shadows. They will usually be harsher than sunlight shadows since the light has no chance to bounce off clouds, sky, leaves etc. on the way to the subject. In many cases, you will probably want to reduce the shadows by using a second flashgun, preferably slightly weaker or further away than the main one.

c) The size of the reflector (i.e. the area of the 'window' from which the light is emitted) on the flashgun is important: a small reflector casts dense hard-edged shadows, while a larger reflector produces fuzzier, lighter shadows.

d) Diffused light is almost always better than direct undiffused light. The light from a flash can be improved either by putting muslin, white cloth or even paper over the 'window' or by bouncing the light off a card or dish reflector. The latter method needs a powerful flashgun as light is lost in the process. This softens the light, lessens shadows, may light the background better by widening the angle of the light emission and reduces glaring highlights off shiny parts, such as beetle wing-cases or dragonfly wings. The general effect tends to be more natural.

e) The angle at which the subject is lit is important, though not always easy to control. Direct frontal lighting, as from a ring-flash or front-mounted flashgun tends to produce flat lighting with poor modelling and rather distracting highlights, though it is perfectly satisfactory for small non-shiny insects. In contrast, extreme oblique lighting from one or both sides reduces reflections dramatically and gives very attractive modelling in most cases, except where there is a deep hollow on the front of the subject, e.g. in a tubular flower, though this is rare among insects and invertebrates.

It follows, therefore, that there is no simple solution to insect photography by flash, especially when you bear in mind that different insects demand different techniques and people vary in what they are prepared to spend, carry or look after. No one 'set-up' can give ideal results in all circumstances, so

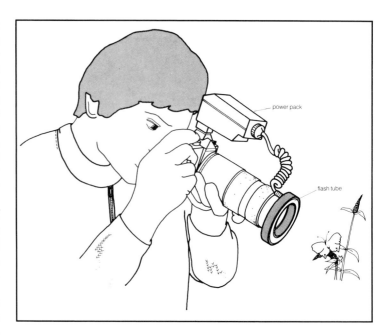

power pack

flash tube

we shall discuss some of the main ones and give their advantages and disadvantages. Some 'set-ups' are available commercially; others can be made up from bits and pieces.

Figure 4.1. A ring flash is very easy and quick to use, with no projecting parts, especially if the power pack is separated and mounted on the camera.

HOLDING FLASHGUNS FOR INSECT PHOTO- GRAPHY A few photographers, including some very successful ones, hold a flashgun in one hand and the camera in the other, aiming the light where it is required. This can be very flexible in terms of rapidly altering the position of the flash, but you are limited to one flashgun, it takes experience to handle the camera one-handed, and it is easy to mis-aim the flash whilst looking through the viewfinder. Most insect photographers have concluded that it is easier, and probably better, to mount one or more flashguns onto the camera, usually via some form of bracket. The main options are as follows:

1. *Ring-flash* These mount onto the front of the lens, and give very flat direct lighting (p. 26). The best types separate all the power pack and electronics from the flash-tube, so that they can be mounted separately in the accessory shoe or even in your pocket. Built-in modelling lights, available on some examples, are very useful if you go out at night to photograph invertebrates as long as they are bright enough to focus by. The light from a ring-flash is unexciting, though for

Photographing a small tortoiseshell butterfly *(Aglais urticae)* using the highly portable and convenient Olympus T28 macro flashes; note the separate power pack on the camera which lessens the weight on the front of the lens. This picture illustrates how focusing can be carried out without the eye to the camera, as described on p. 97

Pupa of cinnabar moth photographed at life size using ring flash. A ring flash is very convenient for subjects surrounded by foliage (which flash brackets would disturb) especially at close working distances, when the lighting becomes less flat.

subjects smaller than about 1cm long, it is perfectly good and can be improved by masking off bits of the ring and diffusing the light. The great advantages of ring-flash set-ups are that they are easy to carry, need no adjustment and have no projections to catch on vegetation or disturb your subject. If you are interested in very small subjects, especially mobile ones like wolf spiders, then ring-flash will suit you, but it is poor for larger subjects such as butterflies or dragonflies.

2. Front-mounted flash-gun brackets There are several types of brackets available that screw into the front filter-thread of the lens and allow one or two small flashguns to be mounted on very short adjustable brackets close to the lens axis. Olympus have produced a worthwhile derivative allowing just the flash tubes to be mounted on the brackets, while the heavier power pack stays

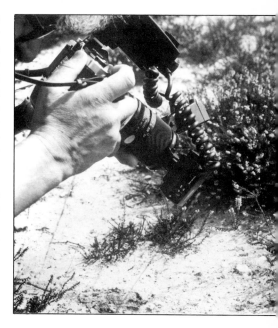

on the camera body. The effect of this sort of set-up is similar to ring-flash; it is more adjustable and flexible, and gives slightly better lighting quality, though it projects more on each side of the lens and is therefore more unwieldy and more prone to knock vegetation. Both ring-flash and front-mounted flashguns are easy to calibrate for exposure (p. 112), but both suffer from the length of time involved in changing lenses or putting on filters or close-up lenses.

3. Camera-mounted flashgun brackets These brackets screw into the tripod bush or the base of the camera and they take the form either of a straight or bent bar, or of a hand-grip which raises the flash above the base of the camera. They are generally cheap and have the advantages of being further away from the subject, thus lighting the background better (see p. 103), and they give rather better modelling since the flashguns are further away from the axis. Two brackets can easily be mounted on opposite sides and they can be angled forward to alter the position of the flashguns. They should either have swivelling accessory shoes or be fitted with 'bounce-flash' heads to allow for tilting and rotating. Some hand-grip types allow extra batteries to be used in the handle for longer life and quicker recharging, though of course these are also heavier.

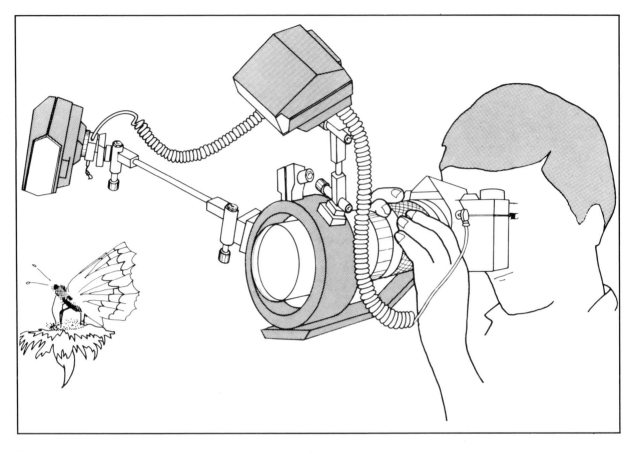

Figure 4.2. Using the Kennett Macroflash I, with two adjustable arms, to photograph insects. The encircling collar allows the flashguns to be rotated to the desired position and adjusted by the joints on their arms.

Robin Fletcher photographing insects using an unusual flash set-up (see p. 108) employing a single powerful flash with a large matt silvered reflector giving very soft natural lighting. In this set-up, the power pack is separated from the flash. The photograph of the oak bush-cricket (above right) was taken in this way.

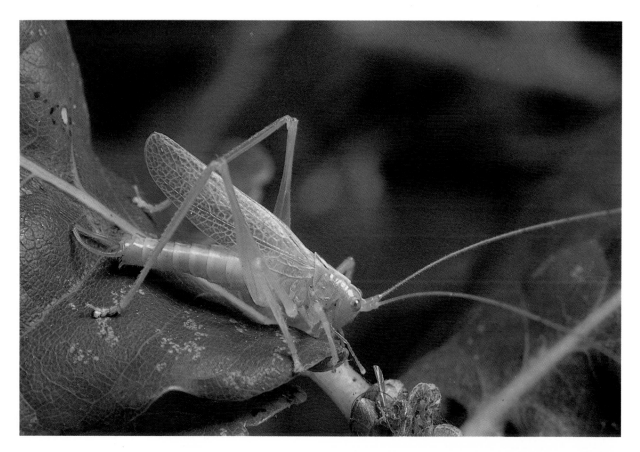

The pleasing natural-looking lighting for this oak bush-cricket (Meconema thalassinum) was obtained with a single flash set-up as shown below left and described on p. 108.

Photographing insects using the Kennett Macroflash 2 flash bracket, a versatile commercially available system, which gives very oblique lighting; excellent for modelling and reducing reflections.

Derivatives of this basic type are many and varied and most are homemade. A particularly useful and flexible type employs a long piece of wood or metal as the bar, extending on either side of the camera; the two flashguns are attached to each end of this by flexible metal arms purloined from microphones or lamp stands, readily available as spare accessories. Such brackets will not hold heavy flashguns so you can either use lightweight units or detach some flash tubes from their power packs and electronics and mount them separately – as we have done. We would stress that this should only be done by knowledgeable electricians since flashguns are highly dangerous and may emit high voltages. This system is readily and quickly adjusted for different subjects from strongly oblique lighting to direct frontal lighting, and the flashguns can easily be altered for more distant subjects should you chance upon a snake whilst working on insects. The system can be a little unwieldy though and difficult to use in well-vegetated situations, though to our minds, it is usually worthwhile carrying it.

A variation, used by a friend of ours, that produces beautiful results uses a single flash-head well to one side of the camera, behind the film plane, with a very large circular matt reflector. The power pack is carried separately. This gives beautiful soft shadows so that the whole effect is highly natural yet still very sharp (see pp. 106 & 107).

4. *The Kennett Macroflash* We have considered this device separately since it has no close equivalent. It is a commercially available item designed specifically for insect photography by Tom Leach, a well-known British nature photographer specialising in butterflies and dragonflies.

The flashguns are attached to single or double-jointed arms (depending on your requirements), which can be locked into any position on a large ring that encircles your lens. This ring is not attached to the lens but to a bar which protrudes forward from the tripod bush on the base of the camera and the ring can be fixed at any point along the bar to give more varied modelling. Within its range, the system is almost infinitely variable and it gives very oblique lighting which is perfect for butterflies and dragonflies. The

system also provides for the addition of a third flash on a long arm to light the background.

Results are extremely good, with highly attractive lighting effects and very little reflection from distracting highlights. The system allows lenses or extension tubes to be changed without difficulty, though the whole set-up is somewhat unwieldy to use or transport and the ring may make focusing difficult on some lenses. The Kennett Macroflash 2 (Figure 4.2) dispenses with the ring, which reduces the flexibility slightly but allows the device to be used with a wider range of cameras or on cameras with autowinders fitted.

In addition to these basic types, it is also possible to make combinations to satisfy your own requirements, e.g. a front-mounted bracket with long adjustable arms. There is no ultimate answer, but we hope that the pros and cons discussed here, together with the illustrations demonstrating the different effects produced by each of them will help you decide. If possible, borrow or try out any system before buying it; some will simply not suit your style of working, while there are a few that do not seem to have been designed for photographers at all!

GETTING RID OF BLACK BACKGROUNDS
Whilst it may often be desirable to make your subject show up against a rather darker background, there are few people who like to see pictures of diurnal (day-flying) insects against a black background and these are best avoided whenever possible. Many flash pictures of insects do have black backgrounds and these have tended to give the techniques a bad reputation. The main techniques for improving the situation are:

a) Use a separate flash to light the background. This can be mounted either on an arm from the camera or somewhere on the photographer. It may be unwieldy but it can be very effective.
b) Use a more powerful flash further away from the subject. This has been explained before; generally speaking, if the flash is 10cm from the subject then the background will only be lit to about 10–15cm behind. If the flash is 1m from the subject, then the background to 1–1.5m will be lit. The pro-

blem lies in getting the flash far enough away and a compromise is usually necessary, though a telephoto lens helps.

c) Select subjects in situations where the background will be adequately lit. This is much easier with small subjects, since the subject and its immediate background will probably fill the frame. For larger subjects, such as butterflies, you need examples that are on large flower heads, amongst leaves or close to the ground; the worst are insects resting on isolated flowers or perches which will almost inevitably produce black backgrounds, unless you can use technique d) below. In many cases, it may simply not be possible to find a better example.

d) By using a long shutter speed and allowing the light from the background to register. There is no need to use flash only at the correct synchronisation speed – you can readily use it at slower speeds. This technique is only satisfactory, however, if the subject is not moving at all; if it is, it will show on the picture as a 'ghost image' next to the sharp flash image.

e) If you are lighting the subject obliquely rather than directly, it helps to use wide-angle flashguns rather than narrow beam ones. Some flashguns cover the equivalent of a 24mm wide-angle lens and these are ideal. If they are positioned so that the subject is at the inner edge of their spread of light, then they will light a wider area of background and therefore lessen (though not necessarily solve) the background problem.

MINIMISING DISTRACTING REFLECTIONS
Many otherwise good insect pictures, particularly amongst those taken with flash, are spoilt by the presence of highly distracting reflections from the light source. These are worst in dragonflies and shiny beetles. It could be argued that such reflections are natural, particularly if from sunlight, and are part of the insect's appearance. While this is true, it can still cause exposure problems, by giving too wide a contrast for the film to cope with, and often looks unnatural in a picture. Reflections from flash tubes can be very distracting and far from natural-looking, and it makes sense to try to minimise these by one of the following methods:

a) Working in diffuse available light. This would give ideal results if the subject did not move, but it is rarely practicable for active subjects. If you do find an inactive subject, such as a roosting dragonfly or a freshly emerged insect, it is worth trying this technique, preferably with a tripod, for superb results.

b) Diffusing your flashguns. If you place white cloth, tissue or paper over the reflectors of your flashguns, it will lessen the 'flashiness' of the resultant pictures, whilst losing only about 1 stop exposure. To improve the effect still further, you can bounce your flashguns off white card or plastic (available specifically for some flashguns, or easily made at home) or into a silver basin-shaped reflector, so that no direct light reaches the subject at all. This gives excellent lighting conditions but you will lose several stops so expect to work at f.8–f.11 or buy a very powerful flashgun!

c) Lighting the subject as obliquely as possible. More reflections are produced, in most subjects, by direct frontal lighting than by oblique lighting. If you mount your flashguns so that they come from as wide an angle as possible, this will minimise reflections. The Kennett Macroflash systems, using the long arms, were specifically designed with this in mind and they give excellent results.

Getting the subject in focus

This may, at first sight, seem to be the simplest part of insect photography, yet this is far from being the case. Before going on to look at the difficulties and techniques that exist, we would urge you to check that your eyesight is adequate (and if necessary fit a correcting lens to the viewfinder) and, if possible, change the focusing screen in your camera to one recommended by the manufacturer for close-up photography. These two factors will both make focusing much easier.

When you are working at close distances or high magnifications, your depth of field is very small indeed, even at small apertures. For example, at f.22 at $\frac{1}{2}$× life size, your depth of field is roughly 11mm whilst at f.11 it would be only 5mm.

Often you will need to work at larger apertures, especially in available light, and then the depth of field will be even smaller. It

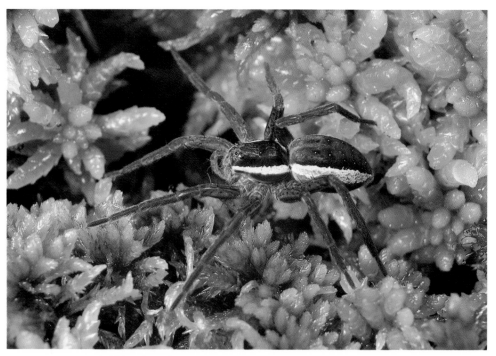

Spiders are often overlooked or actively avoided, yet they make excellent subjects; most have non-reflecting bodies, making the use of flash easier, and, of course, they do not fly away like most invertebrates. They slow down under cool conditions. Raft spider *(Dolomedes fimbriata)* in a bog. Twin diffused electronic flashes, f22.

The shiny, highly reflective surfaces of beetles are difficult to deal with using flash because of the multitude of reflections. For this shot of a minotaur beetle *(Typhaeus typhoeus)* rolling rabbit dung, we used two heavily-diffused flashguns mounted to light the insect obliquely rather than directly.

is very rare for the whole of your subject to fall within the band that is in focus and thus great care is required to ensure that the best use is made of the depth of field that does exist. As with all branches of natural history photography, the amount in focus is only one of the many interconnecting factors that you have to consider, and the following suggested guidelines may be overridden by other factors in many cases:

a) Make sure that the main axis of the subject

is parallel to the film plane (i.e. the back of the camera). This is generally good advice, particularly with butterflies where there is much to be gained by careful alignment, though it is a 'rule' that often needs to be broken for other reasons. Where you are dealing with a more three-dimensional object, such as a resting skipper butterfly, try to get the main plane of focus running through as many crucial parts of the insect as possible by varying the camera angle.

b) Where there is little chance of getting the whole insect in focus – e.g. a picture of a dragonfly from the side – make sure that the most obvious features are in focus, e.g. the eyes in a head-on shot.

c) Use the smallest aperture possible that is consistent with the effect that you want to achieve. There are times, as with plants, when a large aperture is most effective, but with the majority of insect pictures you will need an aperture of f.16 or smaller if possible.

d) You will rarely be able to preview the depth of field in field pictures of insects, so it is very useful to have an approximate mental picture of the depth of field at the main aperture you use, e.g. f.22, and to bear in mind that it extends to roughly half the figure on either side of the plane of focus, i.e. roughly equal amounts will be in focus behind and in front of the precise plane of focus.

Gauging the exposure

With available-light insect photography, the same principles apply as to flower photography (Chapter 2) and many other branches of photography and they need not be reiterated here.

With flash photography, however, the situation is rather different. Exposure determination with flash is likely to fall into one of two main categories: by manual flashguns, or by through-the-lens (off-the-film) direct flash measurement. As discussed in Chapter 1, 'computer-controlled' automatic flashguns are not very satisfactory for insect work or other close-up photography, though ones

Extreme close-ups of active insects in the field are not usually easy, but they are often very revealing when you can take them. This long-horn beetle (*Strangalia maculata*) was involved in feeding on the pollen of a dog-rose, allowing time for some very close pictures. Twin flash, 2:1.

with detachable macro sensors may be usable and they then follow the principles outlined below for TTL flash.

1. *Exposure determination using manual flashguns* Most people use this for insects and it is not too difficult, though there are plenty of potential problems. Fortunately, if you mount your flashguns on or close to the camera, then the increased light that they provide as they are moved closer is almost exactly cancelled out by the increased light required for close-up shots as the lens is extended away from the film. Thus, over a range from half a metre or so to extreme close-up, the exposure will always be constant for a particular brightness of subject. So, once you have set up your flash system, you have to calibrate for the particular film and lens combination that you will use. You can calibrate it by trial and error, basing your trials on the manufacturer's guide number for your flashgun(s), bearing in mind that these will be very optimistic for outdoor use. If you find that f.16 gave the right exposure for a combination of your flashguns with 64 ASA film and a 90mm lens, you can use this virtually constantly.

However, you have to bear in mind that this is a purely manual method of gauging exposure and it takes no account of the subject's tone, reflectivity and so on, and the same compensation will apply whether the subject fills the frame or is only a small part of it. Assuming that you calibrated your set-up for a neutral non-reflective subject, then you will have to stop down (use a smaller aperture) for brighter than average subjects and open up for a darker than average subject, especially light-absorbing subjects like bumble bees. You will also find that insects on a light background, such as a white flower, will be better lit by reflected light and need to be treated as somewhat lighter subjects.

Remember that changing the film type, or the flashguns, or the focal length of the lens will all alter the effective exposure. If you use a macro zoom, it may be useful to calibrate at several useful focal lengths and stick a table onto the flashgun to remind you.

2. *Exposure determination using through-the-lens (off-the-film) flash metering* Only a few cameras offer this facility, though it is rapidly becoming more popular and it offers many advantages. It is not, however, perfect for insect photography and still requires a degree of thought and control. Not only is the metering subject to the usual problems, such as a bright subject against a darker background (or *vice versa*), but this is exacerbated by the fact that the flash may produce a totally different result to that which you see in the viewfinder. For example, an orange butterfly on an isolated flower head will look beautiful in the viewfinder with an attractive mid-toned green background behind it – and there will be no apparent metering problems. But, the light from the flashguns is highly unlikely to reach the background adequately and, in the resulting picture (and to the meter, operating *during* the exposure), it will appear darker. The flashguns will therefore try to give out more light to compensate for this and will overexpose the main subject. This would not happen with manual flashguns since the light level is simply pre-set. Similarly, if you have a dark insect on a white flower, the meter will respond to the bright flower as well as the insect and will tend to underexpose the insect (in complete contrast to the manual method).

Nevertheless, for 80% of insect shots, TTL flash metering is perfect though we give about $\frac{1}{3}-\frac{2}{3}$ of a stop less exposure than indicated for all run-of-the-mill shots where the background is not going to be dark. For difficult situations, such as those above, you have to be aware of them and compensate accordingly using the compensation dial, bearing in mind that the larger the main subject is in the frame the less compensation is needed, since the meter will respond more to the subject than to the surroundings.

Photography in the evening or at night
Most insects are at their most obvious during the warmest and brightest daylight hours, and this is when most people do their insect photography. Surprisingly, though, photography in the evening or during the night can be highly rewarding, for two main reasons. Firstly, most day-flying (diurnal) species will go to roost in the evening, often well before the light is gone, and will in any case be much slower-moving and controllable. Secondly, a whole new range of insects

Many insects and other invertebrates only come out at night and they can be surprisingly tolerant of a close approach, even with a light. This lesser yellow underwing feeding on old man's beard (Clematis vitalba) was photographed late at night using twin flashes and a torch for focusing. 2x life size.

flash, so the techniques are broadly as already described, except that you can be much more flexible and treat the subject almost as if it were in a studio. It can be a simple matter, for example, to place a charged flashgun operated by a slave unit somewhere to light the background, or one to provide strong backlighting if desired. For once, time is likely to be on your side and you should make the best use of it.

Insect photography at night is quite a different matter, but it can be a lot of fun. Choose an area of good wildlife habitat with plenty of nectar-bearing flowers (especially white, scented ones), preferably well away from lights. The best way to look for subjects is to use either a miner's type of headlight, to leave your hands free, or to use a ring-flash with built-in 'modelling' lights that can be used as a torch. The latter is better if you have it, as it lights the subject very clearly when you are focusing and photographing, whereas a headlight may be more difficult.

You will find subjects almost everywhere, as much of the invertebrate world comes alive at night, but the best places are highly scented, pale flowers that attract night-pollinators. Moths will be the most obvious examples, but there are many beetles, ichneumons, flies, spiders, centipedes, molluscs and other invertebrates that are out and about at night, Many of them make interesting and unusual pictures and you don't even have to worry about black backgrounds!

Where to find insects

Space does not allow coverage of all the best places to find insects, but, as an alternative to searching likely habitats for a range of subjects, you can use a knowledge of insects to good effect by predicting where and when they may appear and being ready for them. At its simplest, this may involve waiting by a good insect flower, such as hogweed or buddleia to see what comes. Your chances of success will probably be enhanced by temporarily covering competing flowers in the immediate vicinity, though be sure not to break them or leave them covered. Other means may be more subtle and involve a closer knowledge of individual species. For example, a rose bush with its leaves covered with circular holes led us to suspect that a

comes out at night, most of which you will never see in the day, and a proportion of these can be tracked down if you know where to look.

The best way to start getting successful evening pictures is to go in the late afternoon to a place that you know is very good for insects during the day and start watching out for species going to roost. Most insects roost in longish herbage for protection; they can be incredibly difficult to find so it helps to be sure that they are around in the day. Once found, though, you should have ample opportunities for photography as they will normally be almost completely immobile, unless they have just arrived. If it is still reasonably light you can set up a tripod to give really sharp well-framed results, or you can hand-hold the camera if conditions are reasonable and your film is not too slow.

As the light fades, you will need to use

leaf-cutter bee must be nesting close by; a short period of searching led to us finding the nest hole and setting up the camera as shown on p. 115. Similarly, a wait close to the nest hole of a solitary bee or wasp will usually lead to a good picture, possibly showing the female dragging in a paralysed spider or caterpillar if you are lucky. Similar techniques can be used for photographing dragonflies coming to perches (p. 101), robber flies or hunting wasps coming to take prey from amongst clusters of flies on, for example, cowpats or stinkhorn fungi, and burying beetles on the corpses of dead animals, amongst many other possibilities.

Remember that the weather has considerable effects on what insects you will see and photograph. There is no doubt that sunny days will give you more 'sightings' of insects but they may be too active to catch up with. In periods of hot sunny weather, go out early since most flower-feeders will finish feeding by midday or earlier in these conditions and you will scarcely see them. Occasional sunny days amongst dull ones are usually excellent and cold mornings will delay activity until later in the day. If you find a good place on a sunny day but are unable to get close to

anything, try coming back soon after on a dull day – a few individuals may be feeding very lethargically and others will be roosting close by, allowing an easier approach.

Finally, remember that some insects are highly vocal, especially the grasshoppers, crickets and cicadas. Listen carefully and you can usually track down insects that you would never have seen otherwise.

PHOTOGRAPHY IN THE STUDIO

When we talk about natural history studio photography, we really mean taking the subject out of its natural environment and photographing it in conditions over which we have greater control. A studio can therefore be a temporary set-up in the field, a work top in the kitchen, or a properly equipped natural history laboratory-type studio. Most people will not have access to the latter, but we can all build temporary set-ups and, once the basics are grasped, then such set-ups are relatively easy to arrange. There are a few 'dos' and 'don'ts'. First, as in all natural history photography, look after your subjects properly and never bring in from the field more subjects than you can handle or where necessary, return to the

Photography at night can be highly rewarding offering species and behaviour patterns not normally seen. The picture (left) of a sallow moth feeding on a damaged blackberry was taken with a 105mm macro lens plus extension tubes and focusing was carried out by the light of a torch held by a companion. 2.5:1.

Snail, killed by a glow-worm, being visited by flies which lay their eggs in the remains. Although photographed by flash, the camera was set up on a tripod to ease the period of waiting for several flies to be in the right position.

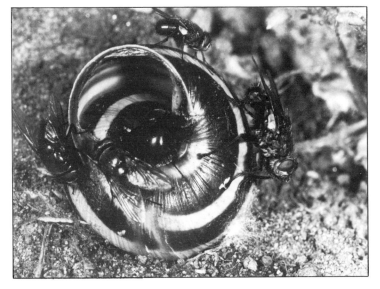

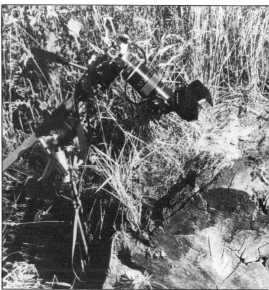

The presence of discs cut from rose-leaves (above left) led us to anticipate the presence of a leaf-cutter bee's nest nearby.

A short period of watching and tracing led to the discovery of the nest in an old log and the camera was set up as shown (above right), to avoid a long wait holding heavy equipment.

After a while, the female bee *(Megachile centuncularis)* returned carrying her leaf disc and this is one of a series of photographs taken at this nest.

habitats. Never bring rare or restricted species into the studio. If you cannot photograph them in the field, do not photograph them at all.

Photograph the subject on or in material appropriate to where it was found. Artificial backgrounds are very useful but should seldom be used on their own. If at all possible use natural lighting. There is no point in using flash or photofloods with all the inherent problems of reflections, heat and multiple shadows, unless they are necessary. With either natural or artificial light, do use reflectors to soften shadows as almost inevitably when you take a subject from its naturally lit surroundings you move it into an area with much more directional lighting. Make sure you have a good light to set up and focus on your subject – preferably one that can be dimmed. Many insects will sit quite

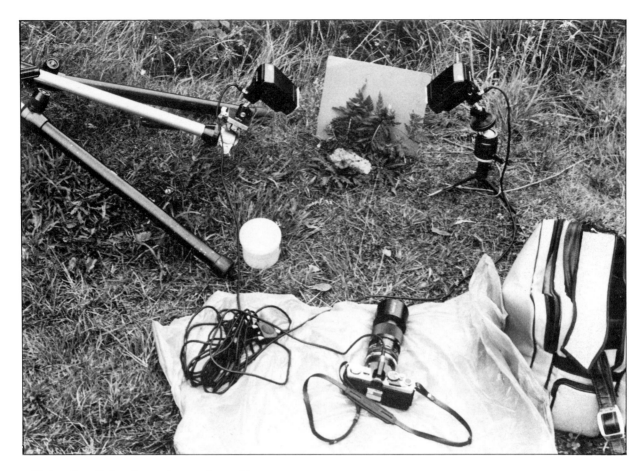

still in dim light, becoming active with increased light intensity. If you are using photofloods, be very careful of the heat they generate and use them with a variable dimmer. If using flash you will need at least three, preferably four, separate small units, unless you are using a special expensive studio flash equipped with all the gear.

One of the best places for studio photography is a greenhouse. Not only does it provide a windfree environment but there is a possibility of using daylight. The natural light can be modified to a diffuse soft light by painting the roof glass white. You can also move a subject to different benches so that the light falls on it from different directions. We have now used a greenhouse for several years for all branches of studio photography. The addition of water and electricity has increased the scope, so that aquaria and 'mini' habitat sets can be kept established indefinitely, and we can thoroughly recommend this method.

Collecting suitable subjects

There is no shortage of invertebrate subjects for photographing in a studio situation, though looking after them may pose problems. When collecting insects, you will need cool dark containers in which to transport them and keep them until they can be photographed. Most insects can be kept 2 or 3 days in a cool situation (not the refrigerator!). There are some exceptions; large beetles can be kept in a vivarium for weeks, but some flies, particularly the biting, beautiful-eyed horse-flies, soon die in captivity and should be released within 24 hours. One of the best things we have found for keeping insects and their containers in immediately after capture is a cool box of the type used for picnics. The cool box does the two jobs of keeping the insects cool and in the dark very well. We prefer to collect insects as late as possible on one day, keeping them outside and in the

A field 'studio' for photographing insects that are not too mobile. Note the neutral-coloured background to prevent black 'holes' behind the foliage. The camera is not tripod-mounted to allow it to be moved if the subject moves; the high speed of the flashes prevents any camera shake from showing.

These superb insects *(Ascalaphus libelluloides)* are highly active in warm weather and difficult to approach. This example was caught in Spain and photographed early the following morning, before releasing it.

dark, and to photograph them next morning very early whilst it is still cool, i.e. before the temperature rises to the point at which they are normally active. Butterflies can be treated very successfully in this way. At first, you will be able to photograph them side on, then, as they warm up and open their wings, you will have time to take a few pictures with the wings fully outstretched.

Some invertebrates pose special problems; the predatory beetles are very difficult to keep still and in a predetermined place. Letting them rest under a stone, and then gently removing it, is successful with some large ground beetles. During photography, they can be kept in shallow dishes, the sort used for black-and-white printing are ideal, filled to about a centimetre from the top with damp sand, granulated peat or proprietary garden compost. Some invertebrates, because they are either hyperactive or dangerous, need restraining in some way. One approach which we have found most useful

with subjects that cannot fly is to place them on a stone or other natural support surrounded by water. But beware, some spiders and the lighter insects will quite readily walk on the surface film of the water!

The set

No matter where the location of your studio, it is best to think of the set in three parts and to think of the effects of your lights on each part or, better still light each part separately. Lighting is considered separately on p. 120.

The three parts of the set are: background, intermediate props or foliage, and the subject itself. If you think like this, you are most likely to avoid some of the horror pictures that are sometimes produced in the name of natural history photographs. You will, at the same time, have a chance to produce pictures with depth, quality and originality.

Background

The background is merely something against which things are arranged, though on occasions, and with a little thought, it can form part of the picture. Painting a suitable background is quite simple and the studio kit should contain several painted up differently on cards. The cards are stiff enough to be bowed to stand up on their own and are painted on both sides. On none of them should any of the coloured patches form hard lines and all colours should merge together. This is easily done by first painting the cards, then blurring the edges with a brush dipped in water and brushed over the board or by painting onto wet board. You can create different habitat boards – blurred vertical stripes of different greens, to simulate reed beds, for instance. Always be most careful how you use background boards. You must preview the effect of the background using the depth of field button and you will often need to light the background separately when taking close-ups, especially if it is more than 10cm from the subject and therefore

This parasitic ruby-tailed wasp *(Chrysis sp.)* was so active we felt that the only way to obtain a clear portrait was to confine it temporarily in an outdoor 'studio' set-up. Sweden. Triple electronic flash, 2:1.

This attractive photograph of a female short-winged conehead *(Conocephalus dorsalis)* – a type of bush-cricket – was taken in the type of set-up shown on p. 116 to allow full control of background and subject, yet giving a natural-looking result. 1:1.5.

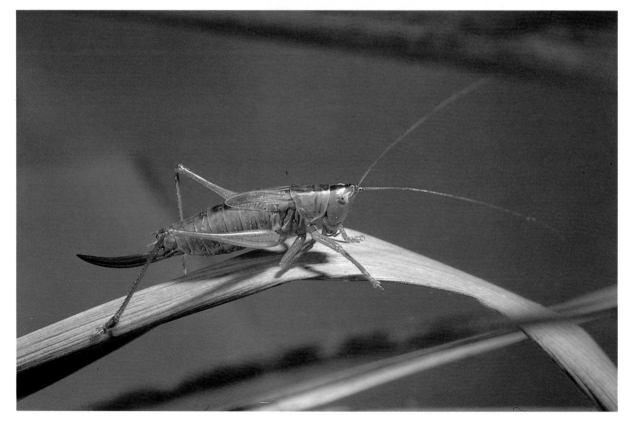

Puss moth caterpillar photographed at relatively high magnification (3.5:1), using 55mm micro Nikkor on bellows (lens not reversed), lit by two flashguns.

receiving much less of the light falling on the subject. If you keep your backgrounds fairly light in colour, you will find there is less need to light them individually. Plain, single colour backgrounds of light blue, green and grey can also be very useful. These plain backgrounds can be bought from art shops and usually have a white reverse, so the card can double as a reflector. In an outdoor studio situation, the background can be a natural lichen-covered rock or a large leaf. In any sort of background, avoid very light spots, reflections and lines which cross, all of which can be very distracting.

Intermediate background/props

Here, we are dealing with the scene-setting part of the set. If a subject is to be photographed on bramble flowers, then bramble leaves should be used behind the flowers – avoid using anything exotic. Setting-up the intermediate background can be very frustrating. It should be set-up before the subject is introduced to ensure that there are no distracting lines immediately behind the subject. Lines and odd dark patches often occur where leaves meet, and some leaves have a bright silvery central rib which reflects a lot

of light. The foliage used for the intermediate background should be mounted in a separate container, so that it can be moved backwards and forwards and from side to side to get the correct position and, more importantly, to get it either in focus or sufficiently blurred, according to requirements. When working indoors, you can use potted plants, such as geraniums provided they are far enough back from the subject to be unrecognisable. Certain types of foliage make better backgrounds than others and, if they are not to be recognisable and are just being used for a blurred green effect, we have found that the leaves of some common plants, such as dock and coltsfoot, to be the most useful and easily obtained. Keep your intermediate background simple; do not try to introduce flowers or insects as such elaborate stage-type settings very seldom work out to look really authentic.

When making a set to photograph insects or invertebrates, the most common mistake is not to make it large enough. If you are photographing a butterfly with a 50mm macro lens at about $\frac{1}{2}$x life size, the immediate area around the insect will be about 8 x 6cm but the background, 20cm behind, will

have an area of about 25 x 10cm. The problem is much worse if the subject moves, or if you move round the subject, so that the camera is no longer square on to the background; then of course you will need a much larger background. We try to arrange a set behind butterfly-sized subjects that is about 50 x 30cm in area. Such a set makes it possible to photograph from a number of different angles without wasting time moving the background foliage between each pose. When photographing insects or other mobile invertebrates on a set, it is best to use electronic flash and hand-hold the camera rather than try to use the camera on a tripod. It is best to keep your small 'disposable' studio set-ups as simple as possible. If you can provide a leafy stalk or plain twig for an insect or caterpillar, then make sure it has few projections, or only one or two leaves for the caterpillar to feed on. You will then know more precisely where your subject will be and there will be less likelihood of it wandering or hiding from view.

Lighting

The general principles of lighting studio subjects have been covered in Chapter 2 and the same means can be used for invertebrates as for plants, though the use of flash is even more strongly recommended because of the need to stop movement.

For complex set-ups we use one of two systems: either we use a main flash to light the subject, plus a fill-in or reflector to balance it, plus another flash to light the background and one more to light the background card; or we use a single large diffuse light overhead (e.g. an old flash unit with separate powerpack) and one smaller flash to pick out the subject. With some subjects you can be more adventurous and try backlighting or grazed lighting for effect.

Experiment, bearing in mind the general rules already outlined, and use the flexibility that the studio gives you to its fullest extent. This can produce some exciting and rewarding results.

5
Mammals and Reptiles

For the residents of most countries of the world, mammals are amongst the least likely of natural history subjects to be encountered. Generally speaking, they are shy, nocturnal and present in relatively low numbers, so it is hardly surprising that they are rarely seen and it inevitably means that the biggest problem for the photographer lies in finding and approaching the subject. Mammals also rely more heavily on their powers of smell and hearing than on their vision, which can add to the photographer's problems, though it may be an advantage if you know what you are doing.

For the purposes of this chapter, we are including other terrestrial vertebrates (except birds) with mammals, e.g. lizards and snakes. Although there are differences in the way that each group will respond to an approaching photographer, these are no greater than the differences between different species of mammals and most of the problems and techniques are the same.

The large mammals, and a few of the small ones, are much better photographed in the field, whether 'the field' is the the Rocky Mountains, Greenland or your local safari park. Many of the smaller mammals, however, can only be adequately tackled by employing some form of artificial set-up, either in captivity or in the wild, and we have separated the general techniques used for this 'studio' photography from those used in the field.

UNDERSTANDING MAMMALS AND REPTILES

To get the best results out of this sort of photography, it is essential to understand the subjects you are working on. Clearly it is not possible to know about all potential subjects, especially in places like African game re-

serves where chance will play a greater part in what you find, but it is certainly worth learning a few general principles, as outlined here, and, if you are on the track of something specific, learn as much as you possibly can about it. The best animal pictures of all are usually taken by research scientists who work with their subjects for up to several years, getting to know all their habits; while this may not be possible, you can at least read up on where they are most likely to be, at what time of year they are most obvious or least sensitive to disturbance, whether they rely most on vision or smell, and so on; this will all help to improve your chances of success and is interesting anyway.

While birds have very acute vision, often much more acute than that of a human being, mammals in general tend to rely less on sight than on other senses. Many species have rather poor vision, and most are colour-blind, though it depends a good deal on their way of life and their habitat. Predators in open country have excellent vision, while herbivores in dense jungle are likely to have poor vision and there are all variations in between.

The sense that mammals rely on most is that of smell. If you have ever watched a dog unerringly pick up and follow the trail of an animal at running speed, you will have realised just how much better their sense of smell is than ours. The whole structure of their olfactory tissue is different; dogs, for example, are a million times more sensitive to butyric acid (the main scent component of human sweat) than we are. While mammals vary greatly in this respect, you can be pretty sure that their sense of smell is better than ours, and you need to do everything to avoid allowing your scent to reach them. Reptiles, in contrast, tend to rely most on 'hearing' vibrations transmitted through the ground as you approach, so be careful how you put your feet down.

Most mammals have good hearing, though they tend to use it as an aid to their other senses as it is less specific; a cracking twig, for example, will not usually cause animals to flee – rather, they will wait to see what else transpires, unless they can smell and sense danger as well. So, if you inadvertently make a noise, just stay absolutely still for a few minutes before moving on. In fact, the ability to stay still when necessary is one of the greatest assets of the mammal photographer.

Mammals' responses to you, once they have seen and identified you, will vary widely according to species and circumstances. Most animals have a very definite limit beyond which you cannot go, but for many species this distance is too great for useful photography. If you have been seen and smelt, it is no use sitting still and it may be best to move gently away at an angle, giving the impression that you have not seen the animals, then try again later, perhaps from a better angle.

PHOTOGRAPHY IN THE FIELD
Special equipment

Your choice of photographic equipment will depend on how large your likely subject is and how close you expect to be able to get to it. You are likely to need a focal length of lens of at least 300mm (on 35mm), and probably more, but it must not be so unwieldy that you are unable to carry it and hold it. A 2x teleconverter of good quality p. 21) is an ideal accessory. An automatic exposure camera can be a considerable boon, especially in action situations. A rifle-grip or similar shoulder-support is ideal for use in stalking; tripods have more limited use, but they are essential for very long distance work, e.g. wild goats across a valley, and helpful in situations where there is a long wait involved. Monopods are a useful compromise.

Ibex photographed in the Sierra Morena, Spain, using a 200mm lens on an automatic-metering camera, mounted on a shoulder support.

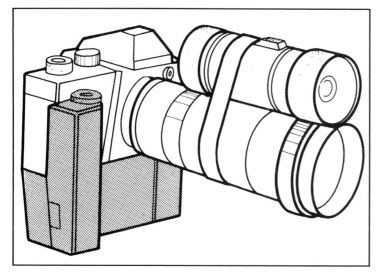

Figure 5.1. For night work, it is essential to have the field of view illuminated to allow focusing. One good way of achieving this is to tape a torch to the lens barrel.

Clothing is important and should be neutral or, better still, camouflaged. A photographer's waistcoat is better than a bag if you do not have too much to carry, or a suitable jacket with good pockets will do as well. Cotton material is better than nylon, as it is quieter. Camouflage netting (available from army surplus stores) can be useful in some situations.

Manual or TTL metered flashguns will be necessary for most photography of bats and any nocturnal subjects. For moving subjects, flashguns will be better mounted on a bracket. A miner's-style headlamp will help to locate subjects at night, while some red cellophane over the torch will allow you to use the light to focus without disturbing most mammals, e.g. when working at a badger sett.

For most mammal work, you will need a reasonably fast film of 100ASA or more, though beware if you use a mirror lens that you are not likely to go off the top of the shutter speed scale. Finally, a small pair of binoculars, of about 8 × 30 will be found invaluable for daytime work.

Techniques

Finding subjects
Probably the two most difficult tasks in this type of photography are finding subjects and then getting close enough to them to take photographs (p. 124). The photographic considerations become relatively minor, except where you are working in conditions with an abundance of mammals such as in some game parks or in 'safari parks'.

As is so often the case, it pays dividends to know your subjects and what to expect. Find out what mammals are likely to occur in your chosen area and discover as much as possible about their habitats and habits. For the better-studied areas, such as Western Europe and North America, there are good guides to the tracks and signs of mammals and these are invaluable to guide you towards possible subjects. Whenever you are out, it pays to be constantly on the lookout for signs: hair floating down the river may indicate a reindeer crossing place upstream; muddy 'wallows' may show you where stags are spending much of their rutting season; cone scales in a car park may lead you to some tame squirrels – the possibilities are endless!

Mammal trails are invaluable things to find, whether they indicate the passage of a single badger, a group of deer or a herd of wildebeeste! You can be reasonably certain that they are used regularly and you can pick your viewpoint to give you the best chance of a picture later, though you need to know what species you are dealing with in case they are nocturnal. Animal lairs and dens are often the best places for pictures, especially when there are young about, and frequently you can use a tree, some natural cover, or even a car, to get close enough. In general, early morning is best for such situations and it may pay to spend the night out if the weather and wind direction is right. Getting up off the ground, e.g. into a tree, reduces the chances of your scent reaching the animals. Drinking places may make good sites, especially in dry conditions, and you can usually quickly tell if they are well used. Carrion is certain to attract something or other and you can often park a car near enough to make yourself a mobile hide.

Reptiles are most easily found by seeing the animals themselves, rather than their signs. Usually you will disturb them as soon as you see them, but most are creatures of habit and they will return quite soon to the same spot, when you can be ready with camera and whatever is necessary. Reptiles generally are best worked on in cool sunny

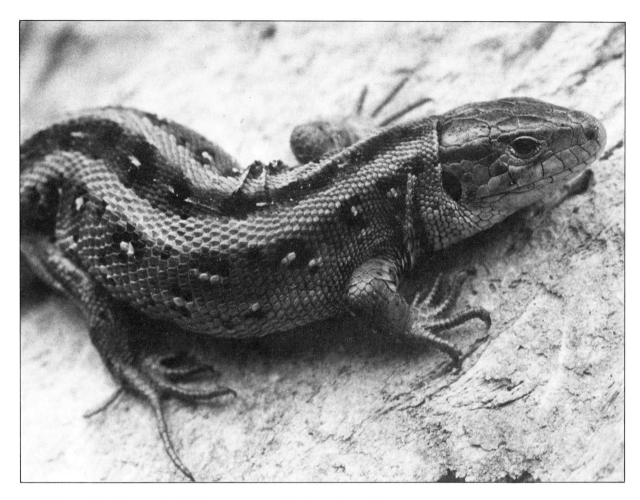

conditions, when they need to bask to warm up and can be approached very closely – early mornings or sunny days in spring are the easiest starting points.

Finally, there is always the element of chance and it pays to be ready for it: we have photographed weasels on a family picnic, a stoat on a walk in the Scottish highlands, a pika in Afghanistan while answering a call of nature, while a friend just back from Greenland took some marvellous pictures of a moulting Arctic fox which wandered into camp one day.

So, be prepared for such eventualities whenever possible.

Getting in close

1. *Stalking* For most people, the most exciting part of mammal photography is the battle to get close enough to your quarry,

and it is stalking that involves the most concentration, 'fieldcraft' and knowledge of your subject. Animals vary widely in how easy they are to stalk, depending on various factors such as the acuteness of their senses, their position in the food chain, whether they are persecuted and the particular habitat they are in. Nevertheless there are some general guidelines that will help to raise the level of success.

a) It is best to concentrate on stalking and nothing else, if you are doing it properly. It cannot be combined readily with other forms of photography.
b) Expect to spend many hours with little or no success.
c) Remember that, because most mammals have a very keen sense of smell, you must stalk upwind. A steady gentle breeze is better than a gusty eddying one.

Sand lizard photographed in Yugoslavia by natural light and hand-held reflector. Note the slightly softer lighting and the absence of a catchlight in the eye, as compared with flash lighting. Taken with 105mm macro lens.

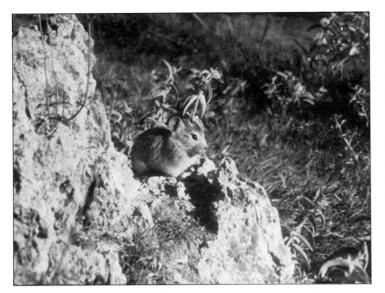

Nature photographers should be prepared at all times; this picture of a mouse-hare, or pika (*Ochotona* sp.), was taken in Afghanistan while the photographer was going to answer a call of nature – and it was the best view we had of pikas during 4 months in the area.

d) Many mammals also have keen vision and hearing, so it makes sense to wear dull or even camouflaged clothing, to cover all bright parts on your camera, and to deaden any noises such as keys, money, buckles or squeaky shoes.

e) Try to anticipate situations so that you see animals before they see you, e.g. go carefully over a brow or round a corner so that you can survey the scene without appearing as a human form; go especially carefully when approaching likely situations, such as river crossings, wallows and other places where animals may be found.

f) If possible, rest after exertion before taking pictures, or the chance of camera shake will be greatly increased.

g) With most mammals, once you have been seen, it is pointless to try to follow them closely. You need to wait and let them settle before trying again.

h) With larger mammals, it is worth taking pictures at 200m or more (with a lens of about 300mm) both to give you insurance shots and to show the animals in their habitat. If you only want close-ups, you will find it much easier in a zoo. Good groups of mammals can be taken from even further away, though a thin line of animals across the centre of the frame can look singularly uninteresting.

2. *Other means of getting in close* For clarity, we have used the term 'stalking' to mean approaching animals on foot. However, it is possible to do something similar using vehicles, boats, horses, elephants or anything appropriate. In Africa, vehicles are most often used as a means of getting close to animals and they can be effective anywhere where animals are accustomed to them – they react much more slowly to vehicles than to people on foot. Boats are an excellent means of approaching close in aquatic situations, or for getting near to basking seals and other animals on the shore. It is important to prevent more than the minimum amount of recognisable human form from showing though.

In India and Nepal, we have used elephants as means of getting close to game and they are highly effective, as well as being much safer than being on foot in tiger country. The size of the people in relation to the bulk of the elephant is so small that mammals virtually ignore you. By this means, we have got close to one-horned rhinoceros, deer, wild boar, crocodiles and even tiger. It pays, though, to take only a minimum amount of equipment, since it is difficult to handle on a moving elephant, and to use a fairly fast film to give high shutter speeds, since elephants never stay quite still and are very bumpy when they are moving.

3. *'Wait-and-see' mammal photography* Instead of chasing after animals, it is quite possible to prepare yourself for a wait in one situation and see what comes along. Naturally, your chances of seeing something is greatly increased if you choose your place carefully. Dens and lairs at cubbing time can be highly productive; make sure you are so placed that the light will be right for when you expect to be photographing, and check the wind direction (though this may change during a long wait). Similarly, drinking places, carrion and other food sources will be most productive and they can be improved by baiting in some form or other. The crucial point lies in siting yourself unobtrusively and in a position where your scent will not carry to the animals. Hides can be used, though mammals are often more wary of them than birds are, and you may need to be patient. Get off the ground if you possibly can to reduce your scent.

You can also employ these techniques in

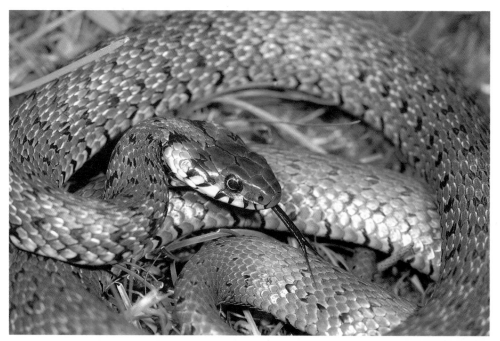

Most reptiles are more easily approached in cool weather when their movements are slower. It pays to know whether your subjects are venomous or not before deciding how close to go. This grass snake *(Natrix natrix)* is quite harmless. Flash was used to catch the flicking tongue and to light the subject evenly.

It pays always to have a camera ready for action. This young weasel approached one of us whilst we were on a family picnic and it was hastily photographed, using a standard flash bracket set-up designed for use with insects.

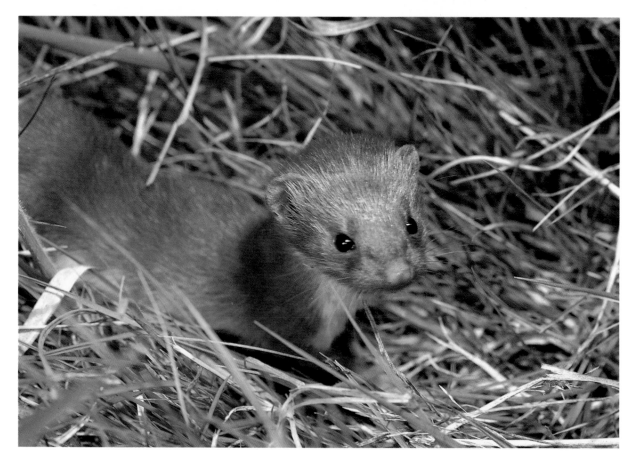

one of the best places of all – your garden! Most gardens will have some form of visiting animal life – usually at night – and you can put out food regularly to attract it. Some species can be accustomed to gentle light or red light, while others may be more cautious. In defined situations, such as racoons raiding trash cans, it pays to focus in advance and hope for the best when you hear them!

Overall, though, your best chance of getting some good mammal pictures lies in finding places where you can get close to wild mammals reasonably easily during daytime. The more practice you can get in these relatively easy situations, the better equipped you will be when it comes to trying more difficult situations.

Most countries have species of mammals that readily become tame and are found in areas close to human habitation. In North America, there are various familiar species; in Britain, it is most often the grey squirrel, while in parts of Asia it is the five-striped palm squirrel. These are all genuinely wild animals, but they are aware of humans and allow a close approach, thus removing one difficulty but leaving plenty of others to practise on. A step onward from this, giving a much wider range of species, is to visit areas where concentrations of wild animals are known to occur, without their normal fear of human beings. Local research is needed here, but they will most often be in national parks, game parks or nature reserves e.g. alligators in the Florida everglades, one-horned rhinoceros in a few game reserves in the Indian subcontinent, ibex in some European mountain parks and, of course, a whole range of species in the many African game reserves. In most cases, discussion with the rangers and wardens will lead you to some good opportunities, especially if you have researched the time of year first, and your chances of a casual encounter will be greatly enhanced by careful choice of location.

It is important to be prepared. This Arctic fox wandered unexpectedly into the camp of a friend of ours in Greenland. Quick thinking and a 300mm lens close at hand gave him a good series of portraits.

Figure 5.2. A simple folding neutral-coloured or camouflaged board can act as a portable hide for use in open country.

(Right) Young fallow deer fawn, found by chance and hastily photographed by available light.

(Left) It is possible to stalk larger animals using a tripod if you do not have to travel too far and it allows the use of better-quality slower films compared with hand-held shots. This set-up was used by Robin Fletcher to take the colour photograph of a fallow deer (p. 130) in the New Forest, England. 300mm lens on Benbo tripod.

Working at night

Many mammals and other vertebrates are only active at night and photographing them in the wild presents special problems. Most of the smaller ones, except amphibians (see Chapter 6) are best photographed in the studio and some of the larger ones are extremely difficult because of their unpredictability. There are some, however, whose movements or whereabouts can be predicted with some certainty and these present opportunities for some interesting pictures.

Bats, strictly speaking, are most often

An unusual view of a tightly-rolled hedgehog taken using twin flashguns. Hedgehogs are ideal subjects to practise on as they are quite tame and regularly visit gardens.

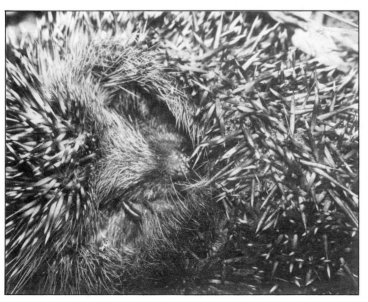

photographed during the day, since they are too active (except for beam-triggered photography; see p. 133) at night; but since the conditions in which you will find them are almost invariably dark, we have covered them here. Bats are attractive, harmless (with a very few tropical exceptions), insect- and fruit-eating nocturnal mammals, rather like flying mice or moles. During the daytime, they roost by hanging from suitable places in caves, roofs, hollow trees or by hiding in crevices – anywhere dark (except for the fruit bats which often roost in the open). In temperate areas, they also spend the winter in a similar roost, though usually it is somewhere with a constant temperature. Bats are reasonably easily found by looking in such places after further research, but, in many areas, they are now so endangered that they are especially protected and can only be disturbed or photographed with a licence. They should never be woken from hibernation by an unqualified person since this may cause them to use more of their slender resources than they can afford, and they will die before winter is out as a result. In large cave systems with high roofs, where large numbers may gather, you will have to use a powerful flash. It is quite possible to set the camera up on a tripod, select the B exposure to keep the shutter open, and fire an 'open' flash (see p. 25) from suitable positions to light the subject clearly and attractively. For close-ups, the simplest way is to use an insect-photography bracket set-up (pp. 26 & 105), though you can position additional flashguns on supports, fired by slave units, to backlight the bat or light the background. Whichever method you choose, work as quickly as possible to avoid disturbing the subject unnecessarily. Roosting fruit bats can be found in tree-tops and they can be adequately photographed from the ground with a lens of 500–1000mm; remember to open up a stop or so beyond your meter reading for a dark subject against a light sky.

It is virtually impossible to stalk animals at night, since their vision and hearing is so much better than ours. The best chances come, therefore, from setting yourself up in a position where you know they will appear, making sure as far as possible that your scent will not reach them. Hides are not usually of much use since your scent will still carry if

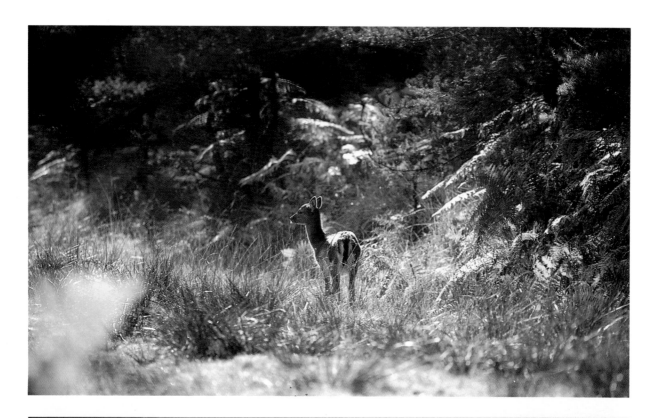

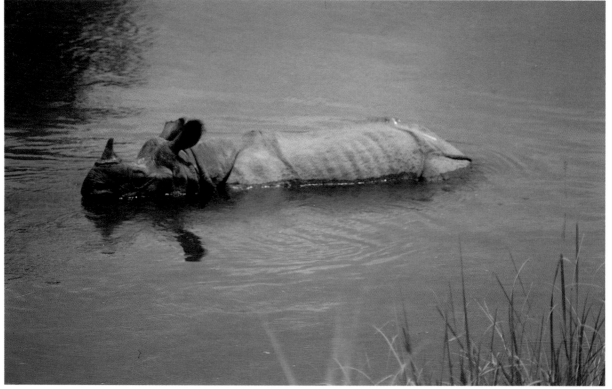

the wind is wrong, and it is most often best to get off the ground if you can.

Lairs or setts provide your best opportunities. In Europe, badgers invariably emerge from their setts at about dusk, unless something disturbs them, and it is easy enough to set yourself up a few hours before. Ensure that your position is comfortable enough for a long wait and that you are dressed for night-time inactivity. A red light will allow you to focus. Once you have got to know a particular sett and the habits of its residents, you can start to think about positioning flashguns in ideal places around the setts, and possibly even improving the appearance of the surroundings. Remote flashguns are best

fired by slave units to avoid wires, and you can activate them by a flash close to the camera, which should be pointing at one of them rather than at the subject, to avoid the 'red-eye' effect of direct flash. If you have such a sett close to home, you can gradually accustom the animals to increasing light intensities, thus making photography much easier.

For animals that cannot be photographed 'at home' in this way, the other main options are to photograph them feeding or drinking. You may discover such places by chance, or hear of them from someone else, or you can put down bait until you find that something is visiting regularly. One often hears of friends who have badgers/racoons/hedgehogs or whatever visiting their gardens, and these provide ideal opportunities if the friends are co-operative. Try putting food out in your own garden and see what happens, though you may find that you are simply feeding your neighbour's cats or dogs.

Whatever you are photographing, there are some general difficulties that working in the dark will bring. Make sure that your flash(es) are adequate for the job in hand and calibrate them in a suitable situation first, since you will probably get only one picture from each nocturnal encounter. You can fit a teleadapter to most guns to make them more powerful, but they must then be aimed very accurately. Make sure that you familiarise yourself with all the camera settings without being able to see them and set as much as possible before going into the dark. Focusing is especially difficult: use a plain ground-glass screen if you can (p. 29) or a special low-light one if your manufacturer makes one, and as powerful a focusing light as you feel you can risk. Red lights are not very easy to focus by.

Photography on safari

The ultimate opportunity for anyone interested in mammal photography must be a visit

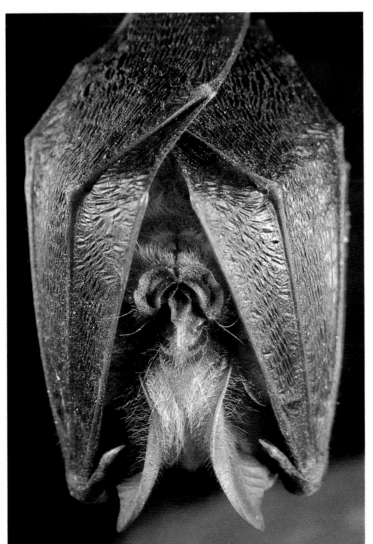

to the game reserves of Africa (or, to a lesser extent, those of Asia). There is nowhere else that gives such opportunities for photographing a wide range of animals going about their lives in the wild in such a short space of time. Because, for most people, this will be a 'once-in-a-lifetime' chance, it pays to be as well prepared as you can. The details of where to go and what to expect vary and specific research will be necessary, but the following general points will be useful almost anywhere:

a) Take as much film as you can! Although the bright mid-day light may tempt you to take a slow film, in practice many of your best chances will be in the early morning and late afternoon and for these a medium speed film (e.g. 100 ASA) is best. This will also allow you more chances at action photography.

b) If possible, take two camera bodies in order to allow for two different speed films and two lenses to be in use at once, provide a check on each one's meter performance, and have a spare if one goes wrong. A good zoom lens of about 70–210mm is ideal, allowing both close views and wider ones, as you will constantly be switching from groups to individuals to close-ups to habitat pictures and so on. Always use a lens hood.

c) If you are with an organised party, you will certainly have a vehicle. If you are going alone, make sure that you can get one. They are essential, both to increase your opportunities and for safety, and they are often required by park regulations.

d) Be selective, or you will find that you have used all your film on second-rate opportunities with 2 weeks still to go!

e) After the first few days of excitement, start attempting action shots, behaviour shots and anything else a little unusual.

f) Metering is difficult. Remember that the surroundings are usually bright with a lot of reflected light around, so that darker animals will be under-exposed if you follow the meter reading.

g) The dry seasons will generally give you the best opportunities, though of course these are also the peak tourist seasons. The wetter seasons are harder work, with worse conditions and more dispersed animals, though they do provide a few wonderful opportunities, better backgrounds and less people.

Photography in zoos and safari parks

For those not fortunate enough to be able to travel abroad in search of subjects, the local zoos and safari parks can provide surprising opportunities and good practice.

Choose zoos or parks where animals are in as natural conditions as possible and go mainly for close-ups. A reconnaissance will pay off, allowing you to decide what film and equipment to take. If possible, go at a quiet time before too many people are about. Early mornings give a good combination of attractive light and fewer people.

Remember that, if animals are behind mesh, it is possible to remove this totally from the picture by going as close to it as you can and using a reasonably large aperture. All thinner forms of barrier will disappear from the final picture using this method.

PHOTOGRAPHY IN THE STUDIO

Many small mammals, especially if nocturnal, can only really be satisfactorily photographed in the studio. This is not an easy option, however, since the mammals have to be caught, transported, looked after and fed whilst in captivity, a set has to be constructed and adequately lit, and the animal has to be persuaded into the right place at the right time to have its photograph taken.

Collecting subjects

The most practical way of obtaining small mammals for an overnight stay in the studio is to use 'Longworth' traps. The traps are sturdy two-part aluminium boxes with a simple but effective release which brings down a metal door. The small mammal can be taken home in the trap. Before leaving the trap out overnight, the catching area can be prebaited for several nights. The trap should

be carefully sited where there is evidence of small mammals – partly eaten food, tracks through grass etc. A white-topped cane placed near the trap will help you to find it again. These traps should not be used during very cold weather for, although small mammals such as mice are active, even in snow, it is doubtful whether they would survive above ground all night in a metal box even though it is customary to put some bedding material in this trap. Enough food should be put in as well so that any small mammal caught can last overnight. We do not recommend any other way of catching mammals. Great care should be taken when opening Longworth traps as they have occasionally caught weasels and snakes.

Techniques

For the short time they are in a studio small mammals will somehow have to be confined and the best thing we have found, both to keep them in and to use as a studio set, is a fish tank. The minimum size is about 45cm long, 25cm wide and about 30cm deep. The deeper the better and a tank 45 to 50cm deep is ideal. A deep tank is needed to accommodate tallish vegetation for climbing subjects like harvest mice. The tank should have a lid – this is simply a sheet of glass that fits the top exactly. There is no need for ventilation holes since the sheet of glass can be raised on 5mm thick pieces of wood at the corners. 75 to 100mm of peat should be put in the bottom. This should not be too wet or condensation will soon form on the inside walls of the tank.

Simple props should be introduced to obscure the far side of the tank, and these form one of the most crucial features of the final picture. The peat floor should also be covered with leaf mould or whatever is appropriate and some sort of focal point will be needed to attract the mouse or vole. This is usually food, which can either form part of the photograph, e.g. ears of corn for harvest mice, or be hidden in a small rotten branch or stump. When all is ready, the subject can be introduced. Some species will settle down immediately, and photography can start after a few minutes, while others, like the house mouse, may need a week to settle into an activity pattern so that you can predict the time for photography. If you do keep small mammals for any length of time, an adequate supply of food and water must, of course, be provided.

There are some variations on the fish tank studio. Wooden boxes with a plate glass front have been used but this limits you to lighting the subject from the front, and possibly the top, only. We prefer a slightly deeper tank so that we can use flash through the side and from above. Our flash heads are usually covered with diffusers of different thickness (one or two layers of tissue paper is ideal) and just placed on the glass top of the tank and up against the sides slightly nearer to the front than the back. The set is quickly and easily made up without elaborate stands etc., though we do use two small mini tripods occasionally to support the flashes at the sides. However, we prefer to use normal laboratory retort stands for our small studio flashes, since they are much more versatile and manoeuvrable.

Small mammals in studio tanks can be photographed with special triggering devices, which are especially useful for nocturnal animals or those whose activity occurs at an inconvenient time. A triggering device which activates a motordrive is the only practical system. A trigger firing the electronic flashes only would require the shutter to be open for long periods in a totally dark studio, which is clearly impracticable. Our triggering device was constructed several years ago before they became commercially available at a reasonable price. It fires the motordrive on an Olympus camera. The motordrive has a socket for a 2.5mm jack plug, which is readily available from radio spares shops, though some other motordrives have a more complicated connector only available from the camera manufacturer. The triggering device made for us has two photocell (light-activated) switches that can be used together or independently. When used together in a cross-beam layout, both beams must be broken to activate the camera. You can therefore effectively pinpoint the area where the animal must be to trigger the motordrive. With our set-up, using one of the tanks described above with the light beams and photo-tripping cells mounted on the outside, the sensitive zone is

(Right) Zoological gardens can provide good opportunities for natural-looking studies. This European lynx, taking life easy, was photographed in a Swedish zoo but it could have been in the wild. Available light, 150mm lens.

(Bottom right) An impala ram *(Aepyceros melampus)* in the Chobe National Park taken in available light using a 300mm lens.

(Left) Reticulated giraffe *(Giraffa camelopardis)* in Kenya, browsing. The East African National Parks give endless opportunities for high-quality, available-light mammal studies. A zoom lens helps with framing as you cannot always move as close as you want.

about 4cm long and 2.5cm deep. Even with this small area, and using a 100mm macro lens on f.16, you have to be prepared to accept a large number of failures. Reference to Figure 5.4 will show how we prepared the set-up. The lights and photocell triggers can be mounted on a fixed light metal or wooden frame, which considerably helps in setting-up since the beam is very narrow over the short distance, and the acceptance angle of the photocell is equally narrow.

The circuit for our unit is printed here (Figure 5.5) and is easily built by any electronically minded person and, if you cannot do it yourself, then perhaps a friend could do it for you. The photocell switches are connected to the main circuit with three-core cable about 1m long and mounted in a 35mm film can, along with the other components (Figure 5.6). A thin tube allows light from a narrow angle to strike the photocell without the use of a lens. The housing for the photocell and the tube can be of any material providing it is light-tight. The light source in our unit is a torch bulb, similarly mounted in a film can with a 1m lead taken to a separate 6 volt supply. The main circuit is fitted into a standard plastic box obtainable from radio spares shops and is drilled for mounting on/off switches and the two light-emitting diodes (LEDs). The LEDs (one for each photocell) go out when the light circuit beam is broken and are there to aid the setting up of the cross-beams.

When the cross-beams have been set up, a plasticine model mouse is lowered on a string into the tank and moved across until it triggers the unit – both LEDs going out. The camera is then focused on the model in this position. The model is then removed and the connections made from the control box to the motordrive. The flashes are then set up and connected to the camera and a few trial runs made with the model using an empty camera. When all is satisfactory the camera can be loaded with the film and the real mouse introduced to the set. If you leave it set up overnight, there will be little film left next morning. To make sure that the flashes and light sources will remain on overnight we run ours off the mains electricity *via* a car battery charger. The main circuit in the control box has enough battery power for at least 12 hours. With luck, one or two pic-

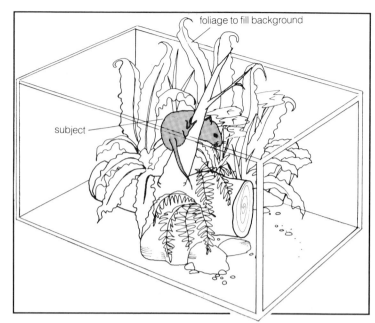

tures out of a 36-exposure cassette will be satisfactory. The new 35mm Polaroid colour transparency film will help in refining the set-up before it is left overnight and can be used to check any studio lighting set-up. The Polaroid film is two to three times more expensive than normal transparency film but is well worth using as a check when a lot of time and effort is involved. Kennett Engineering now make an excellent release using pulsed infra red light which can be used in daylight. This release can be used for taking pictures like that of the robin (p. 91) on a specially set-up stump or perch, with camera housed in a waterproof box, and left as long as necessary.

Figure 5.3. A set-up in an old aquarium to allow photography of small mammals in natural-looking situations.

Figure 5.4. Layout of photocells and lights. The camera is fired when both beams are broken.

Figure 5.5. Circuit diagram
for simple camera trigger
unit designed by John
Liversidge.

Figure 5.6. Photocell
holder.

6
Water and Seashore Life

The photography of life under water, or at the water surface, presents a whole range of problems – as well as opportunities – not found in other branches of photography. Aquatic life includes representatives of most groups of animals and plants, including some such as amphibians which spend part of their life away from water. We have included them here since they are most often photographed in water at their breeding period, though amphibians found and photographed wholly away from water, such as in your garden, can be treated in the same way as most small terrestrial vertebrates (see Chapter 5), except that they are generally easier since they are less active.

A great deal of good and highly enjoyable photography of aquatic life can be done in the field, especially in the amphibian breeding season. It has to be admitted, though, that the best 'portrait' shots of aquatic or partially aquatic organisms in water are usually taken in captivity, and we have covered this in enough detail to give you the information to try it out, if you enjoy studio photography.

PHOTOGRAPHY IN THE FIELD

Special equipment

The equipment for field work varies according to the subject and precise lens/camera combinations will be developed according to individual needs. However, the main feature that links all the organisms in this chapter is that they are most likely to be found in or near water and, secondarily, many of them are most active at night. These factors will guide the choice of equipment.

For natural light shots, when you get the chance, a tripod and a close-focusing telephoto of about 300mm are invaluable for the more predictable subjects, such as mating toads or frogs. For more active subjects, a short telephoto between 80mm and 135mm, preferably close-focusing or macro, is best, as this can be hand-held or mounted on a rifle-grip. For any shots where the subject is below water-level, a polarising filter is invaluable (p. 30) but it does cause a light loss of $1\frac{1}{2}$–2 stops, which – on underwater subjects which will be poorly lit anyway – can be a considerable problem and may rule out natural light shots of moving subjects.

Subsidiary equipment that will ease your problems includes a pair of waders (or other means of getting into deeper water), a polythene sack or pad for kneeling on wet ground (or waterproof trousers), and an underwater cover for the camera (such as the EWA range), allowing you to submerge the camera if necessary.

A fair amount of fieldwork on these subjects will have to be done using flash, either to stop movement or make up for low light levels in the water, or because you are working at night when the animals are at their most active. A flash bracket set-up

Immature edible frog photographed at night in Hungary, using twin flash on front-mounted brackets with a 105mm macro lens. Focusing and searching was carried out using a torch.

similar to that described for insects (p. 105) will serve for these subjects, though bear in mind that it will have to operate at greater distances than for insects and must be adjustable for this and powerful enough. A miner's-style headlamp or powerful built-in modelling lights on your flashgun will be necessary for night work; you may also need a powerful torch in order to find your subjects initially, reserving the lights that you do not need to hold for focusing and taking the pictures.

A small torch taped to the lens barrel can be useful, though on some lenses it is difficult to stop it revolving or fouling the focusing mechanism.

Techniques

Finding and approaching the subject

The biggest initial problem lies in finding and approaching your subjects. The advice given on stalking insects (p. 97) and mammals (p. 124) applies widely to these aquatic groups, but remember that many aquatic organisms are sensitive to vibrations, as well as sight and sound, so be careful how you tread.

Much the best way to photograph amphibians is by finding them at their breeding sites. It will always pay off to find out as much as you can about each species in your chosen area – when it spawns, what conditions it likes, if it calls at night – to help find a good site and to secure some good pictures. Pictures of toads are usually reasonably easy since, once mating is underway, they become oblivious to all else, leaving you to concentrate on finding the best viewpoint and composition; it may even be possible to enter the water yourself! Frogs are similar, though generally more wary so a careful approach and the use of a longer focal length lens is advisable. For diurnal (daytime) species, the most attractive pictures are generally taken in subdued sunlight, though this is not always possible.

Some frogs and toads, and most newts, are much more active at night than in the day and special techniques are required. Some species are active and visible by day, but will only call by night, showing themselves in their full glory with vocal sacs distended. You can either go out at night with a torch and search your local ponds and lakes during the breeding season – usually spring – to see what is there, or try to find out in advance which sites are most suitable for what you want.

The photographic possibilities will vary enormously according to the species and the situation; newts, for example, are generally unhelpful, staying mainly below the surface and only appearing for a few seconds at a time. Some toads, such as the natterjack toad (*Bufo calamita*), will call loudly at night, often from exposed positions and most tree frogs behave similarly, though they are by no means easy to locate!

Once located, 'singing' males can be photographed, though often they stop calling when a light is shone on them. A weaker more diffuse light or a red light may help and patience will occasionally be rewarded if you simply wait. Alternatively, you can compose and focus, switch off the light and wait until the calling re-starts, then take the picture immediately you switch the light on again. There again, you may be quite happy with a good portrait of a nocturnal species doing nothing, since most people will never have seen one anyway!

Given the choice, most amphibians are best photographed from a low angle which shows their body at its best, though some circumstances may warrant a different view, e.g. the natterjack toad has a yellowish stripe down its back and this can be best seen from above. Individuals found actually in water will usually have to be taken as they are found; a polarising filter will help to reduce reflections and show the features more clearly, but that loss of $1\frac{1}{2}$ stops may make things too difficult with slow film or in poor light.

Most amphibians have a pre-adult 'tadpole' stage. These are often more easily approached than the adult, though they are rarely still. Tadpoles in a pool with a sandy floor show up more clearly, as do individuals clustered around green waterweeds growing near the surface in clear water. Aquatic invertebrates present generally similar problems, though most of them are difficult to catch up with in the field, except by luck. A few species return predictably to the same

spot and this gives you a much better chance of success since you can be ready for them.

Water spiders (*Argyroneta aquatica*) build nests below the water which they fill with air by collecting bubbles from the surface. Once you see one behaving in this way, usually in spring or early summer, you can be sure that they will return to the surface and you can organise your tripod or flashguns accordingly.

Immobile aquatic organisms, such as sponges, are relatively easy since you can use a tripod and a polarising filter to show the subject clearly, though moving water may impair definition. Flash can be very useful to provide extra light and stop movement, but remember to have the flashes at more than 45° away from the optical axis to prevent reflections coming back into the lens and ruining the photograph.

Fishes are extremely difficult to deal with satisfactorily in the field, though you can sometimes get biologically and visually interesting pictures which may be photographically poor. The best opportunities are provided by spawning sites, seashore rock pools, waterfalls which migratory fish need to ascend, and areas where fish are fed regularly. Many freshwater fish spawn in shallow water over a gravelly bottom and they are often easily found and approached at such times. The timing and situations vary widely according to the species involved and preliminary research is essential for good results. Once subjects are found, the techniques outlined in this chapter can be used, though you should be prepared for your subjects to be moving constantly.

Waterfalls and rapids on spawning routes are wonderful places to watch migratory

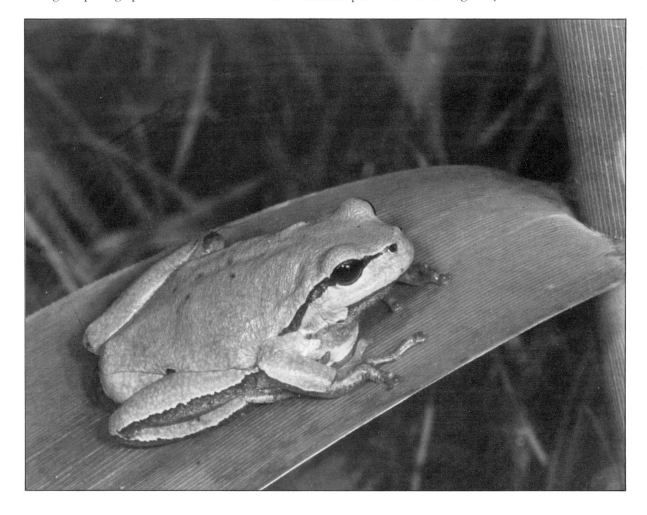

Tree frog *(Hyla arborea)* photographed at its breeding pond using twin flash. The dull cold conditions made this cold-blooded amphibian less active.

fishes – such as salmon and sea-trout – leaping up falls. You need to know the right time of year to visit and preliminary work to establish the photographic possibilities and difficulties will be well rewarded. A telephoto lens of about 200mm will probably be required, though you may get close enough to dispense with this. Wider views showing the fish and the falls can be as dramatic as close-ups of the fishes. Needless to say, a fast film is very useful since speeds of about 1/500 second will be required to stop movement. In quiet places, you can set up flashguns on supports remote from the camera to light the falls clearly and without reflection, leaving you free to concentrate on getting the fishes in focus in the viewfinder. Powerful flashes are best as a small aperture will increase the chances of getting subjects in sharp focus and slave units can be used to fire them.

Finally, in many managed lakes and rivers, the game fish, e.g. brown trout, may be fed regularly. Here they will gather in large numbers and they are usually oblivious to human presence. Unfortunately, they rarely stop moving; so a fast film will help, especially if a polarising filter is used.

For all these opportunities, you will find that a few hours practice with ornamental fish in your garden pond will yield dividends in experience that will undoubtedly improve your results with wild species.

Working at rock pools

The main problems when working at rock pools are: reflections and getting enough light to the subject. The simplest way to reduce reflections is by fitting a polarising filter and rotating it to give the clearest view. It will not, however, be successful in all

A temporary outdoor 'studio' set-up for photographing rock-pool animals on the shore. Here, Peter Wilson is photographing the common prawn shown on p. 146, using an Olympus OM2 with two flashguns and a Tamron 90mm macro lens. Note the taped stripes on the cable release, to minimise the chances of losing it.

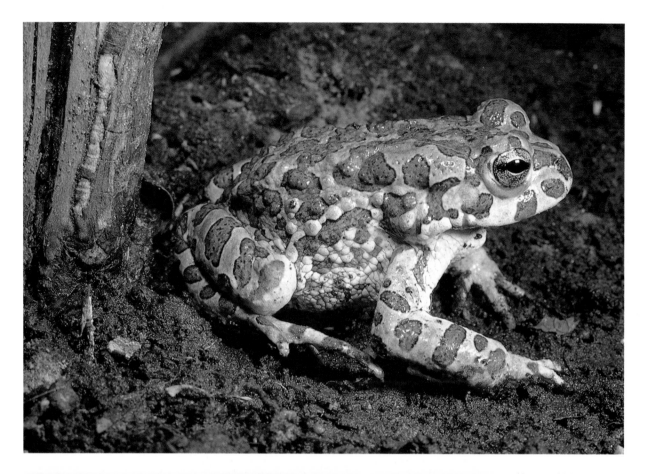

Many amphibians are most easily found and photographed at night, as described on p. 139. This green toad *(Bufo viridis)* was taken at night by the side of a pond in Hungary, using twin flashguns mounted on a bracket.

Where large numbers of animals are present in a pond, such as this mass of breeding common toads, a more distant view can be taken. This allows natural light to be used satisfactorily since movement by individual animals will not spoil the final result.

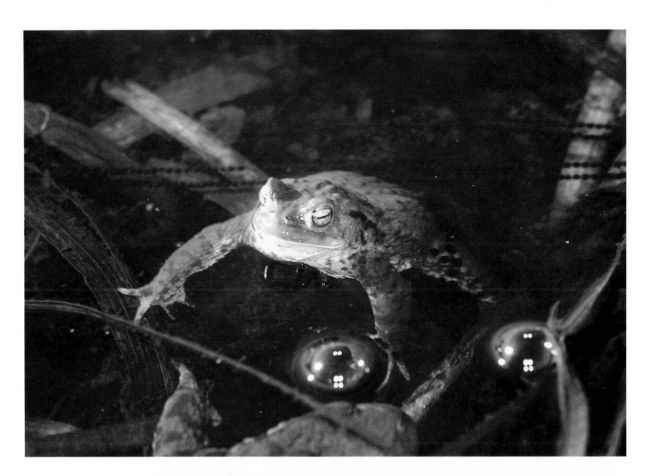

If flash has to be used on animals in water, then it needs to be used carefully to avoid excessive reflection from the water surfaces. This common toad *(Bufo bufo)* was photographed, with its spawn strings in a breeding pond, using two obliquely positioned flashguns.

Tadpoles make excellent subjects for first efforts at tank photography since they are readily available, easily looked after and neither very small nor very agile. This common frog tadpole *(Rana temporaria)* was photographed against a background of waterweed using twin oblique flashguns to light it. 1:1.5.

Photography on the seashore

Working on the seashore presents extra problems compared to everyday photography, particularly because of the need for protection against salt and sand, and because of the difficulties of access to the best areas. Some useful general tips are:-

1. Always check tide-tables before undertaking a serious session, both for safety and ease of access to subjects.
2. Many of the best subjects occur around low-water mark so a low spring tide is the best time for a visit. In some areas, these always occur in the evening or early morning, whereas in other areas, e.g. south-west Britain, they occur nearer midday, making life easier.
3. Rocky shores are usually much better than muddy ones.
4. Start work before low tide and follow the tide down.
5. Tin cans or mugs placed over the tripod legs will prevent them from sinking into soft mud or sand.
6. Protection of your camera and equipment from salt and sand is vital in these situations, and we suggest that you:

a) Keep a UV or sunlight filter on the lens, preferably with a lens hood too.
b) Use a tripod with sealed legs, such as the Kennett Benbo, or protect the legs by tying polythene bags well up around them.
c) Protect the camera and other equipment from direct spray, immersion or sand wherever possible. Wash off any salt water as soon as possible – it is highly corrosive.
d) Change films in sheltered positions, preferably away from sand – one grain in a cassette can scratch the whole film.
e) A protective camera cover, such as the EWA-marine flexible waterproof camera housing, is generally useful as a protection and can be helpful when taking photographs in rock pools (see opposite). A specialist camera, such as the Nikonos, is excellent for general seashore work, but the absence of through the lens viewing and interchangeable lenses is very limiting for close-up work.
f) Check your camera insurance!

Star sea-squirt on algal frond, taken in close-up (1.5:1) to show the form and pattern of each colony. As this example was on an alga rather than a rock, it could be backlit to show the internal structure better. Twin flashguns plus reflector.

circumstances and such filters do reduce the light by $1\frac{1}{2}$–2 stops. Alternatively, you can choose your angle carefully and hold a black card to prevent reflections of the sky from appearing in the picture (a tripod and the delayed action release will free both hands for this sort of thing). In some circumstances, it is possible to allow sunlight to reach the subject whilst keeping reflections from the sky out of the picture by this means, but in other situations it does lead to a loss of light. It can be coupled with the use of one or two flashguns angled in from each side to light the subject without reflection, if necessary.

Finally, you can 'submerge' the lens to avoid the air-water interface altogether. This can be done using an underwater camera, such as a Nikonos (unsatisfactory for close-ups), or a protective waterproof housing, such as the EWA-marine. As a substitute, working on a different principle, you can construct what amounts to a long lens hood and can then submerge the end in water leaving the lens dry. This reduces all reflections but really needs a tripod to allow you the stability to prevent immersion of the lens! The hood should be removed with care after photography to prevent salt water reaching the lens or filter.

The problems of getting enough light to the subject can be solved by lighting with

flash (which can be very successful if lit obliquely enough), using a tripod and a long exposure in still conditions, or by using a fast film.

PHOTOGRAPHY IN THE STUDIO

Collecting and housing subjects

Enough has been said to show that the opportunities for top-quality work in the field are relatively limited, though many interesting pictures can be achieved. The opportunities can be greatly extended by making use of 'studio' facilities, by keeping the subjects in captivity in your home, or in temporary aquaria in the field. First, though, a word of caution on behalf of aquatic animals; the conditions under which they live are very specific and may be difficult to reproduce. There is no excuse for killing or harming species in order for you to photograph them, so please carefully research your subjects before collecting them and familiarise yourself with general aquarium techniques. You should also put specimens back as close as possible to the position in which you found them.

Without going into details, the biggest problems for the animals are likely to be oxygen levels and temperature, which are inter-related, and pollutants such as chlorinated water. Chlorinated water can be rendered harmless by leaving it to stand for 24 hours before use. Temperature and oxygen levels are more difficult to control and the needs vary according to the species, but most animals need to be kept as cool as possible and an aerator will help to maintain the oxygen supply.

When collecting material, make sure that you separate predators from everything else, and don't collect more than you need – it will only cause problems and some animals will probably die unnecessarily as a result. Keep the whole collecting vessel as cool as possible and put a cover over it if there is anything that might fly (e.g. many water bugs) or jump out.

Special equipment

The equipment needed for studio work varies enormously, according to the subject, and space does not allow the inclusion of the details of how to keep different animals in captivity. Your main requirements for the photographic side will be: good quality glass aquaria (or, better still, plate-glass ones) of at least two sizes; glass 'inserts', cut to size, to allow you to confine subjects temporarily to one part of the aquarium; a range of background materials, including natural colours and patterns as well as black, at least some of which should be waterproof; a bench light for focusing and composing; a supply of 'props', such as washed gravel, appropriate water plants, stones, to create an effective set; a good tripod, plus camera with at least two flashguns. We have found that a camera with TTL flash metering is much easier for this work since there is no need to calibrate for each set-up according to position of flash units, reflection from the glass, turbidity of the water and so on – you just shoot!

Finally, there are many occasions when you will need to mask your camera to prevent its reflection appearing in the picture. This can be done with black card or material leaving an aperture for viewing and taking.

The set

The basic requirement for a home aquatic studio is a good-sized glass aquarium with a glass insert to confine animals to the front if necessary. A series of smaller tanks will give you more flexibility for closer work. The glass must be scrupulously clean and free from scratches and blemishes. Some photographers use a tank that is larger at the back than the front to prevent the corners from appearing in the picture, though in most cases this can be avoided and a non-rectangular tank makes the confining of individuals to one area more difficult.

If possible, specimens should be introduced some while before photography begins, to allow them to settle in and start behaving naturally. The next problem to overcome is suspended particles in the water which will show up like falling snow in any flash picture. It is wise to wash all introduced materials – rocks, weeds etc. – and either

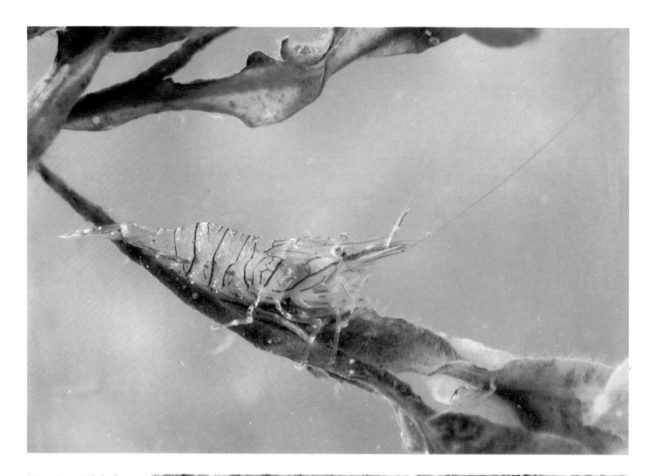

Although not technically perfect, this picture of a common prawn from a rock pool gives an idea of what can be done in a rapidly-arranged outdoor studio, using the set-up shown on p. 141.

Highly mobile aquatic organisms, such as this spotted goby in a rock pool, are difficult to deal with. The light is too low for good action shots with available light and it may be difficult to follow the subject with flashguns whilst still avoiding reflections. The ideal solution is to persuade a companion to hold a flashgun on a long lead and he/she can check the angle and direction whilst you follow the subject. Single flash, 90mm macro lens.

This predatory dragonfly larva was photographed in a tank, set up as described, using a 'natural' background of vegetation and a neutral-coloured card to fill any gaps. Twin flash. 1:1.

A few plants can be photographed more satisfactorily underwater. The insect-eating bladderworts have underwater bladders which trap small water animals but when out of the water they lose their buoyancy and give little hint of their function. Lesser bladderwort *(Utricularia minor).* Tank, using two flashes obliquely behind.

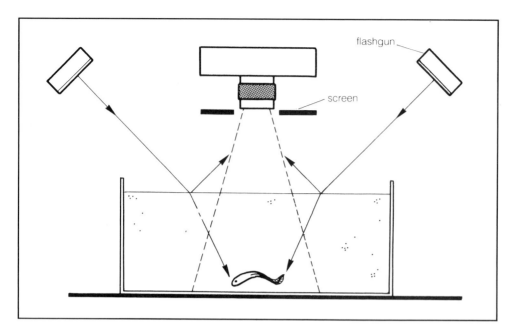

Figure 6.1. Correctly-positioned camera and flashgun to prevent reflections when photographing through a water surface. The flashguns are positioned at more than 45° away from the optical axis, and a black mask around the lens minimises camera reflections.

filter water if at all murky or use clean water, leaving it to stand to dispel the chlorine if necessary. You will need a range of objects – 'props' – to make your set look natural and these can be collected at the same time as your livestock to give a more accurate rendering of the habitat, which you should observe closely at the time of collecting. The bottom of the tank should also simulate the natural environment as closely as possible, for example, a creature collected from a gravel-bottomed river will look out of place over sand. Dry stones or damaged weeds will usually produce streams of bubbles for hours; to avoid this, you can either wait or use pre-wetted stones, be more careful when collecting weeds, or make sure that the offending articles do not appear in the photograph. All weeds will give out more oxygen bubbles in brighter light, though these need not be a problem.

It is difficult to fill the whole background with natural material in a natural way. If you want a well-lit natural-looking set, use as much weed and stone as possible for the immediate background and place a suitably coloured waterproof background inside the back of the tank to fill in the out-of-focus gaps. For some situations, a plain black background is best, to avoid shadows or unnatural set-ups. Use black-painted hardboard inside, or black velvet outside, and

throw as little light as possible onto it. You do need scrupulously clean water for this technique or all particles will show up clearly.

Techniques

Lighting

Most subjects that you will bring to an aquarium to photograph will be highly active and mobile – hence the need to confine them. This will almost inevitably mean that flash has to be used in order to stop movement and also to prevent overheating, which would occur with a continuous source of light. There are a few static subjects which can be taken in available light – freshwater sponges or the underwater 'bladders' of bladderwort – but for most purposes, electronic flash is necessary. As usual, the flashguns can be positioned wherever you like, to give the effect you want. Backlighting, angled to avoid any reaching the lens directly, is excellent for translucent subjects and can produce dramatic results with, for example, some water snails, frogspawn and most smaller aquatic animals. A single light from above reproduces daylight most accurately, though it may be better with side

reflectors or fill-in to reduce the shadows. Probably the most frequently used form of lighting is two flashguns angled in, one on each side of the subject, to light it clearly. Modelling may be better if one is more powerful than the other, or if only one flashgun is used, balanced by a reflector opposite it. With any frontal lighting, the flashguns must not be too close to the optical axis or else the light will reflect directly back into the lens off the glass.

With all tank photography, it is important to prevent reflections of the camera or photographer in the glass from appearing in the photograph. You can blacken or darken all bright parts or, more simply, construct a black mask that leaves a hole for the lens but little else. This can be attached to an old filter mount or lens hood to screw into the front of the lens. A benchlight or two set up before taking the photograph, in a similar position to the flashguns, will show up any reflections or shadows more clearly and these can be corrected as necessary.

Exposure

Gauging exposure for tank photography can be difficult since there are so many variables, such as the amount of light reflected from the glass or diffracted by particles in the water. The easiest solution is to use TTL flash metering, bearing in mind the normal constraints of TTL meters, such as light subjects against a dark background which will need to be compensated for at about 1 stop less than indicated.

Without TTL flash metering, you will need to calibrate your set-up by taking a series of shots at different exposure settings and noting down the details carefully. Your starting point can be worked out using the known guide number of the flashguns and trying different exposures on either side of your estimated correct one. You may then be able to use this calibrated set-up for other subjects with more confidence, though whenever you try a new set-up, e.g. back-lighting, you will need to 'bracket' your exposures according to whatever experience you have gained. For most subjects you will want as much depth of field as possible, so you will need a small aperture. This can be achieved by moving the flashguns as close as possible to the subject or by using more

powerful flashguns. Optically variable flashguns, should be set to their most powerful setting as this also narrows the cone of light to prevent stray reflections.

Taking the picture

We have covered the general considerations of setting up the studio, but the subjects will, of course, vary widely in the way that they need to be treated photographically. As you will discover, it can be a considerable problem getting your subject into the right place in the right pose when you are ready to press the button. There are four tips that will help to make this easier, though you will still need considerable patience for some subjects:

1. Detach the flashguns from the camera and mount them on separate stands with long leads and/or slave units. This leaves the camera free and more mobile, with no risk of knocking the flashguns on something; it makes life easier even if the camera is mounted on a tripod.
2. Draw an erasable line on the tank just outside your field of view. This will allow you to observe your subjects without looking through the viewfinder and you can be ready as they move into the frame.
3. Use a short telephoto (e.g. 100mm macro) from further away if your picture is likely to show the back corners of the aquarium or if the background is difficult to organise – this will reduce your problems, though you will need to be extra careful about reflections in the front glass.
4. Use a glass insert cut to size to confine more mobile subjects, e.g. fish, to one plane so that they can more easily be caught in the viewfinder and kept in focus. Do not confine anything too tightly or it will look unnatural and stressed.

The larger aquatic or partly aquatic vertebrates, such as newts, frogs, terrapins and crayfish, are reasonably easy to photograph, but much more difficult to photograph well. In large aquaria, they tend to disappear out of sight, while in small aquaria they often take up unnatural poses against a corner or edge. The only answer is patience and observation, coupled with a very limited amount of manipulation of the environment – such as lowering the light levels – if

necessary. Feeding may help to tempt individuals into better positions, but animals not reared from a young stage will often be wary of food at first. Pairs of animals may breed or show courtship behaviour, though this may be delayed or even absent in captivity, especially if conditions are not right. You should find out as much as possible about the needs of your particular species and provide them if you can, e.g. female toads like to tangle their spawn strings around weeds, while frogs are less fussy, and newts lay eggs individually on single leaves, wrapping them as they go.

Fishes are often more difficult since they are highly active; confinement by an insert will help to get a static 'portrait' shot, but action shots are much more of a problem. The idea of a 'frame' just outside the field of view will help here as you can watch the fish swim into it, perhaps aided by some judicious tapping or swirling of the water.

Smaller invertebrates, such as dragonfly larvae, water beetles and caddis-fly larvae, pose difficulties because of the higher magnifications needed, making framing and focusing more difficult. The less mobile species, such as water snails and many larvae, are easy enough, but the active ones, such as diving beetles, demand great care and patience as they move so fast and are always turning away at the crucial moment. It can be achieved by feeding them a larger prey than they can really cope with, but this is hardly natural. Other than the general ideas already discussed, there is really no short cut, apart from patience and observation and a good supply of film! Very small invertebrates, such as water fleas, will usually have to be taken *en masse*, preferably in a small tank to concentrate them. Wait for a suitable moment, but do not expect all individuals to be in sharp focus unless they are very tightly confined.

Finally, remember that aquarium set-ups can also be used to take otherwise unobtainable pictures of aquatic plants held up by their natural buoyancy in the water. The possibilities are endless and there is even the chance of some action shots, such as pictures of aquatic insectivorous plants trapping their prey!

Stickleback photographed at ¾x life size in glass aquarium, using twin flashguns mounted independently of the camera.

PHOTOGRAPHY IN PUBLIC AQUARIA AND ZOOS

The opportunities provided by public large-scale aquarium facilities vary enormously. The golden rules are to ask permission first and to go prepared for a variety of conditions. It is also always best to go at an off-peak time, and some more specialised places, e.g. museums, may allow you to work on after closing time if you ask nicely. The subjects range from dolphins, or even sharks, in large marine aquaria to dragonfly larvae in small tanks at a nature trail exhibition centre.

The same general photographic rules apply, except that you are likely to be much more constrained in where you can mount your flashguns, whether you can use a tripod and your choice of viewpoint. A short telephoto lens will be useful and a black cloth may be better than a mask when working on larger animals. Many good pictures are taken in these circumstances, and the animals are usually thoroughly at home, so it is worth a try!

7
Habitat and Landscape

A neglected aspect of natural history work is the photography of the habitats in which the species live and grow. The definition of a habitat is very wide, but for the purposes of this chapter, we are considering everything from a close-up that shows several species interacting and living naturally together through to landscapes showing whole mountain ranges. Thus we overlap with pure portraits of subjects (as covered in other chapters) at one end and with pure landscape photography at the other, though here we are only considering landscapes as habitats for species rather than as pictorial subjects in their own right.

In any lecture, exhibit or publication, a good habitat photograph can tell the viewer far more than just a series of close-up species portraits and the combination can be highly informative. After all, species pictures could have been taken anywhere, and you can find good illustrations of each species in any book, but the habitat pictures are specific to one location and say a great deal about the environment of the species in question. Ideally, a picture will show both a species, or several species, and the environment that they are in, but this is not always possible, nor necessarily desirable, in every situation.

Special equipment

The special equipment needed is relatively limited compared to the range needed for some natural history photography. It is wise to use the slowest film that you can, for maximum detail and impact, since most habitats do not move while you take them. However, you will find a good tripod invaluable since depth of field can be of paramount importance when showing a habitat *and* its key species, so small apertures and long exposures are often the order of the day.

Lenses are likely to be somewhere between 28mm wide-angle and about 100mm short telephoto and there is no doubt that a good quality wide-angle to short telephoto zoom is invaluable. One of us uses a 24–48mm zoom for most habitat work and it opens up a tremendous range of possibilities. Shift lenses (see p. 18) are useful for woodland work, but not worth buying specially for this.

Your other main accessory requirements, both equally important, are a polarising filter and a good lens hood. A polarising filter can improve your skyscapes, differentiate between tree species, put detail into woodland scenes and reduce glare from water, amongst other things, and the loss of light caused by them is less of a problem in this type of work. Lens hoods are invaluable for any against-the-light work and are essential if you have a filter on the front of the lens to improve contrast and reduce flare.

Techniques

The first and most important decision is 'What do you want to show in your picture?' It is likely that you want your habitat pictures to be attractive, but instead of simply taking the first attractive view, consider what you are trying to portray and then you will probably be able to combine attractiveness and information in one picture. Do you want to show the structure of the woodland where the pied flycatcher was breeding and the abundance of holes in the old trees? Do you just want to show an impression of colour in that old hay meadow, or is it more important to show the density and variety of flowers within it? In a mountain picture, do you want to show the range of habitats – screes, pastures, boulders and so on – or do you just want to convey an impression of altitude? Or do you want to combine an identifiable

Colonisation of coastal mud by saltmarsh plants on Humber estuary, England. Taken at f.22 and carefully composed to give both foreground and general interest. The plane of focus was set just behind the main sea aster clump (right foreground) to maximise the depth of field.

picture of a species with a clear idea of the habitat in which it occurs? These are some of the many considerations which may face you, and it is best to sort them out in your own mind before you take too many pictures.

In general, the best starting point for habitat pictures is the standard lens, since this gives a perspective and appearance most similar to that viewed by someone who is there, and most often this is exactly what you want to convey – what the habitat looks like. Other lenses may help in other situations, though. For example, a wide-angle lens is best to show species in their habitat (see p. 155) or for working in confined situations when you are unable to get back from, or above, your habitat (and this frequently happens, unless you own a helicopter!). A short telephoto can be useful for 'pulling-in' part of a view, for example on the side of a valley opposite to you, or on a river island, and occasionally it may be useful for its perspective-flattening capability, e.g. if you wish to show that a woodland or jungle is really dense and impenetrable. Generally, long telephoto lenses beyond about 200mm, and wide-angle lenses beyond 24mm, give too much apparent distortion to present a reasonable picture of the habitat, though both have their occasional uses.

Although a lot of good habitat pictures can be taken hand-held, you will soon find that a tripod is worthwhile and gives you an added dimension of possibilities because of the opportunity to have everything in focus from about 1m to infinity. Even if you do not use one, it is well worth providing some foreground interest to improve the composition and give added information. If you use a tripod, you can make everything sharp, but if you do not, make sure that the most important bits are sharp, and make full use of the depth of field (p. 43).

Species-and-habitat pictures

When taken properly, these can be both striking and highly informative. Some of the principles have been discussed already in relation to flowers, though we are concentrating here on showing the habitat well, with the species as a bonus. Naturally, flowers give the easiest opportunity and, in these situations, a combination of wide-angle lens and small aperture will give excellent results. If possible, choose a species that is characteristic of the habitat and has a strong enough colour to stand out. It is usually better to show its growth form rather than just a few flowers or branches. Animals are more difficult and you will rarely have the opportunity to use a wide-angle lens and a small aperture. If, however, you use your frame fully, it is surprising how often you can do something and, for most such situations, you will find a standard lens best. For example, when setting up your hide on a perch used by, say, a bee-eater on its way to the nest, consider a viewpoint that will allow a general picture as well as a close-up; a standard or slight wide-angle picture showing the bird in one corner with the habitat and nest-hole behind will make an excellent foil to the close-up of the bird (as well as being a good cover picture for your next book!). Reptiles, birds' nests, butterflies and, occasionally, mammals can all be treated in the same way with careful composition, though it is understandable if you elect to take the close-ups first.

Habitat close-ups

This may sound like a paradox, but in many situations the 'habitat close-up' will provide the most interesting and informative picture, especially as part of a series showing both wide and close views. Some habitats are unimpressive in general view, e.g. flat grassland, small bogs, fens and marshes, water's edges, heavily grazed situations. If, however, you pick out a small area, somewhere between $0.5m^2$ and $5m^2$, and show all the plants or animals within that area – depending on the scale of variation – you will convey a good idea of what is there, how the component parts relate to each other, the density of the vegetation and so on. (The photograph on p. 155 shows this sort of approach.) A tripod is especially valuable for this sort of work, where detail is vital.

Whatever the habitat, the key rules are to think carefully about what you want the picture to show, to use good foregrounds to strengthen the interest and composition, and to use a tripod whenever you can to give added depth of field and to make you look more carefully at the subject before you photograph it.

(Above) Habitat close-ups (see p. 153) may give a better impression of vegetation than either a general view or a plant portrait, e.g. this close-up of the plants on Öland island, Sweden.

(Left) Bluebell wood in spring, eastern England. The tilt-and-shift movements of a 5 x 4 in camera were used to increase the depth of field and straighten the converging verticals of the trees. The huge transparency size gives very high resolution of detail.

(Right) When photographing a general view of a habitat, it often gives added appeal, as well as additional information, if some flowers *in situ* can be shown in the foreground, as with these cowslips on ancient chalk workings in southern England.

Appendices

APPENDIX 1 CARE AND STORAGE OF EQUIPMENT

Any natural history photographer, especially one who deals with more than one subject area, is faced with the problem of carrying around large amounts of equipment without damage to it or himself, preferably with it all ready for instant use. Naturally, there is no perfect answer and individual solutions vary widely according to individual needs. However, a few guidelines may be useful.

It pays to look after your equipment well, guarding it against significant knocks and keeping lenses and filters clean. Dust or grease on the lenses can considerably impair definition or increase flare and it is worth carrying a cleaning kit in your bag. If carrying large amounts of equipment, a rucksack is the only satisfactory way of avoiding considerable strain and difficulty when walking, although you will need to pack it carefully and use outside pockets to make items as accessible as possible. If you are hoping to photograph active mobile subjects on a chance basis, it will pay to have a camera set up in readiness about your neck, preferably switched on and with aperture and shutter speed set correctly. If you are interested in various particular groups, e.g. flowers, insects and birds, it will pay you to separate the items for each into different clearly labelled hard or semi-hard boxes which can be easily stored in the car or carried in a rucksack. Foam inserts with holes cut to size for each item are possibly best in this respect.

If you use a flash set-up for insect photography or other close work, you will find it useful to acquire a case in which it will fit fully pieced together. This can then be transported anywhere in readiness; the alternative of setting up the equipment when required can take several minutes and may involve the loss of your subject. Tripods are best carried attached to the outside of a rucksack or in their own case if carried for long periods.

When stalking, or even in other forms of photography, as long as you are not carrying too much equipment, a photographer's waistcoat with multiple varying-sized pockets can be ideal. Your main outfit, say camera plus 400mm lens, will be around your neck, while the pockets can contain films, extension tubes, filters, other lenses, converters and even lunch!

For any camera that uses battery power, carry at least one full set of replacement batteries, preferably reasonably fresh ones. Before going away on a long trip, it is wise to insert new batteries and to check your light meter readings against a known accurate standard, or quickly run a test film through. Before a 'once-in-a-lifetime' trip, it will pay to get your camera fully checked and adjusted professionally first.

Whilst on an extended trip, continually check your meter against other cameras if you can and, whenever you finish a film – unless in the middle of some action, or in a dusty or salty place – check the inside of the camera for hairs, dust etc., and check the shutter speeds and diaphragm size by eye when making a few exposures.

If you possibly can, try to acquire a second camera body with the same lens mount as your main one. These can be acquired very cheaply, either as the cheapest in your particular range, or secondhand. This will provide a spare in the event of failure, a standard to check the other camera against and an opportunity to load both fast and slow film (or colour and black-and-white).

If you lay your camera up for long periods (though we hope that you will not after reading this book!) remove the batteries, keep it cool and dry, and check it thoroughly when you re-start photography.

APPENDIX 2 GOING A STAGE FURTHER

Reading books may help to guide you towards taking better pictures, but there is no substitute for practical experience and we urge you to try out as many of the techniques described as you can and to learn from each mistake. We all learn different things from any experience, but you can speed up the process of learning from the less good pictures by making notes on each new technique or situation that you try, so that you can be reasonably sure what, if anything, went wrong, or – just as importantly – what went right if you get a real winner. Think hard about the results and you will learn much more quickly.

It helps also to learn from the experience of others. If you are not fortunate enough to be able to go out with an experienced natural history photographer locally, then try to join a club with some natural history tendencies. Some national societies, such as the Royal Photographic Society in the UK, have a Nature Section, with meetings arranged all over the country. There are also postal clubs, some of which specialise in nature work, and these will give you a chance to see other people's work and have your own commented on, even if there is no-one local who is interested. Adult education courses on natural history photography, both evening lectures and weekend or longer courses are now quite frequent, and they give a better chance of feedback and learning experience than a book alone can ever do.

If nothing else, it will pay to look at the work of other photographers – in books, lectures, exhibits etc. – and find out as much as you can from them, or from the photographer if you can. Experience will show you what questions to ask!

Using your pictures

There are many ways in which your pictures can be used – for lectures, private shows, competitions, publications, exhibitions, campaigns – and it is much more satisfying if they are well used and appreciated. Your first requirement is undoubtedly to label and classify the pictures accurately and sensibly. Labelling should be as clear and precise as possible, with the correct name (including the Latin one) if you know it; if not, at least put the location, date and habitat so that you have more chance of getting it identified later. Pictures come back to you in sets of 24, 36 or whatever, and many people leave them like that, but how often do you need to dig out all the pictures taken, for example, between May and June 1983? It is much more likely that you will need a picture of a particular species, group of species or place, and to this end it makes much more sense to classify them properly once you have amassed more than a few films. Using good guide books as references, you can separate your pictures into the main groups – birds, insects, flowers etc. – and then subdivide these, e.g. insects into butterflies, dragonflies etc., as required. The more pictures you amass, the more useful this will be, and you will quickly be able to find what you want – and put it back accurately. As the collection grows, you will find an increasing need for cross-referencing and a card index system will be helpful for this. It helps to number each slide to a predetermined system – this makes putting away much easier, and it is essential, if you start submitting slides to publishers, to identify each slide accurately.

Storage of slides is a matter of personal preference, depending on space, need and finance. Storage in projection cassettes is not

very satisfactory unless you regularly need to project each set in exactly the same order and do not often require individual slides from them. For large amounts, we find clear hanging files to be much the quickest and easiest, but they are not cheap. The cheapest method is to keep them in the original boxes, but reclassified as necessary and not filled too full. Whatever they are in, slides should be kept as cool, dry and dark as possible to prolong their life. Direct sunlight hastens their deterioration very quickly and humid conditions promote fungus growth very rapidly.

Once you start to build up a good collection of pictures, you will inevitably begin to use them more. If you begin to use them to illustrate lectures, think hard about the gaps that exist and try to fill them – for example, a lecture on photographing birds will be much more interesting if it includes pictures of the habitats you have worked in, any unusual hides you have had to put up, and perhaps some of the other forms of natural life encountered while doing it, rather than just a straight series of bird pictures. Keep a few of your failures too, to show what can go wrong and why!

With the great demand for information on natural history, more and more good natural history pictures are being published and naturally you may turn to thinking about recouping some of your costs by selling of your pictures. The competition is very fierce and standards are very high, but there are still possibilities. Unless you have a really large collection of good pictures (say, over 30,000), you are unlikely to interest publishers in coming to you directly. This leaves you the choice of going to an agent or creating your own markets by writing and illustrating your own articles and books. Agencies exist in most countries and some specialise in natural history. They will sell your work to a wide range of markets, taking a percentage fee (usually 50%) for their efforts. They demand high standards, large quantities and regular supplies of accurately labelled material; if you can fulfil this and find a 'niche' with an agency, you can look forward to regular cheques to help with your expenses, though you should not expect miracles.

Finally, if you feel you are taking good pictures, why not try entering a few competitions, locally, nationally or internationally? Follow the rules carefully, be highly critical of your work and try your luck. If nothing else, it helps you to raise your own standards.

Index

Page numbers in *italic* refer to black and white illustrations. Page numbers in **bold** refer to colour illustrations.